The Philadelphia Flower Show

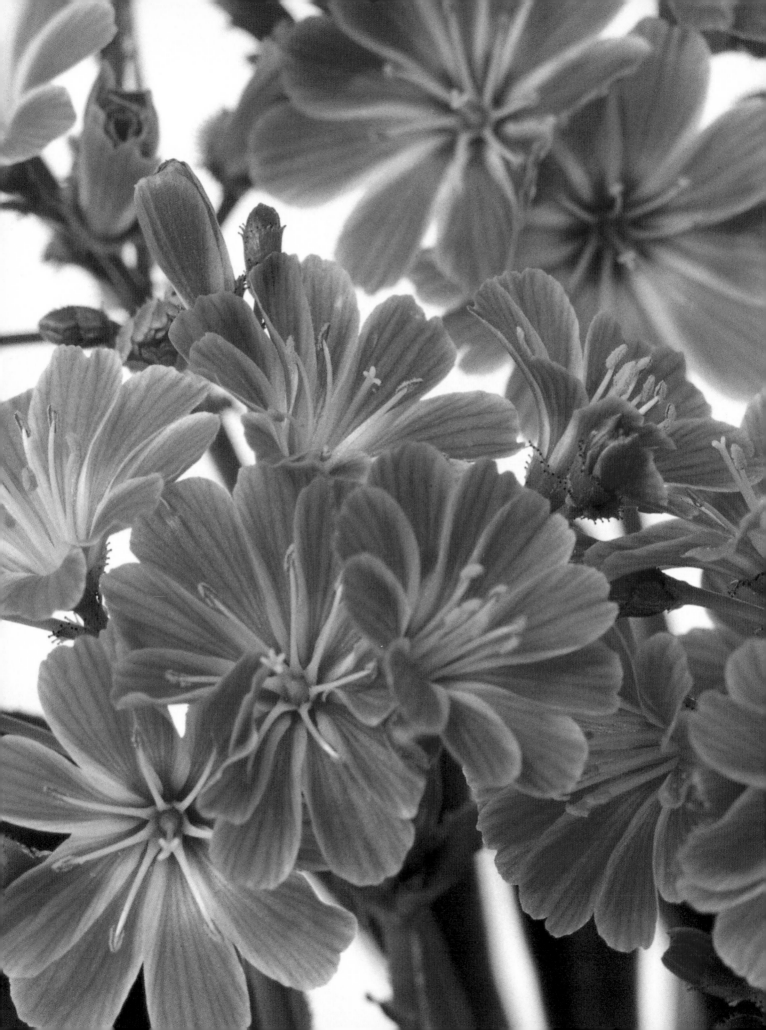

The Philadelphia Flower Show

Adam Levine and Ray Rogers

FOREWORD BY KEN DRUSE

PHOTOGRAPHS BY ADAM LAIPSON

EDITED BY GEORGE SCOTT

A Chanticleer Press Edition

HarperResource

An Imprint of HarperCollins*Publishers*

To the exhibitors and volunteers who make it possible
for the Philadelphia Flower Show to go on each year.

PUBLISHED BY
HARPERCOLLINS PUBLISHERS INC.
10 EAST 53RD STREET
NEW YORK, NY 10022

PREPARED AND PRODUCED BY CHANTICLEER PRESS, INC.
AND CHARLES NIX & ASSOCIATES.

FIRST EDITION PUBLISHED NOVEMBER 2003.

THE PHILADELPHIA FLOWER SHOW IS A REGISTERED TRADEMARK
BY THE PENNSYLVANIA HORTICULTURAL SOCIETY.

MANUFACTURED IN SINGAPORE.

03 04 05 06 07 1M 10 9 8 7 6 5 4 3 2 1

LIBRARY OF CONGRESS CATALOGING-IN-PUBLICATION DATA HAS BEEN APPLIED FOR.

ISBN 0-06-057513-1

HARPERCOLLINS BOOKS MAY BE PURCHASED
FOR EDUCATIONAL, BUSINESS, OR SALES PROMOTIONAL USE.
FOR INFORMATION PLEASE WRITE:
SPECIAL MARKETS DEPARTMENT, HARPERCOLLINS PUBLISHERS INC.,
10 EAST 53RD STREET, NEW YORK, NY 10022.

Contents

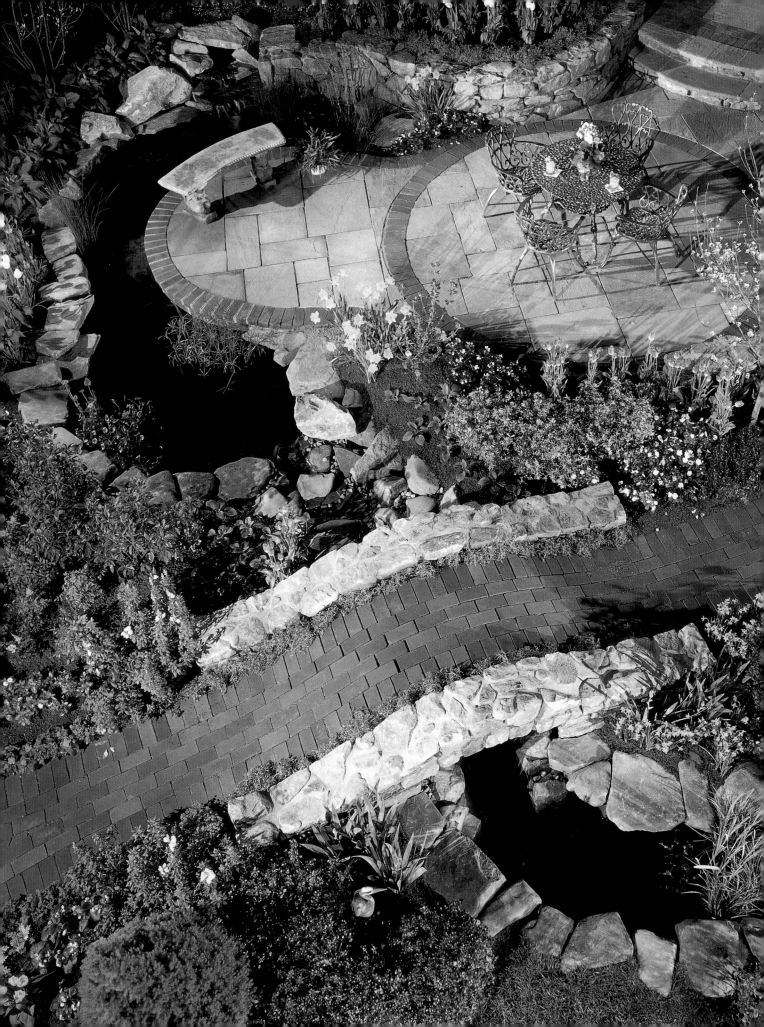

Preface

When I was studying horticulture in college, it dawned on me that the one place I wanted to work when I finished my studies was at the Pennsylvania Horticultural Society. As a student, I had participated in a small way as a volunteer for the Philadelphia Flower Show and liked everything I saw— the excitement of the preparations, the amazing creativity of the exhibitors and the friendly welcome from staff and volunteers.

Imagine my excitement then to find out shortly before graduation in 1979 that the Society was planning to hire a public relations coordinator. I was totally unqualified for the position, but this didn't seem to cloud the judgment of the interviewers and soon I was knee-deep in preparations for the 1980 Philadelphia Flower Show.

More than two decades later, I still find my involvement in the Show to be enormously satisfying and exciting. Through these pages, I hope readers will be equally inspired by the Show's magical transformation from bare concrete to a horticultural marvel. In this book you will find stories and photographs that cover wonderful exhibits and wonderful people. Some no longer exhibit, but their displays live on through the photographs and in our memories.

People involved with the Show—staff, exhibitors, sponsors, volunteers— often refer to themselves as a family. We have our agreements and disagreements, but at the end of the day, we are all connected. We are a group brought together by a love of gardening and plants and with the same goal—to produce the very best Show possible for our visitors and to raise funds for Philadelphia Green, the Pennsylvania Horticultural Society's community greening program. Over the past 30 years, we have carried out more than 3,000 greening projects in Philadelphia, from tiny neighborhood parks to extensive city landscapes.

Truly, the Philadelphia Flower Show family sows seeds each year in the Pennsylvania Convention Center that flourish year-round in our city.

Jane G. Pepper

JANE G. PEPPER, *President*
PENNSYLVANIA HORTICULTURAL SOCIETY

Simple Pleasures
EBERHARDT'S LANDSCAPE & DESIGN
AND ROMANO'S LANDSCAPING
1994

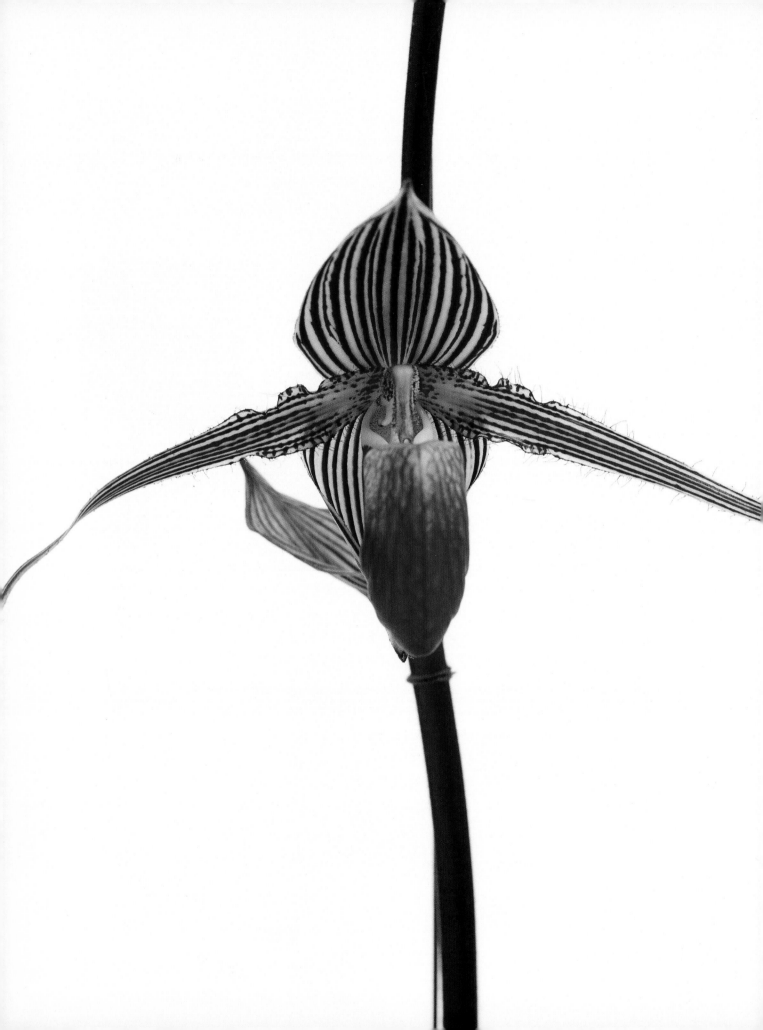

Foreword by Ken Druse

Whenever the promise of spring threatens to be broken by yet another snowfall, I recommend hemisphere-hopping to winter-weary gardeners. Christchurch, New Zealand, or São Paulo, Brazil, sound good by the end of February. But those of us who can't jet to warmer climes should consider traveling to exotic southeastern Pennsylvania. There, the gardens of the world assemble under one roof for an annual event known around the globe as the Philadelphia Flower Show.

The gardens at the Philadelphia Flower Show may include a facsimile of an indigenous woodland with jack-in-the-pulpits, or an English cottage bearing scores of sapphire delphiniums by the back door. You might see the antebellum plantings of Tara, or a carbon copy of the late Queen Mum's borders. I've seen waterfalls over two stories high, and nearly microscopic plantings with flora in thimble-size pots. Gardens inspired by places from Tuscany to Tucson, from Normandy to North Carolina, might appear. Latitude be damned: The only limits to the possibilities are imagination and chlorophyll.

It's logical that the Mother of North American flower shows would be staged in the undisputed "Mecca of American Horticulture"—the Delaware Valley. Creating plantings for beauty—food for the soul and not just the belly—is a tradition in an area with estates and staffs to maintain them. The grand gardens of the du Ponts and their descendants produced pleasure palaces like Longwood Gardens, Winterthur, Nemours, and the Mount Cuba Center. These estates entered plants and flower arrangements in the Philadelphia Flower Show and won blue ribbons. The first families and people they influenced also energized local nurseries, which have become among the best in the country and now mount extravaganzas for the Show.

But the local gardening tradition predates the estate gardens. Benjamin Franklin's friend, John Bartram, built the first botanical garden in North America on the banks of Philadelphia's Schuylkill River before the Revolutionary War. The non-profit Pennsylvania Horticultural Society (PHS), the nation's first such organization, was founded in 1827, and its members organized the first Philadelphia

Paphiopedilum rothschildianum
'Rex' FCC/AOS × 'Mount Kinabalu'
KATHLEEN HARVEY

Flower Show in 1829. The Show was held in an 82-by-69-foot building called Masonic Hall on Chestnut Street. Twenty-five Society members shared plants like magnolias from around the world, peonies from China, an India rubber tree, Arabian coffee trees, and West Indian sugar cane.

By the mid 1960s, though, the Show was at a crossroads: A construction project threatened to postpone the event for several years. But the then-executive director of the Pennsylvania Horticultural Society, and one of my personal heroes, Ernesta Drinker Ballard, helped the Show persevere. She convinced the sponsors, a group of professional nurserymen and growers, to move the Show first to the 23rd Street Armory and then to the Civic Center. In 1968, the Horticultural Society became the official producer. Today, this is the largest indoor flower show in the world with more than 50 display gardens under the roof of the Pennsylvania Convention Center.

Some people say that the Show is too commercial, with over 140 merchants represented in the marketplace section. Unlike most home and garden shows, however, you will not come upon see-through dishwashers or Japanese kitchen knives. These vendors must all be garden-related, but one can still find a gizmo or imitation bonsai, and just when you think you've seen enough copper butterfly lawn sprinklers, you might notice a polyester banner declaring, "There's no place like Gnome." Despite this sort of offering, you can always buy summer-flowering bulbs, like cannas and dahlias, months before they will be at the garden center; seeds of unusual varieties; a wonderful rare succulent; or next year's hot new plant. In the end, the Show is a discerning shopper's paradise.

One of the most amazing things to me is that the Show turns a profit, even though in some cases the dazzling displays are subsidized by PHS. And under the direction of the president of PHS, Jane G. Pepper, the Show has become the model for just about every other flower show in North America. Other shows dream of making a profit. Some do, some don't, but all send their representatives to be schooled by this triumphant event.

Proceeds from the Show help fund PHS outreach programs including Philadelphia Green, the nation's largest and most comprehensive neighborhood

greening program. Philadelphia Green works with more than 800 organized community groups on thousands of projects that include street tree planting, creating vegetable and flower gardens, and maintaining neighborhood parks.

The Show and its connection to Philadelphia Green helps balance commerce and art, commercial and artificial. I am not as impressed by the scale of the displays, and rarely find the humor in animated scarecrows or the magic in transforming car tires into planters festooned in razor ribbon. I won't wait in lines to shuffle through a witch's lair or princess's castle. But I am wowed by the botanical magicians' achievements. Consider what it takes to force plants to bloom out of season, and at that, to the greatest level of perfection imaginable. Growers have to control temperatures in greenhouses. Plants must be cut back on the right day, or brought in from the cold, or watered and warmed. Nights must be turned into days, and in some cases, days into nights to make plants think they have enjoyed a full winter, sense the onset of spring's lengthening days, or autumn's shortening hours of daylight. Often, growers work with several of each variety to ensure that at least one will blossom at just the right moment, and another version waiting in the wings to replace one that might fade during the run of the Show.

But the part of the Show that makes a trip each year more necessary than nice are the amateur horticulture classes. I may come across a perfectly planted hypertufa trough, as well as take home a brochure on how to make one myself and install the jewel-like alpine plants I see blooming months before their outdoor counterparts. Almost 3,000 individual plants are entered in competition. I can always discover some of the most perfectly grown, esoteric, rare, and spectacular indoor specimens. These exquisite plants are like *haute couture* gowns or Chinese lacquerware. They are the museum-quality examples of their kind. One or another of these plants transfixes me, and the crowds are usually thinner in the amateur class areas, so I can take uncrowded time to pay my devotion. I'll stare until the perfection of the plant and the dedication of its keeper have been passed on to me.

The most valuable part of the Show comes *gratis* with the price of admission—learning new things and, above all, inspiration.

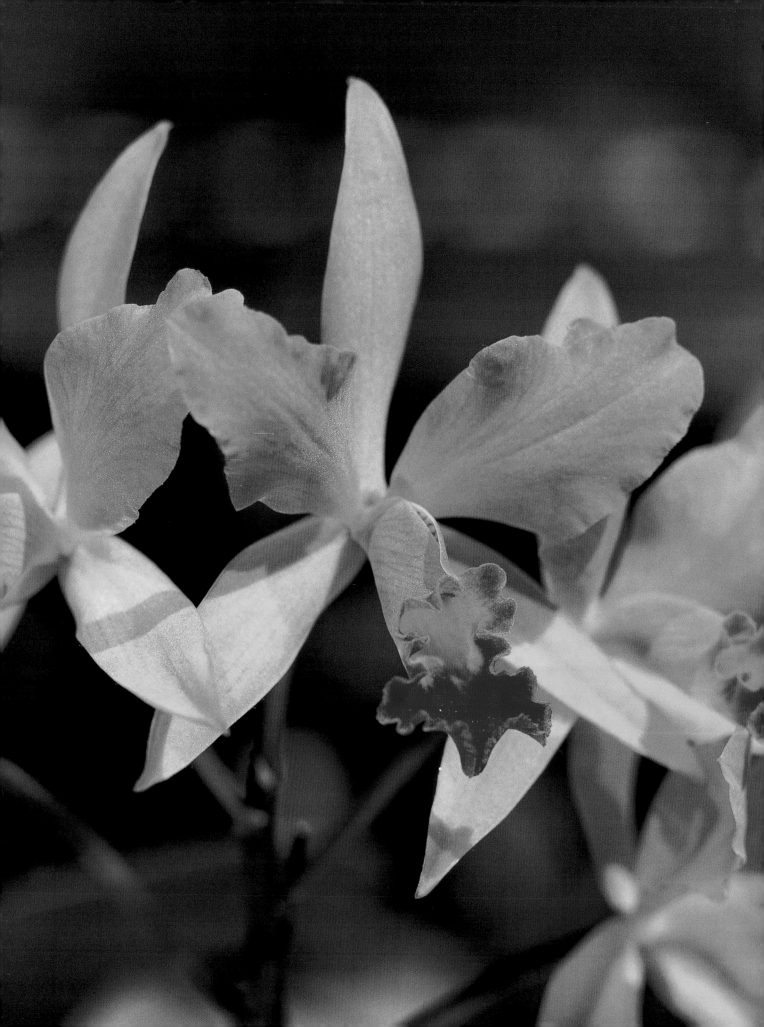

The Philadelphia Flower Show and The Pennsylvania Horticultural Society

"The visitors were numerous, and often crowded the hall to excess.... Old and young, the gay and sedate, came by the hundreds to partake of this feast of flowers."

—*Baltimore American Farmer,* JUNE 10, 1831

For nine days in March every year, the 10-acre main exhibition floor of the Pennsylvania Convention Center is transformed into a horticultural extravaganza. The Philadelphia Flower Show, with roots reaching back 175 years, is now the largest indoor flower show in the world and is the standard of excellence by which all others are judged. Produced by the Pennsylvania Horticultural Society, the logistical work for each Show actually begins two to three years prior. It involves the coordination by PHS of more than 50 major exhibitors, roughly 3,000 entries in hundreds of competitive classes, and a dedicated corps of more than 3,500 Show volunteers who put in long hours to help bring it all together and keep it running smoothly.

Coming at the tail end of the gray Pennsylvania winter, live plants forced into early flower are an irresistible part of the Show's appeal. And they come in an amazing variety and scale, from tiny alpine

<< OPPOSITE PAGE

Laeliocattleya Fire Island 'Fiery'
HCC/AOS
MAURICE MARIETTI

Coming at the end of winter, the Show is a welcome respite from the usually cold, gray days in late February and early March. The explosion of colors attract hundreds of thousands of visitors each year to the Convention Center in downtown Philadelphia.

flowers in 4-inch pots to 25-foot tall blossoming trees. For their major exhibits, commercial nurseries will begin preparing to force plants up to a year or more in advance, using a combination of science and intuition to bring bulbs, annuals, perennials, shrubs, and trees into full bloom. Forcing on a smaller scale is also accomplished by the amateur horticulture competitors, whose jewel-like plants on display are often the result of years of preening and pampering.

This book about the Philadelphia Flower Show combines beautiful photographs with stories that take the reader behind the scenes of this annual event. Organized along the same lines as the Show, the book includes chapters covering the competitive horticulture classes, artistic and design classes, and the major exhibits. All photographs of the competitive classes were shot at the 2003 Show, while the photography in the major exhibits chapter covers a range of Shows since 1985.

Major exhibits are created by landscape nurseries, floral design businesses, high school and college horticulture programs, city agencies, and educational institutions. Exhibitors include the Philadelphia Water Department, the Fairmount Park Commission, the Philadelphia Zoo, and plant societies devoted to rhododendrons, rock gardening, African violets, cacti and other succulents, bonsai, ivy, ferns and wildflowers, and botanical illustration.

The competitive classes include a few professional horticulturists and floral designers, but most entrants are amateurs, who don't compete for monetary gain,

but for the challenge of doing one's horticultural best. The depth of their dedication is perhaps epitomized by the heroics (some might say insanity) of Barbara Sullivan, a member of the Martha Washington Garden Club in Yardley, Pennsylvania. In 2003 Barbara slipped and broke her wrist while loading her car with plants for the club's window box and lamppost exhibit. The entry had to be installed that morning, and even though Barbara says her hand was "hanging like a dead fish," she refused to leave the space empty, and with the help of another club member, she managed to get the job done.

Some competitors have been entering the Show for decades, while every year newcomers step nervously into the fray and end up delighted by the friendliness of the competition. "When I was recruited to be a member of the Providence Garden Club, and then began exhibiting in the Show, it really changed my life," recalls Chrissy Ribble. "I went from being a homemaker with baby throw-up down my back to being involved with these incredibly creative, friendly people."

While most exhibitors are middle-aged or older, a dedicated group of teenagers participate as well. Whether they are brought in by teachers or simply following in the footsteps of family members, everyone dotes on these youngsters. Even though the Philadelphia Flower Show will be 175 years old in 2004, the Show's future is in the hands of the young people, who are the amateurs, and professional gardeners and designers of the future.

Ribbons and rosettes are part of the reward for exhibitors in the competitive horticulture and artistic and design classes. Many participants plan all year to present their creations to a panel of expert judges. Whether awarded a ribbon or not, most competitors enjoy the creative process and comraderie as much as any prize they might win.

History

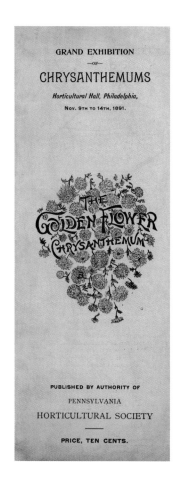

GRAND EXHIBITION OF
CHRYSANTHEMUMS
PROGRAM COVER, 1891

*Chrysanthemums became wildly
popular in the 1880s, and for a time
the Pennsylvania Horticultural
Society added a chrysanthemum
show to its annual exhibition
schedule. Besides the mums,
the 1891 show also featured displays
of roses, carnations, pansies,
foliage plants, palms, lycopodiums,
dracaenas, fruits, and vegetables.*

When a group of prominent Philadelphians founded the Pennsylvania Horticultural Society in 1827, one of their goals was "to inspire a taste for one of the most rational and pleasing amusements of man, and to facilitate the means of cultivating that taste." To that end, it became a custom at the Society's early meetings for members to exhibit examples of their horticultural achievements. According to a newspaper report, the display at the meeting of November 1828 included "upwards of forty specimens of beautiful flowers... fifteen varieties of pears and apples...Cauliflowers and Broccoli, both fine for the season," and a two-year-old bottle of wine made from American grapes, "thought to have excellent body and fine flavour."

In June 1829 the Society undertook its first public display, advertising a one-day "Exhibition of fruits, flowers, and plants" that was the first of its kind in the country, and the progenitor of today's Philadelphia Flower Show. Among the hundreds of plants on display were "the magnificent and curious Strelitzia," or bird-of-paradise flower, and a plant new to American horticulture, a euphorbia, "with bright scarlet bracts, or floral leaves, presented... by Mr. Poinsett, United States Minister to Mexico," now familiarly known as the poinsettia.

"The exhibition collected together...the fragrant and smiling offspring of the earth, in their richest odours and their gaudiest hues, and then restored them to the possession of their public spirited and generous proprietors," read a June 1829 article in the *Philadelphia National Gazette*, that could just as well describe the

Show today. "They who witnessed this
exhibition…enjoyed the opportunity of
comparing together a greater variety of
plants than has at any time before been
assembled among us in a single view….
The visitor was alike impressed with the
vivid and variegated hues which everywhere delighted
and refreshed the eye; and with the multitude of fresh
and fragrant odours which were wafted upon every
breeze…. In a word, the spacious
hall was redolent with sweets, and
sparkling with beauty."

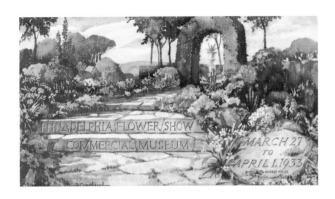

PHILADELPHIA FLOWER SHOW
BLOTTER CARD, 1933

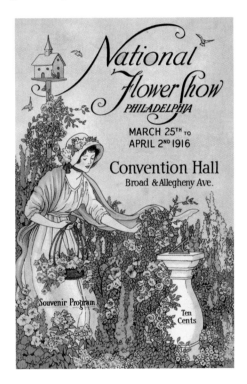

With the success of this initial
exhibition, the Society made it
an annual event. The early shows
became popular social affairs, where
thousands of visitors came to see
not only the beautiful displays of
flowers, but to "see and be seen." The
exhibitions were held in various
venues until 1867, when the Society
built its own Horticultural Hall,
next to the Academy of Music on
Broad Street. Beginning in 1872, two
exhibitions were held each year, in
both spring and fall, and when chrysanthemums
became popular in the late 19th century, a mum show
became the focus of the autumn exhibition.

Before each exhibition the Society published a list
of the competitive classes, a system that, except for the
cash "premiums" offered for the best entries, would

NATIONAL FLOWER
SHOW PROGRAM
COVER, 1916

*In 1916 the Society of
American Florists held
a major exhibition in
Philadelphia, with the
cooperation of local and
national horticultural
organizations.
The success of this
show inspired the
Pennsylvania Horticultural Society and the Florists'
Club of Philadelphia to begin a similar March
exhibition in 1924, from which the present-day
Philadelphia Flower Show has grown.*

be very familiar to modern-day competitors. At the 1885 show, premiums ranged from $1.00 to $30.00 for 76 classes of fruits, vegetables, potted plants, cut flower specimens, and floral designs. In the latter category, displays covered the spectrum from joy to grief by including classes for a "bride's bouquet" and a "funeral design."

In order to raise money, the Society sold Horticultural Hall in 1917 which, by that time, had twice burned and twice been rebuilt. Except for the war year of 1918, various shows continued to be held, including peony, rose, and dahlia shows as those flowers grew in popularity. But the proliferation of local shows sponsored by newly formed suburban garden clubs around Philadelphia consistently cut into attendance, and the Society's smaller shows were eventually abandoned.

In 1916 the fourth National Flower Show came to Philadelphia and staged one of the largest horticultural exhibitions the city had ever seen. Eight years later, spurred by their memories of that Show's success, the Florists' Club of Philadelphia and the Pennsylvania Horticultural Society staged a free two-day exhibition, which they expanded to four days in 1925. That event, christened the Philadelphia Flower Show, drew a reported 83,000 visitors to the

DISPLAY AT COMMERCIAL MUSEUM
PHILADELPHIA FLOWER SHOW, 1930

Beginning in 1924, the Philadelphia Flower Show was held in the Commercial Museum, a cavernous iron-framed building, built in 1897. Located near 34th and Spruce Streets, it was torn down in 1964 to make way for the Civic Center, where the Show was held between 1968 and 1995.

*Getting a single perfect rose to bloom atop a
5-foot stem, as shown in this competitive class for
commercial rose growers, required removal of all
but one bud to concentrate the plant's energy into
that one flower. Even so, only one in five plants
so grown would bloom on the exact day for the
competition. This meant that hundreds of plants
had to be grown to get the 50 flowers called for in
this class. One newspaper described the process
with this catchy headline: "Beauties Pinched for
Flower Show."*

Commercial Museum, a cavernous hall that hosted
many of the city's conventions and trade shows.

"In these large and popular shows the Society
is carrying on its principal aim, which is to increase
an interest in plants and the love of flowers in the
hearts and lives of young and old, rich and poor,"
wrote James Boyd, the Society's President, in one
of his annual reports. "Of course, our commercial
members benefit considerably from these shows,
because the public is shown how to express sympathy,
congratulations, etc., with a gift of beautiful flowers."

When the Philadelphia Flower Show was
incorporated in 1927, commercial interests had control
of the organization, with the board consisting mainly
of prominent nurserymen and florists, whose displays
made up the bulk of the exhibits at the Show. Estate
gardeners, who staged large displays of orchids, acacias,
and other plants, were also represented, but in this
scheme the Pennsylvania Horticultural Society's role

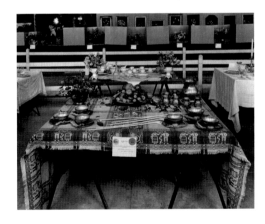

AMATEUR AND GARDEN CLUB CLASSES, 1931

*This "table for a specified occasion or anniversary,"
entered by Mrs. Robert Liggett and Mrs. Boyle Irwin
III, won a first prize in 1931. The flower arrangement
niches are visible in the background.*

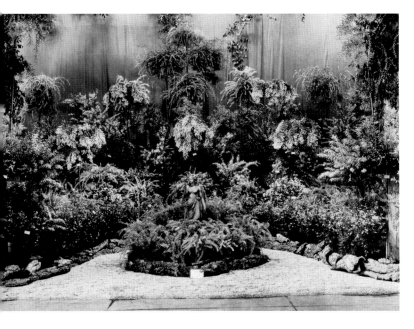

WIDENER COLLECTION OF ACACIAS, 1932

Joseph E. Widener's collection of rare acacias, tended and multiplied by the gardening staff at Lynnewood Hall, his Elkins Park, Pennsylvania, estate, were a beloved feature at the Philadelphia Flower Show for more than 15 years. In 1941 Widener gave the entire collection—588 plants of 16 varieties—to the newly built National Gallery in Washington, D.C.

SPADE AND TROWEL GARDEN CLUB
DURING FLOWER SHOW SETUP, 1954

Members of this Kennett Square, Pennsylvania, garden club are installing their Show exhibit, which, when finished, included a garden outside and a furnished room inside the picture window. From left to right, Mrs. Thomas R. Jackson, Mrs. J.A. Almquist, Mrs. A. Duer Pierce, Mrs. William J. Scarlett, and Mrs. J.R. Wilson.

was to organize the Show's amateur and garden club classes. The Show eventually expanded to six days and even during the depths of the Depression, regularly drew tens of thousands of visitors. Proceeds from the admission fees and trade booth rentals went into a fund to pay for the expenses and cash premiums for the following year's event.

In March 1942, Don Rose, a Philadelphia newspaper columnist, wrote:

> "The Philadelphia Flower Show is a tremendously encouraging thing in times like these, a reassurance that the life of mankind and the goodness of Mother Nature go on, even while momentous issues are being decided on the war fronts of the world. It will not worry a petunia or tomato that we aren't doing too well in the far Pacific. A tomato attends to its own business on the home front…and the petunia does pretty well, too, brightening the corner of the world where it lives with vivid color, even though dark shadows cloud the horizon of the world's tomorrow."

Although no Shows were held between 1943 and 1946, due to World War II and the lack of fuel and manpower to run greenhouses that supplied many of the plants, the event was re-established in 1947 and ran popularly until 1964. That year the City of Philadelphia announced its plan to demolish the

Commercial Museum (which had opened in 1897) and build a new civic center on the site. The board of the Philadelphia Flower Show, not interested in interim arrangements to stage the Show elsewhere, decided to suspend it for three years until the new building was completed.

Into the void stepped Ernesta D. Ballard, the new executive director of the Pennsylvania Horticultural Society. "Besides garden visits and a subscription to *Horticulture* magazine, the only other benefit of Society membership was a ticket to the the Show each year," Ernesta recalls. "I convinced the Society's Executive Council that we just couldn't afford *not* to do a Show." Between 1965 and 1967, the Society held three Shows in makeshift locations, each one slightly larger and more ambitious than the previous year. When the Civic Center was completed in 1968, PHS negotiated a lease for the time and space at the Center to the exclusion of the old Philadelphia Flower Show, Inc. When that organization protested, Ernesta countered that the Society and garden club volunteers had done much of the work over the years with little in return for their efforts. Her argument prevailed, control of the Show was returned to its original founder, and after several years the event began to grow and prosper.

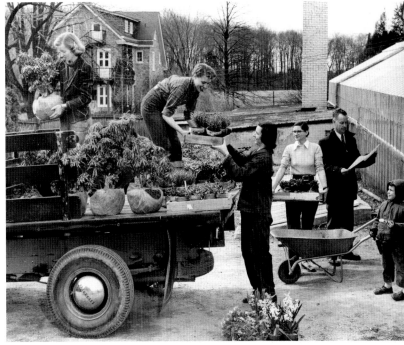

CREW FROM THE SCHOOL OF HORTICULTURE FOR WOMEN, LOADING A TRUCK WITH PLANTS FOR THEIR SHOW EXHIBIT, 1954

For Ernesta Ballard (third from right, with glasses), the school's 1954 exhibit was her first exposure to the Philadelphia Flower Show. Ten years later, as executive director of the PHS, Ernesta helped the Society regain control of the Show, which had been controlled by commercial interests for 40 years.

Ernesta was executive director at PHS until 1980, and during her tenure she appointed J. Blaine Bonham Jr., who has made Philadelphia Green a model urban greening program for other cities; Jane G. Pepper, who succeeded Ernesta as the head of the organization; and Ed Lindemann, who became the Show designer in 1980 and its director in 1994.

In 1996 the Show moved to its current home, the Pennsylvania Convention Center, and under the able guidance of the current administration, the growth and popularity of the Show seems assured for years to come.

"It's such a wonderful group of people," says Cecily Clark, who has been entering the Show's competitive classes for more than 50 years. "Everyone is focused on the same objective, and while there's a strong sense of competition, there's an equally strong sense of interest and concern about each other's work, and a willingness to share information and to give encouragement when it's needed. The Show is beautiful to look at, and there's so much to learn. There's a lot of camaraderie in pursuit of a high degree of excellence, and the proceeds go to a wonderful cause. What more could you want?"

Ed Lindemann has been the Philadelphia Flower Show's wizard behind the curtain for the past 25 years—the designer and director who makes sure the event dazzles each year on time and on a projected budget. Planning for a particular Show begins as many as three years ahead of opening day, which means that as one Show approaches, Ed and his team are busy working on the two upcoming Shows. To say that Ed's job requires a detail-oriented nature would be an oversimplification. As one admirer puts it: "He's a master juggler who can keep a dozen balls—a hundred balls—in the air at once."

Hired in 1972 as a horticulturist, Ed started work at PHS in early March and was immediately recruited to help out at the Show. He quickly became enamored of the annual spectacle, and for several years he worked alongside John Kistler, a landscape architect who was then the Show's freelance designer. After Kistler's death in 1979, Ernesta Ballard, the Society's executive director, asked Ed if he wanted the job. "In 1980 they gave me a year's trial, and since we never had another discussion, I guess it worked out," Ed says with a smile. Since 1981 he has been working alongside PHS president Jane Pepper, who encourages his creative ideas for the Show as long as they stay within the budgets she approves.

A graduate of the horticulture program at Delaware Valley College, Ed also has a long-standing interest in theater. "If I've made any change in the Show over the years," he says, "it's that I've made it more theatrical in addition to horticultural." Use of dramatic lighting has become standard in most areas of the Show. Where aisles between exhibits had been straight, he added curves, to keep people wondering what they might find around the next bend. The Show's Central Feature—the first exhibit that visitors see after coming through the main entrance—has become more elaborate and entertaining. "There's keen competition for the ever-decreasing amount of time people have to devote to entertainment," Ed says. "Because of that, flower shows can't just be collections of plants; they can't look like they did in the 60s or 70s or even the 80s. Museums

face the same problem when mounting new shows. You can't just have collections anymore, you have to bring the collections to life."

Advance planning for the Show includes developing the theme, drawing rough sketches of the Central Feature, and then inviting nurseries and florists with extensive Show experience to help flesh out and execute this idea. Set designers are hired, props are made or purchased, and if tropicals are used, plants are purchased and reserved to be shipped to Philadelphia in time for the Show.

In the competitive classes, class titles are written to conform to the Show theme. Once the Central Feature is designed, the rest of the floor plan is laid out in consultation with the nurseries, florists, and other organizations returning as exhibitors.

As the Show approaches, Ed writes a scenario for the setup period, outlining the necessary tasks day by day and hour by hour. Major exhibitors submit setup plans of their own, and these are compiled and staffing lists are developed to make sure an adequate union work force is on hand. Planning for more than 3,500 volunteers, whose assistance is crucial to the Show's success, also has to be worked into the scenario.

"You have 10 days to get it in there and get it up and running," Ed says. "It takes right down to the last hour, 7 A.M. on Saturday, and you really need a plan of attack. You can't just have everybody arrive and say, 'Go to it!' The main idea is not to paint yourself into a corner, but to paint yourself out of it. That's how we do it—everything comes in through the back, so those exhibitors farthest from the doors go in first. And it turns out equitably, since the last in get to leave first."

Setup is the crunch time, with a thousand things happening at once. Any problems must be dealt with immediately, because with such a tight schedule and the deadline of opening day drawing closer, there may not be a tomorrow. "You have 40 to 50 major exhibits all happening at the same time, and the fact is that there's no 'We can do it again,'" Ed says. "Anything that isn't working right has to be fixed on the spot. We have no dress rehearsals, yet any given year we may have sold 100,000 advance tickets, so you can't say that you're not going to open until two days from Tuesday."

During the Show, Ed meets with the press, introduces speakers, gives behind-the-scenes tours to people from the horticulture industry, some of whom he may be courting for participation in future Shows. And then, suddenly, it's all over. What takes two to three years in planning and execution all has to come down in three days beginning after the Show's 6 P.M. Sunday closing. Ed usually stays until the last shred of mulch is gone, until the Convention Center is so clean that a visitor would never suspect that the Flower Show had ever been held.

"Everybody thinks I should feel sad or nostalgic, but I don't," Ed says. "My honest feeling is one of great relief. Of course, we have no control over the weather, which can sometimes really cut into attendance, but if the Show went well from a production point of view and we had no major problems, I'm relieved that it's over. It's all part of it: The closing should run as smoothly as the setup."

After 25 years as its designer, Ed plans to retire following the 175th anniversary Show in 2004. Of all the people he has worked with over the years, he is most grateful to the Show volunteers. "They're the reason it happens," he says. "There is absolutely no way the Show could go on without them. The hours these people put in is phenomenal." Even after the many years of long hours and the ceaseless planning and problem-solving, Ed still gets a thrill from the Show each year: "Nobody on staff has seen more productions than I have, and I still get goose bumps when I see it all come together."

Big-picture Gardening

Gardening has been America's most popular pastime for many years and especially over the last few decades enthusiasm has hit a fevered pitch. It comes as no surprise then that the Pennsylvania Horticultural Society—with its world-class

For many years, John F. Kennedy Boulevard from 20th Street to the 30th Street Train Station was an unwelcome site to commuters and visitors to downtown Philadelphia.

Philadelphia Flower Show and groundbreaking urban greening program, Philadelphia Green—has flourished for over 175 years.

As the producer of the Philadelphia Flower Show, PHS provides leadership and expertise to gardeners across the nation, engaging thousands of volunteers, exhibitors and visitors in the pursuit of their favorite passion. The Show's myriad offerings of extraordinary landscape designs, specimen plants, and high-level floral arrangements set the standard for horticultural and artistic excellence.

Regionally, PHS takes a hands-on approach to motivating the legions of gardeners and partners in its membership and community programs. Year-round classes and workshops build horticultural skills and foster community organizing endeavors that consistently raise the level of local gardening expertise and enthusiasm. Its Gold Medal Plant Award program, award-winning *Green Scene* magazine, and 14,000 titles in its McLean Library provide a wealth

of guidance and resources to support the great interest in gardening throughout the Delaware Valley.

Since 1974, the PHS Philadelphia Green program has helped residents create, restore, and maintain community gardens, neighborhood parks and downtown public landscapes, completing more than 3,000 greening projects. Working in partnership with community organizations and city agencies, the program educates and empowers city residents to make Philadelphia a more attractive and livable place through horticulture.

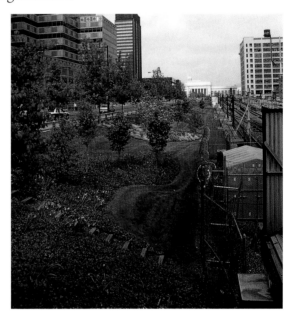

In the late 1990s, PHS's Philadelphia Green program transformed J.F.K. Boulevard into a green gateway. This is just one of the thousands of sites in and around Philadelphia that have benefited from PHS programs.

Philadelphia Green has been recognized throughout the nation as a model for urban revitalization. In the city, program efforts are being put into action in the massive urban revitalization known as "The Neighborhood Transformation Initiative." A collaborative Green City Strategy, executed by the city and PHS, will utilize the skills and know-how of the Philadelphia Green program to stabilize and maintain thousands of vacant lots with an eye toward future economic development.

Motivating people to improve the quality of life and creating a sense of community through horticulture is the PHS mission. It puts the emphasis on growing people as well as plants, and encourages gardeners everywhere *"to bloom where they are planted."*

THE HORTICULTURE

CLASSES

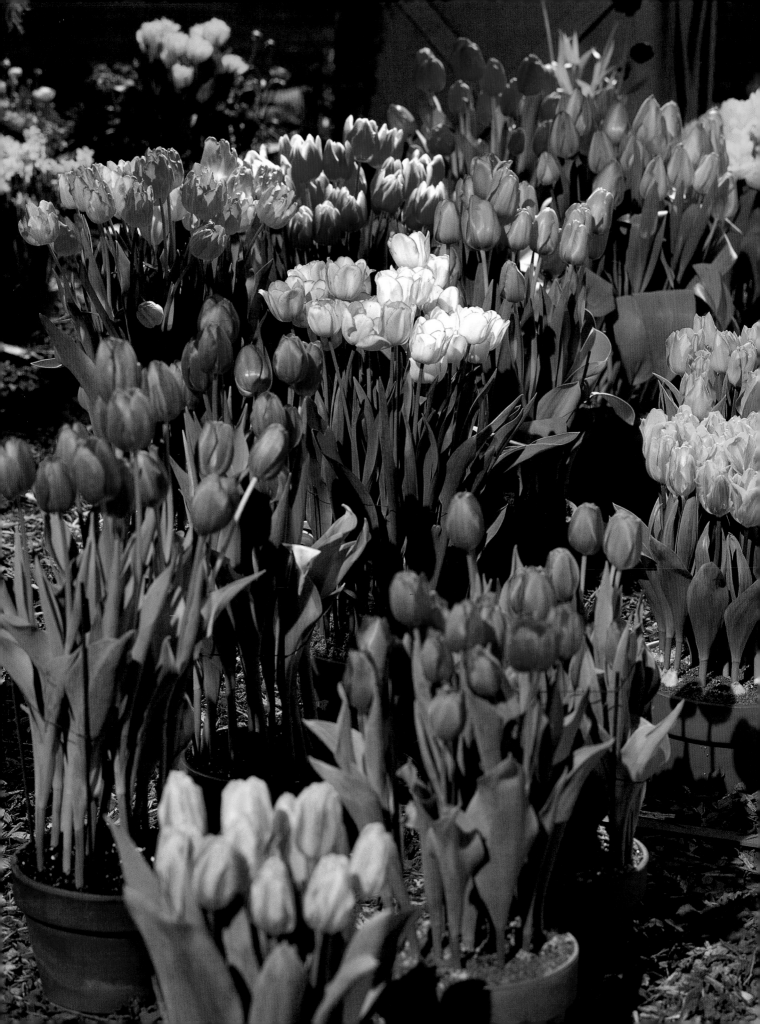

The horticulture classes

at the Show, staged in an area known as the Horticourt, celebrate the beauty of container-grown plants and the skills of their owners. Every year, garden enthusiasts of every stripe, from apartment windowsill tenders to professional growers, bring their prized plants to the Show to compete for awards.

For hundreds of exhibitors, the three judging days for awards (Saturday, Tuesday, and Friday) are the Triple Crown of the gardening year, marked on calendars and counted down as green thumbs work their magic to bring home a blue ribbon. No matter their order at the finish line, every entry and exhibitor becomes part of the grandest competition of its kind in the world.

The entry process begins the Friday before the Show opens at the Pennsylvania Convention Center, and the exhibitors arrive with their plants, entry cards, pre-entry lists, and grooming supplies. The infrastructure of the Horticourt itself is already in place: the mulch beds edged in Belgium block, the risers for the orchids, the pergola-like frames for the hanging baskets, the low benches, and a large display area with high, stepped benches. The exhibitors and volunteers—literally hundreds of each—must now turn the stage setting into the Horticourt of the Philadelphia Flower Show. Amazingly, it is all accomplished in just a few very fast-paced hours.

On Saturday morning before the Show officially opens, the Horticourt is set up with dozens of tables, some for exhibitors to do their final grooming of

The Horticourt

<< OPPOSITE PAGE

The tulips and other bulbs featured in their assigned area of the Horticourt attract many admirers. Most of the bulbs are "put down" in their pots the previous fall, kept cold and moist over winter, and then brought into warmth and light a few weeks or days before a specific entry day. This artful timing produces entries at the peak of perfection for the Show.

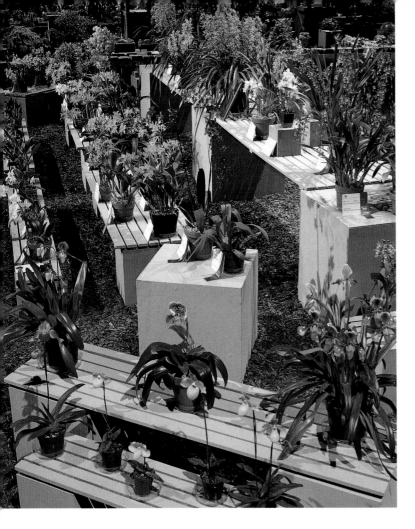

The hundreds of orchid entries at the Show, always staged beautifully and often ringed two or three rows deep with visitors, take center stage in two large island beds.

entries, such as removing any damaged leaves or flowers, or doing a bit of cleverly hidden staking. Other tables are the domain of the passers, the volunteers who act as quality-control agents. They make sure that entries are not admitted with aphids or whiteflies or other "livestock." They make helpful suggestions for improving the overall appearance of the entries, and they are often called upon to help complete the botanical identification of plants. They also certify the pot size and the plant itself to assure they meet the requirements of the Show schedule.

Although more correctly known as the Exhibitor's Guide, the schedule presents information for major exhibitors and competitors in the artistic and design classes, but it is the section on the horticulture classes that receives the closest scrutiny from the Horticourt participants. Within that section, details are given on the hundreds of exhibits staged throughout the week (344 different classes in 2003). A class is a competitive category created for judging and educational purposes, such as "rock garden plant in bloom" or "foliage begonia."

Once a passer verifies that a potential entry meets the class specifications, it is time to make sure the necessary paperwork is done correctly. This ensures that the entry is tracked properly throughout the

setup and judging process. Exhibitors present two white index cards bearing the name of the plant and the class number on one side, and the exhibitor's name and other information on the other. Each card serves different functions, but it all boils down to making sure that the judges and Show visitors see the correct information.

When everything is in order, the passer marks the white cards, and the exhibitor moves on. In the meantime the aides and runners efficiently process the paperwork, keeping class-entry lists and cards organized amidst a rising level of energy.

Once passed, the entries are placed throughout the Horticourt in the areas laid out for the various classes. Often a class is moved because it is too big for its allotted space, or to make room for its burgeoning neighbor. This part of the process is accomplished by the intrepid group of volunteers, known as "stagers," who place 200-pound topiaries and artfully arrange the bulbs, hanging baskets, orchids, succulents, and everything else onto the mulch, the benches, and onto neutral-toned wooden boxes and cylinders.

With everything passed, recorded, and staged, the Horticourt is ready for the judges. Over 175 of them come from all over the country to evaluate and award the entries according to a range of criteria including

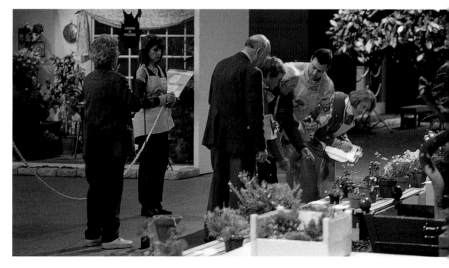

Knowledgeable judges come from all over the country and even from overseas to evaluate the thousands of entries in the Horticourt. Clerks record the results and lay down the ribbons while barrier aides give the judges some working space. A member of the Judges and Awards committee is also on hand to help with questions.

It's all in place! After the frenetic entry process and evaluation by the judges, the Horticourt is ready to dazzle hundreds of thousands of Show visitors. The "big bed" contains giant topiaries and other large specimens, as well as smaller plants staged in their respective competitive classes around the perimeter.

health and condition, amount of bloom, overall aesthetics and other factors. Assisted by another set of aides as well as members of the Judges and Awards committee, the judging teams methodically make their way through the process of determining the coveted blue ribbons, and then it is time to consider the top awards, the big rosettes. A blue ribbon is the best of its class; a rosette is awarded to an entry that is judged to be the best of a much broader category, such as all of the plants in the genus *Narcissus* entered in the Horticourt.

As the judges evaluate the entries, all exhibitors wait for the results away from the Horticourt. Admitted back around noon, exhibitors make their way to their entries to check the results. Occasionally an excited scream or whoop can be heard in the Horticourt as an exhibitor discovers a ribbon or rosette, representing in many cases the culmination of years of careful tending of a prized plant.

Over the four entry days at the 2003 Show, the above process was performed 2,716 times for 248 exhibitors. It was the first time for some exhibitors, but many more veterans had already been through the entry process at least once, or, in the case of Cecily Clark (see page 29), an amazing 53 times.

What keeps people coming back to enter the horticulture classes year after year? For some it's the thrill of winning, and for others it's the satisfaction of entering a favorite plant grown to perfection for the enjoyment of others. Whatever the motivation, many exhibitors return every year to display their labors of love.

Over the course of the 2003 Show, Horticourt exhibitors made entries in 344 competitive categories, called classes. The six entries pictured below were part of a class reserved for nonflowering succulents other than Aloe, Gasteria, or Hawthoria, all of which had their own separate classes. The size of the display pot was restricted to 4 to 6 inches across the top.

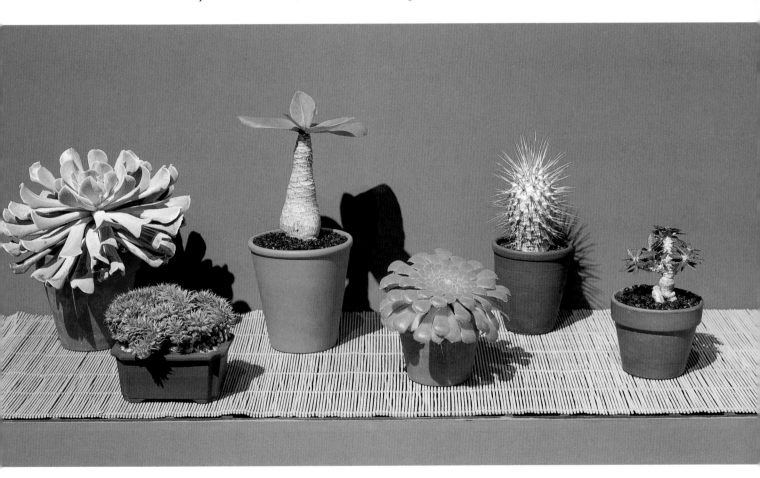

Echeveria 'Topsy Turvy'
DIANA WISTER

Brighamia insignis
STEPHEN MACIEJEWSKI

Pachypodium namaquanum
RAY ROGERS

Graptopetalum
'Silver Star' crest
ELLEN SMITH

Aeonium tabuliforme
MARY-JANE GREENWOOD

*Euphorbia
cap-saintemariensis*
LEAH ERICKSON

Trained Plants

Julie Haroutunian's 4-foot *Genista canariensis* standard is the latest member of her blue ribbon–winning line of this species.

Julie starts her *Genista* from tip cuttings taken in the fall and then gives the plants plenty of light throughout the year. She also keeps a careful eye on watering and on spider mites, which consider this species a favorite. *Genista canariensis*, commonly known as Canary broom, grows naturally as an upright shrub, so producing a single straight, clear stem doesn't present a serious challenge. However, training and timing for appearance at the Show requires significant skill. Once the the tips have been cut off and the branched heads have begun to form, they must be cut back repeatedly during summer to get them to thicken up. A final trim for symmetry at the end of September or the beginning of October completes the job. Only very sharp scissors will do when pruning a *Genista* standard; duller blades strip bark from the branches and can kink them, ruining the plant's overall appearance and knocking it out of contention for top awards at the Show. Cool nighttime greenhouse temperatures of approximately 40–45°F in fall promote compact growth and the all-important formation of flower buds. In order to bring a given plant into peak bloom for the Show, Julie says she "plays with light and temperatures to get it just right." The result is an explosion of lemon-scented flowers that stands out across the Horticourt.

Some people just seem to have an exceptionally green thumb. For several years I tried to produce an attractive entry of *Breynia*, and every year my attempt would end up leafless or dead weeks before the Show. So when I walked by this sensational specimen on the first day of the 2003 Show, I crouched down to get a better look: It was full of leaves, had no dead spots, and had a head so uniform it could have been drawn by a draftsman. It won the blue ribbon in its class on the first entry day of the Show, and to me it was among the most impressive horticultural accomplishments in the Horticourt that day.

On a tour of Dorrance Hamilton's greenhouses I asked estate manager Joe Paolino where he kept the *Breynia.* "Right in front of you," he said. There it was, reminding me of the specimens I had grown a few years before: severely cut back, with lots of brown, leafless areas, and definitely not bringing me to my knees. I asked how the crew managed to get the plant looking so impressive for the Show. "It gets the same treatment as lots of other things here," Joe pointed out, and he went on to describe the program: It's given plenty of sun, watered almost daily, fertilized, repotted yearly, trimmed regularly, and—here's where I failed previously—kept at 70°F in winter. Under that regime, the shorn *Breynia* before me would no doubt fill out and be glorious again for future Shows.

FOLLOWING SPREAD >>

(LEFT PAGE)
Genista canariensis
JULIE HAROUTUNIAN

(RIGHT PAGE)
Breynia disticha 'Variegata'
MRS. SAMUEL M. V.
HAMILTON

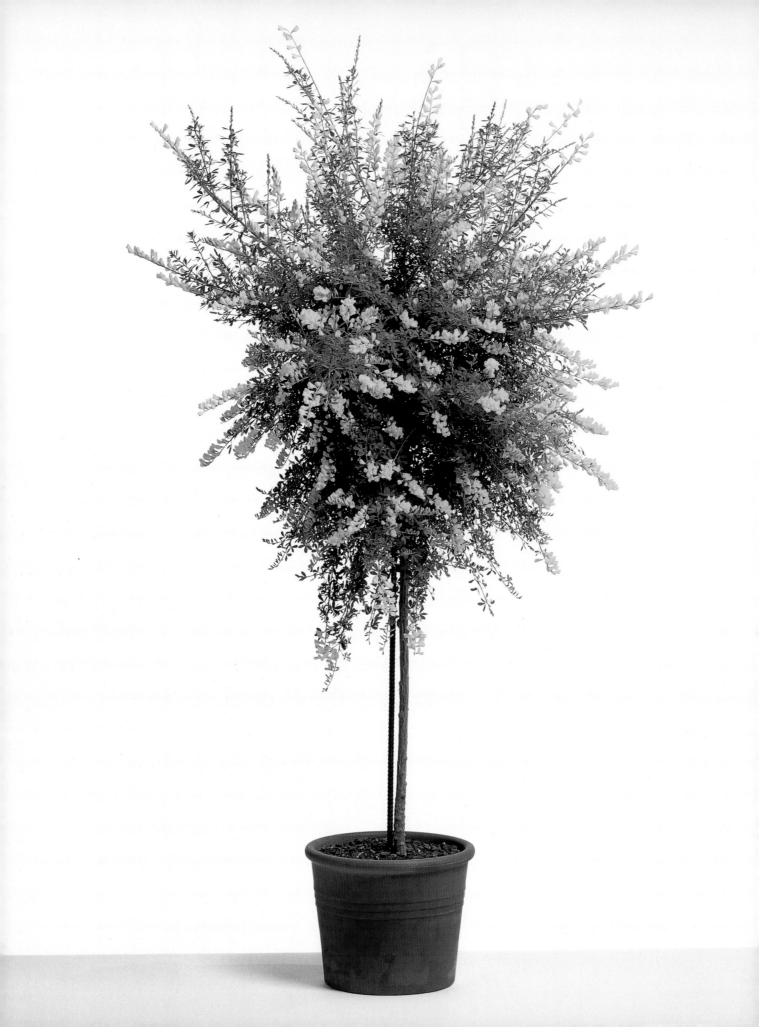

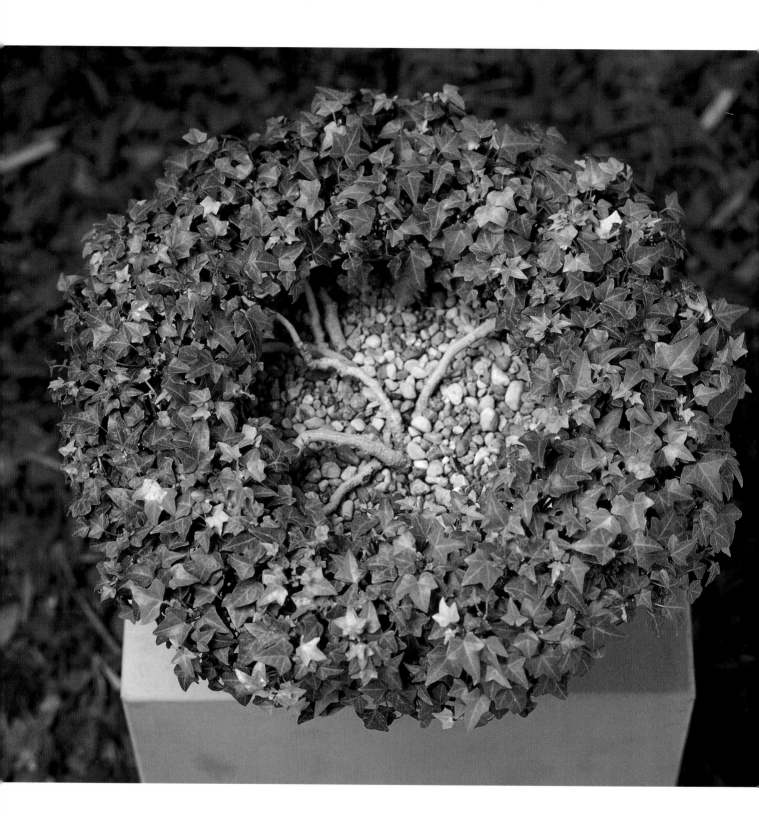

2003 marked Cecily Clark's 54th year at the Show. Over the years her herbs and trained plants have won top awards, including four Edith Wilder Scott awards for the outstanding blue ribbon winner of the week, more than any other exhibitor in the history of the Show. Her Show friends always look forward to seeing Cecily and her inspiring entries.

Cecily made just a few entries in 2003, including this ivy, which had impressed many Show competitors and visitors in 2002 and had won a rosette from the Philadelphia Unit of the Herb Society of America. Like many plants at the Show, this ivy has an interesting story, as Cecily tells it:

> "In 1988 my daughter brought home the remains of a bridesmaid's bouquet and asked me if I would propagate the ivy in it—a plant for her, and one for the bride—which I did. I also kept an extra for myself. I grew it for several years, informally, and finally it got very woody, bald in the middle, and not very appealing. I had decided to throw it out when something stayed my hand. What remained of it looked like the spokes of a wheel, and there was just enough growth to suggest that, with a little luck and some judicious pruning, the remaining growth could be coaxed into a complete circle. It took more than a year, but it worked, and eventually I decided to show it. I had no idea what the name of it was, but someone on the Show floor found someone else who knew, and I got a blue the first time around. It's a long and labor-intensive way to get a blue, but that's the kind of thing that happens when you get involved in the Flower Show."

Herbs

Hedera helix 'Chicago'
CECILY CLARK

The first time I saw it, this plant's seductive gray-green foliage immediately made me choose to grow it along with the many other geraniums I raise for competition at the Show. Wanting to produce a dense, symmetrical mound normally expected of show geraniums, I routinely pinched out the centers of the shoots for about a year, hoping it would branch out and fill in. It refused to submit to my will, so I let it have its way for a while, thinking that maybe I'd trim it back later to see if it would cooperate at a different time of year.

A few years later, I removed a great many dead leaves that clung to it and repotted it into a larger, taller pot. I liked its eccentric look, so I kept it in my collection of potential entries.

A few weeks before the 2003 Show, I repeated the leaf-plucking procedure. Up to that point, I must have removed at least a thousand dead leaves. All cleaned up, with renewed black-gravel topdressing and the salt deposits removed from the pot, it was entered in two herb classes at the Show. It definitely made an impression on the judges, winning a rosette from the Philadelphia Unit of the Herb Society of America.

Tribes in southern Africa have long used the antibacterial roots of *Pelargonium sidoides* (what they call *umkcaloabo*) for treating tuberculosis, among other maladies. Its health benefits have been verified by medical research and products made from it are now widely sold in Germany.

Pelargonium sidoides
RAY ROGERS

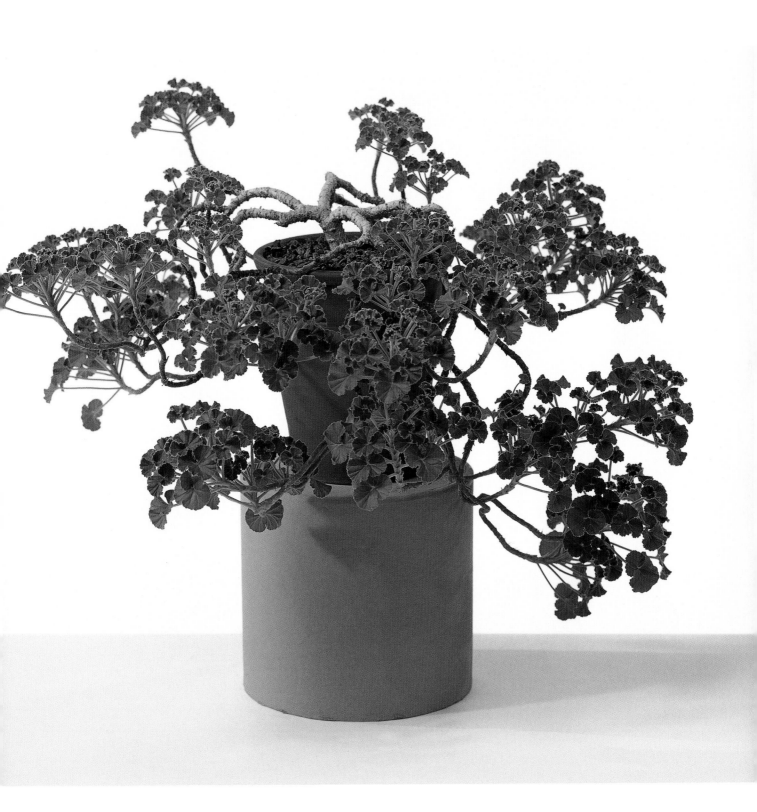

Begonias

Sylvia Lin knows how to bring out the potential in begonias. Over the years she has studied with experts, read books, and through her own experimentation she has become highly skilled at growing this popular genus. Her scores of awards won with various begonias at the Show over the years are testimony to her abilities.

Sylvia discovered that some varieties grew best for her in a modest-sized greenhouse off to one side of her kitchen. The area provides plenty of light, but heavy shading prevents sunburn of the leaves during warmer times of the year. A peat-based mix with added oak-leaf mold, an initial handful of timed-release fertilizer, and frequent applications of diluted liquid fertilizer complete Sylvia's recipe for success, save for one key factor: She grooms her plants to perfection. Her diligent removal of dead and damaged leaves, dirt, spray residue, and other distractions has inspired many Show exhibitors to strive for her level of perfection.

Started as a single small plant in 2000, under Sylvia's guidance, 'Libby Lee' completely covered its 4-inch moss-lined basket. It won three blue ribbons and earned Sylvia her third Susie Walker award in 2003, awarded to the best begonia on a given judging day.

Begonia 'Libby Lee'
SYLVIA LIN

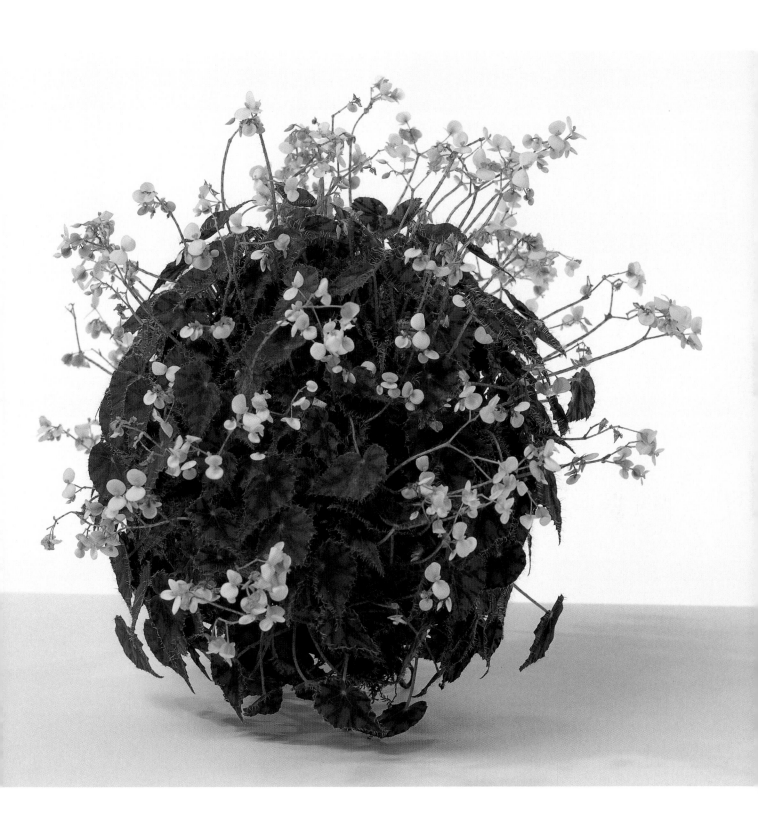

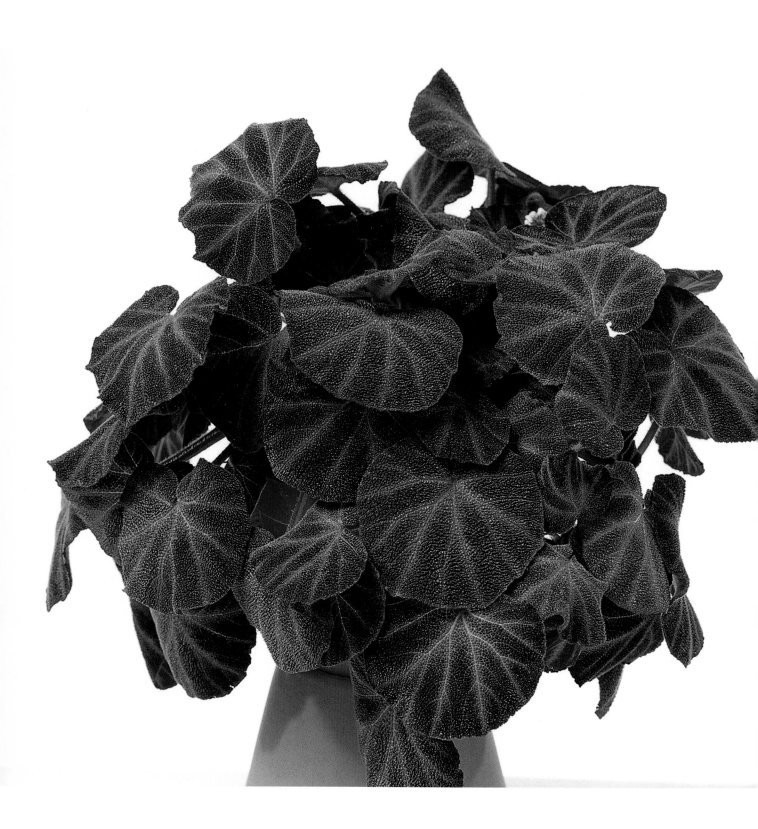

This species grows naturally in shady mountainous areas of Brazil, where the humidity is high and breezes keep the air fresh. It isn't easy to duplicate these conditions, but a carefully maintained greenhouse can come close. Such were the conditions in the begonia and fern greenhouse at Meadowbrook Farm until a fire broke out in February 2002. Before it was succesfully contained, the fire damaged and destroyed many plants. Virginia Page, Meadowbrook's begonia and fern grower, was forced to discard many specimens, but she couldn't bring herself to part with a badly damaged *Begonia soli-mutata* that had been started about six months earlier from a piece of leaf. She cut it back severely and gave it special care, growing it in a very open peat moss and bark medium, watering it from below, providing specialized fertilizers, and giving the plant a quarter turn every day to encourage nicely balanced growth.

Back into the humid and well-ventilated greenhouse, the difficult-to-grow *soli-mutata* thrived. It rose from the ashes of the greenhouse fire and won both a blue and a red ribbon at the 2003 Show.

Begonia soli-mutata
VIRGINIA PAGE

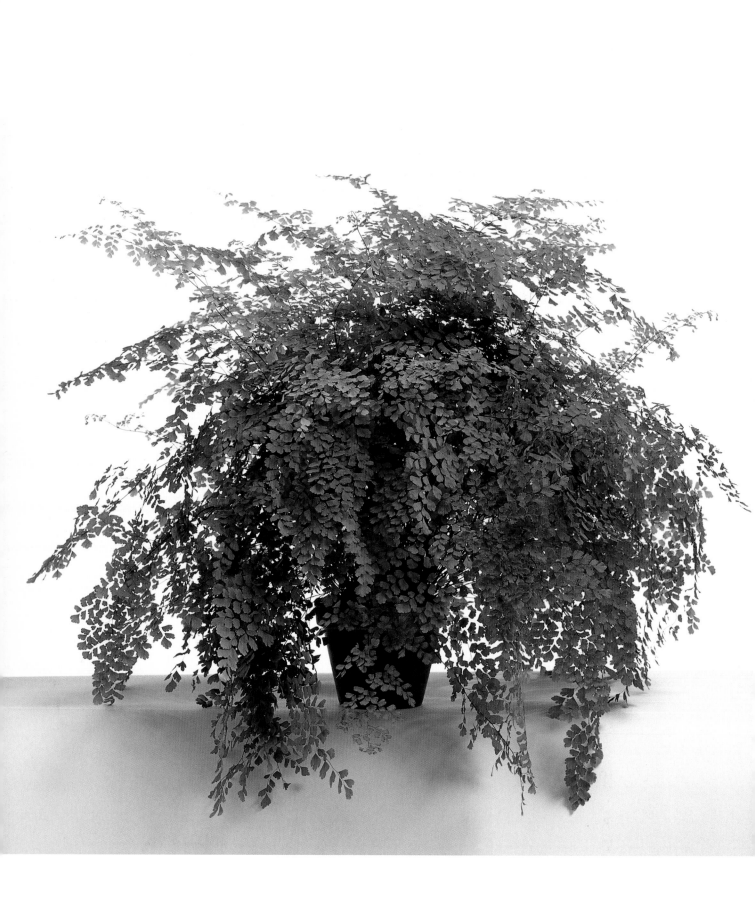

Ferns cause Virginia Page to wax eloquent, "Ferns have intrigued me since botany class in school. The light, delicate nature of their fronds, beginning with the uncurling emerging fiddleheads, hold a magical nature that conjures an image of elves and fairies. When I walk into a greenhouse filled with ferns, it's as if I've entered the quiet of a forest glen. Ferns evoke a mood and seem to have a spiritual sense about them."

Virginia is obviously in tune with ferns, having successfully grown them as a personal gardening challenge for 30 years, most recently as horticulturist at Meadowbrook Farm. She tends many of them in a shaded greenhouse in a very loose bark and charcoal medium, watering them every day and giving them diluted fertilizer at every third watering. This splendid specimen of maidenhair fern started as two 4-inch-tall plants inserted into a 6-inch pot a year before the 2003 Show. The pair grew as one plant and almost completely disguised the pot under a cloud of intricate fronds; some Show visitors wondered out loud if there was indeed a pot somewhere underneath at all. Working its magic on the judges, it captured a blue ribbon.

Ferns

Adiantum raddianum 'Fragrantissimum'
VIRGINIA PAGE

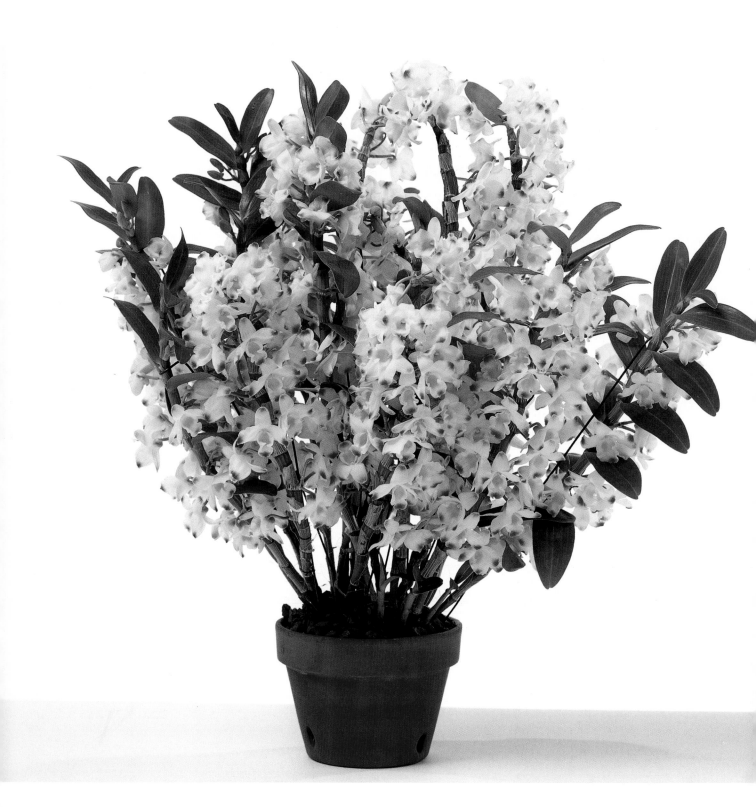

Overheard in front of this entry more than once at the 2003 Show was the exclamation "That's not a real plant. It's a bunch of cut stems stuck into a pot." Far from the truth, it's a seven-year-old orchid in full bloom, expertly grown by Michael Bowell, garden designer and self-described "general-practitioner horticulturist."

Although this was Michael's only entry in 2003, he chose what ended up as the blue ribbon winner in its class. Michael gave this semideciduous *Dendrobium* cool winter night temperatures, plenty of bright light all year, and lots of moisture in summer and very little in winter. There was no special temperature manipulation or other forcing technique employed. In recent years, Michael has simply entered plants that bloomed at the time of the Show without any coaxing or out-of-the-ordinary exhibitor's tricks.

For many years Michael created large displays and made multiple entries at the Show, including rosette-winning windowsill collections dripping with orchids. His biggest challenge was "getting so many plants to look 'dandy' *at the same time,*" a goal many other exhibitors have strived for.

Orchids

Dendrobium
 Second Love 'Takaki's'
MICHAEL BOWELL

Loc Tran is a Vietnamese-American who left Southeast Asia in 1980 as one of the thousands of "boat people" fleeing oppression. He settled in New Jersey and in 1989, a friend from Thailand sent him a package of bare-root orchids as a gift. Included was a plant of *Dendrobium thyrsiflorum*, a species that grows naturally

in Thailand and elsewhere in the mountain jungles of Southeast Asia. Loc grew this challenging species in well-aerated, fast-draining bark, hanging the pot high in an unshaded greenhouse so that it received maximum light. He also gave it plenty of water and fertilizer in active growth time but little water and no fertilizer during the winter, when it was still green but dormant. When flower spikes began to appear he resumed watering, and the orchid rewarded Loc with magnificent bloom clusters in February and May.

Loc enjoyed the two bloom periods but noted that the relatively short-lived flowers always bloomed too early and too late for the Show in early March. In 2003, he postponed its usual February bloom period by placing it in a cooler location during its dormant time. The plant responded by blooming just in time for the Show, when it was exhibited for the first time, and won the blue ribbon in its class.

This *Dendrobium* is one of approximately 1,000 orchids Loc grows in two greenhouses he leases for his business, which provides floral services to commercial and private clients.

Dendrobium thyrsiflorum

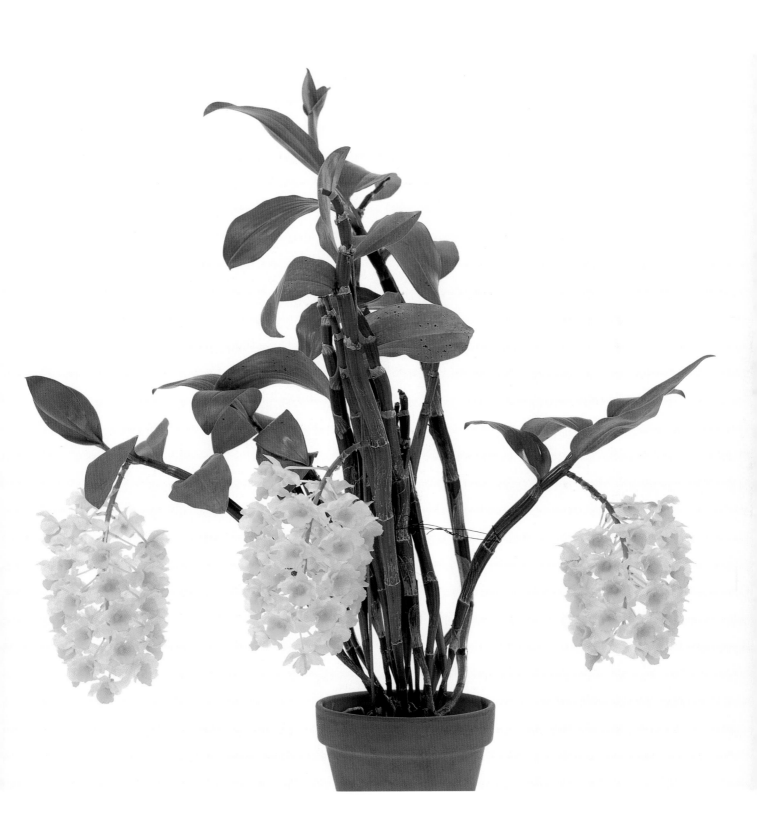

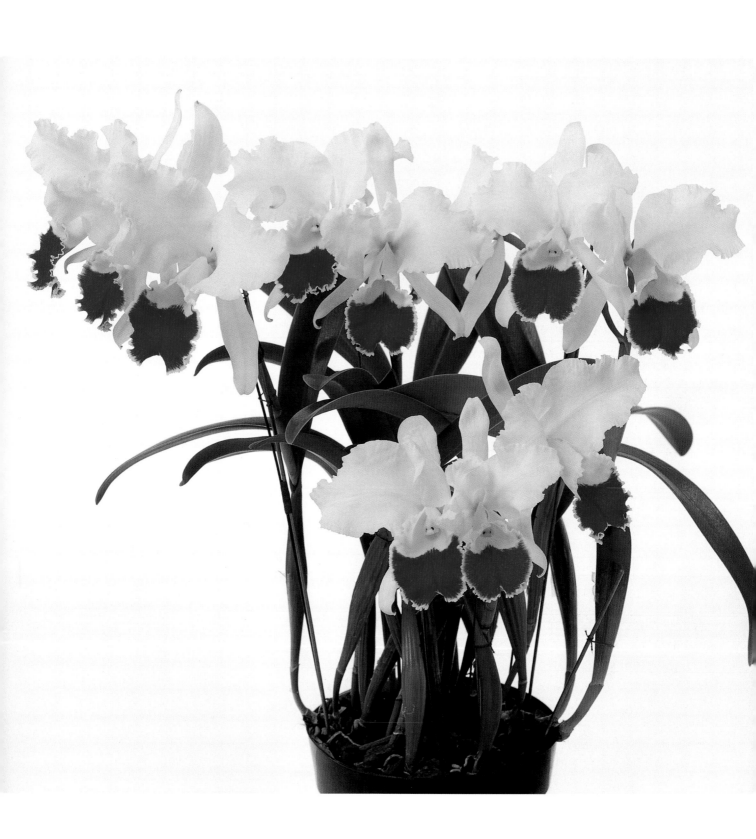

Soon after retiring from the engineering division of RCA, Nancy Volpe was bitten by the orchid bug. She and her husband, Joe, tend their collection, which at one time numbered 1,300 individual plants in a 1,000-square-foot growing area. They love to share their orchids with others and promote the hobby of orchid growing; over many years, they have donated or presented as gifts more than 4,000 plants.

In 2001, they sold the majority of their collection, which included a specimen of one of Nancy's favorite cattleya orchids. Not wanting to part with it entirely, Nancy kept a small piece before saying goodbye to the mother plant. In two years, that small piece grew into this blue ribbon–winning entry in the 2003 Show. The judges commented that they "could see her beautiful lip [the purple and yellow petal] from across the room. She is smashing."

How this beautiful plant earned its famous name dates back more than 40 years. In 1962, Kansas City, Missouri, held the First Heart of America International Orchid Show. Participants enjoyed a tour of the Truman Library led by ex-President Harry Truman himself. Mr. John Lines, an orchid grower from Tennessee, told President Truman he wanted to name a recently cultivated orchid in his honor. Truman replied, "So many things have already been named after me. Would you please name it after Bess?" Upon the President's request, Bess Truman was officially named and registered.

Cattleya Bess Truman 'Spring Fling'
NANCY VOLPE

What's in a name? In this orchid's

case, quite a bit. The genus name *Paphiopedilum*
combines two Greek words, the goddess Venus,
Paphio, with *pedilon*, meaning "sandal," alluding to the
slipper-shaped lip at the lower part of the flower. The
species name *rothschildianum* honors Baron Ferdinand
de Rothschild, a member of the famous Rothschild
European banking family.

The first cultivar name 'Rex' refers to the
original female parent from which all other identical
specimens have been propagated. A cultivar (shortened
from cultivated variety) is a plant that has been
propagated for particular desired characteristics. The
abbreviation FCC/AOS indicates that the original plant
of 'Rex' was considerd a particulalrly fine example of
the species and was awarded the First Class Certificate
by the American Orchid Society. The "×" indicates a
hybrid cross between two parents. The final part of
the name, 'Mount Kinabalu,' refers to this plant's male
parent, an orchid from the mountains of Borneo that
grows in only three known locations in the wild.

Paphiopedilum rothschildianum
'Rex' FCC/AOS × 'Mount Kinabalu'
KATHLEEN HARVEY

Kathleen Harvey first admired a
plant of this particular cross at a
Southeastern Pennsylvania Orchid
Society show in the early 1990s but
didn't acquire a specimen until
2000. Approximately 14 years old,
it flowered for the first time for the
2003 Show and attracted a great
deal of attention.

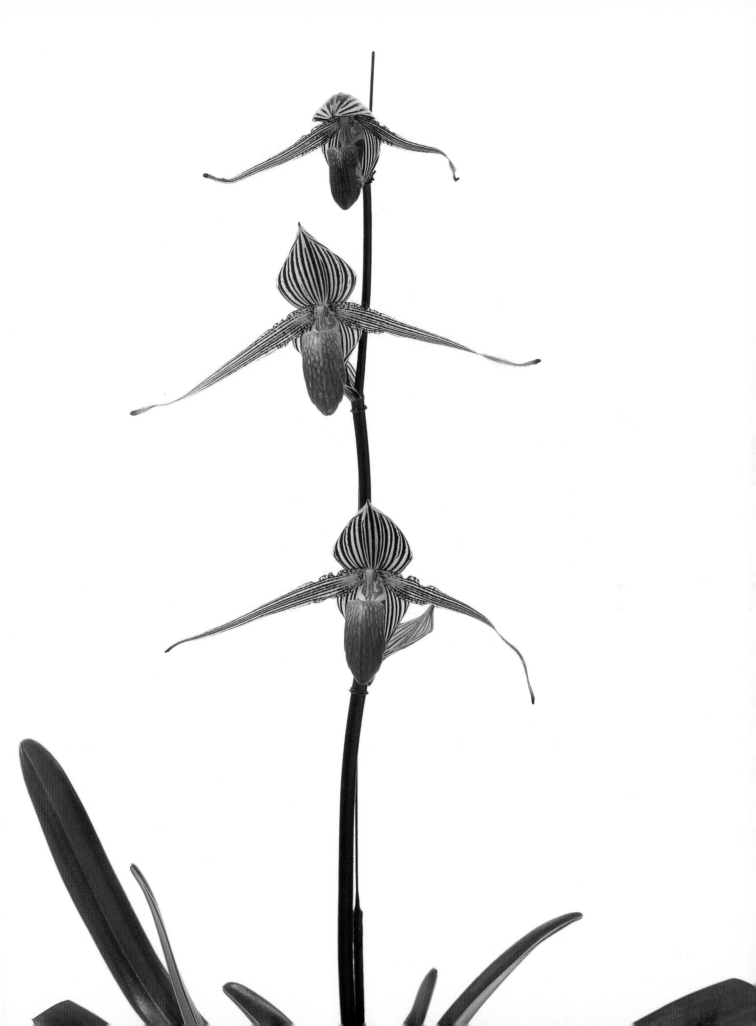

Invincible 'Spread Eagle' is one of approximately 1,000 orchids under the care of Joe Paolino and his gardening crew at Dorrance Hamilton's estate in Wayne, Pennsylvania. The plant is given optimium conditions of bright light, heavy shade in summer, plenty of water, and is grown in an open bark medium. In colder weather it's kept in a greenhouse set at 65–70°F. Fertilized heavily during the earlier part of the growing season, and later with a different mix to initiate flowers, it grows like a champion and routinely provides offsets for growing into additional specimen plants. By December it often starts to send up flowers, so to slow it down, Joe puts it into the coldest greenhouse (around 55°F, too cold for less robust *Paphiopedilum* cultivars), and by early March it's the picture of perfection at the Show.

It routinely wins awards, including the latest in its string of blue ribbons at the 2003 Show and two Certificates of Cultural Merit for the American Orchid Society in 1984 and 1991, both awarded at the Show.

Its first year of competition was in 1983 when it was one of two plant entries marking Mrs. Hamilton's first year in the Horticourt. Over the years and after thousands of entries, Dorrance Hamilton has garnered many ribbons and rosettes including the Mrs. Lammot du Pont Copeland horticultural sweepstakes trophy for nine years in a row (1995–2003). The trophy is presented to the individual winning the greatest number of award points in the horticulture classes during the week of the Show.

Paphiopedilum Invincible 'Spread Eagle'
MRS. SAMUEL M. V. HAMILTON

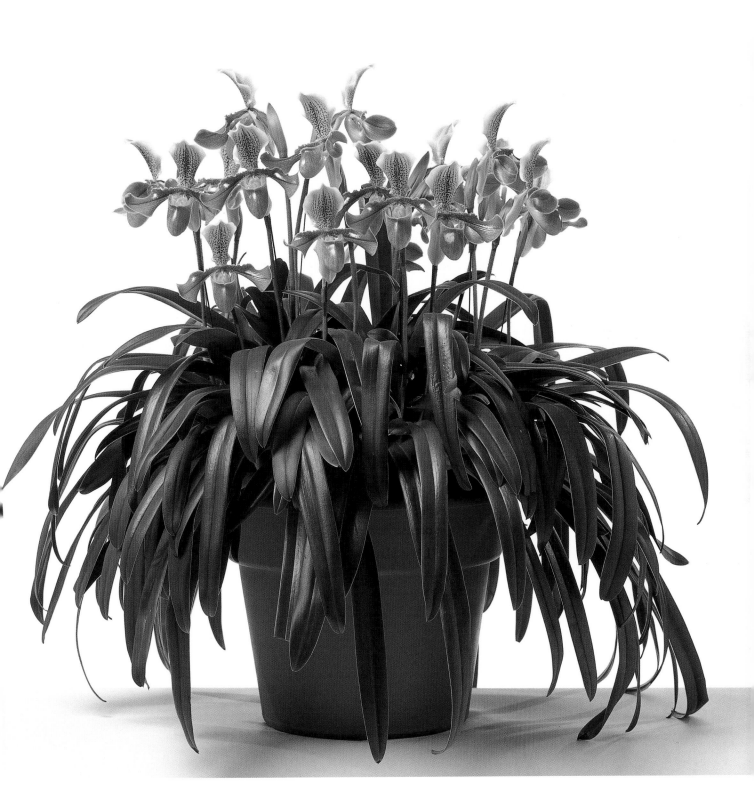

Popular horticultural advice prescribes that all orchids, including the beauties exhibited at the Show, must be grown in a greenhouse along with hundreds of their kin. Aneka Bell doesn't follow the rules: Her collection thrives in her east-facing kitchen and spare upstairs bedroom.

'Pink Butterfly', the blue ribbon–winning entry in its class in 2003, occupies a place of prominence in Aneka's kitchen. Grown on a shelf attached to sliding doors leading outside, the plant receives good sun in winter, contrary to advice that this species requires shade. The trees in the nearby woods leaf out just in time to provide enough shade during the brighter months of the year. Aneka doesn't grow this plant in a traditional orchid pot, which is a terra-cotta pot with vertical slits to allow for extra drainage and air movement. Instead, it thrives in a green plastic pot with plenty of punched holes.

Aneka is a professional research scientist who applies her training in the scientific method to her orchid hobby. She modestly sums it up by saying, "I just play around."

Phalaenopsis schilleriana 'Pink Butterfly' AM/AOS
ANEKA BELL

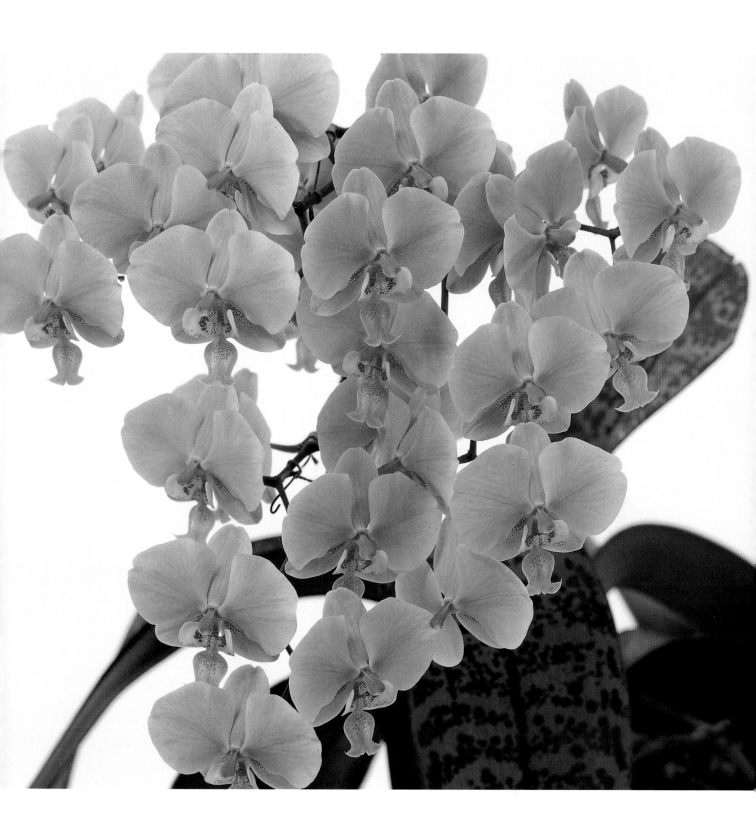

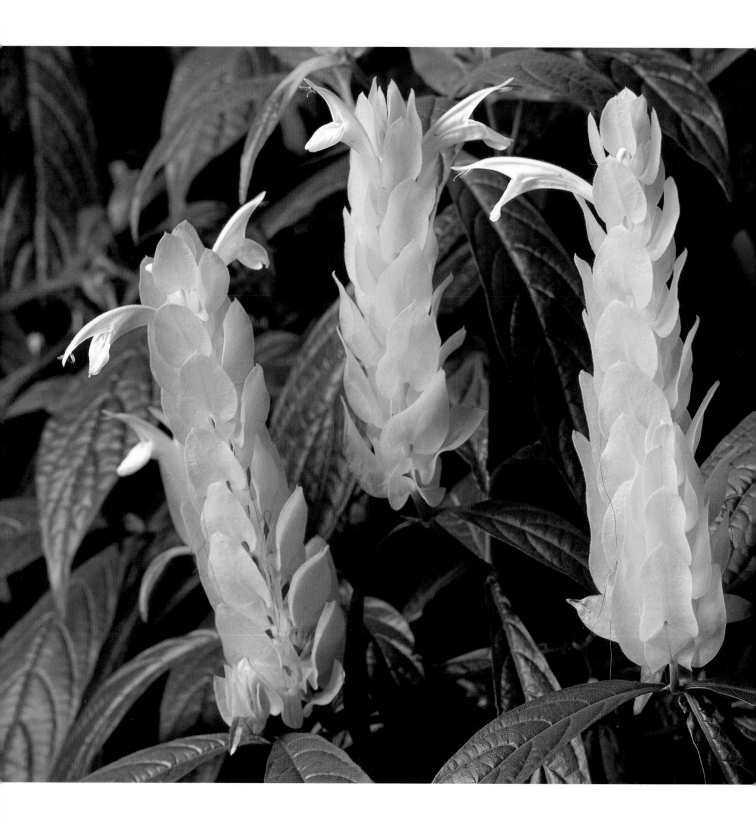

Some entries literally keep their growers up at night because of their very narrow window of opportunity to dazzle judges and visitors at the Show. Others obligingly perform for a much longer time and don't make their growers jump through horticultural hoops. Such is the case with Dorrance Hamilton's "Lollypops." Started from a cutting received in 1986, the *Pachystachys lutea* grew into a large shrub that blooms off and on for about half the year. Watered and fertilized frequently, this plant and the smaller ones propagated from it thrive in a brightly lit, warm greenhouse that simulates their native tropical South American home. Regular removal of the flowers by the gardening crew promotes repeated blooming. By early March, scores of the lovely and unique flower clusters decorate the plant.

Like Dorrance Hamilton's clivias (see page 52) and many other plants (azalea standards, myrtle topiaries, orchids, hanging baskets of ferns, and succulents), "Lollypops" is a favorite at the Show. Although some specimens grace her home and grounds at various times of the year, many of the plants are specifically maintained for display at the Show. "Mrs. Hamilton and I and the crew are happy to show these plants," says estate manager, Joe Paolino. "Otherwise, they'd never be seen outside the estate."

Flowering
Plants

Pachystachys lutea
MRS. SAMUEL M. V. HAMILTON

Many veteran Show exhibitors maintain "old reliables" in their collections of potential entries. Dorrance Hamilton, an exhibitor in the Show since 1983, is no exception. Received as a smallish division in the mid-1970s, this now large and venerable clivia has often graced the Horticourt with its stunning orange flowers. Clivias are considered signature plants of the Show, and sometimes a competitive class of them—both the traditional orange and the highly prized and rare yellow-flowered forms—is presented in the Horticourt.

It's not easy to repeatedly bring a clivia into flower just in time for the Show, but Joe Paolino, the Hamilton estate manager, and his crew rarely fail. Kept in a cool greenhouse until summer, the clivia then take up residence in a sunken and heavily shaded structure. They grow happily in large tubs of potting mix and are given ample water and fertilizer throughout most of summer. In late summer, the fertilizer is changed to a different mix to promote good bloom, and watering is tapered off. Starting in mid-to late fall they receive almost no water and are kept cool to induce dormancy.

In December, when the crew begins to turn their attention to the next Show, the clivias are moved to a warmer greenhouse. The increased temperature and watering stimulate the plants to send up their flower spikes. A final check before entry time completes the routine.

Clivia miniata
MRS. SAMUEL M. V. HAMILTON

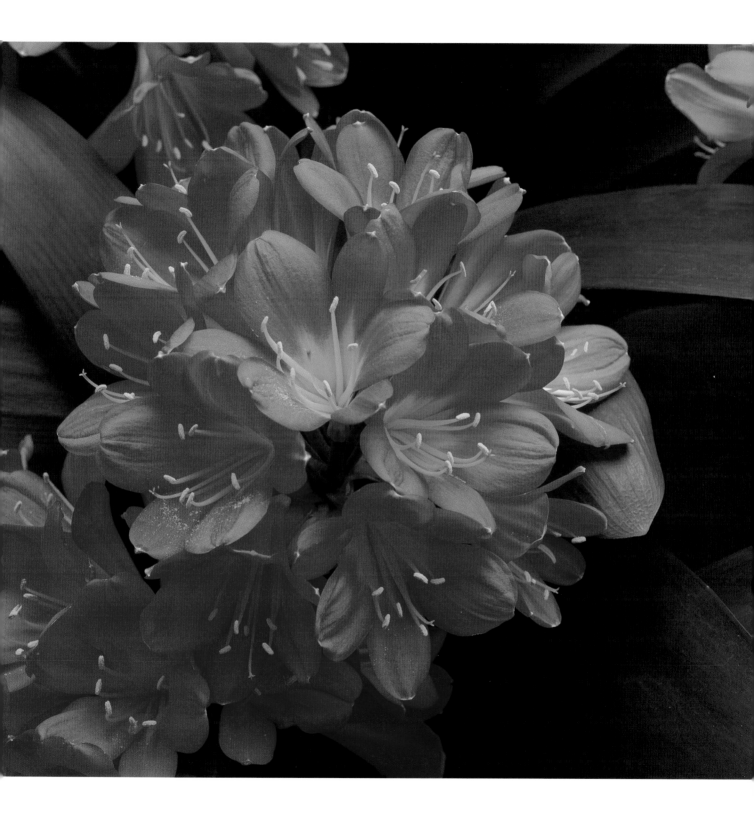

Cacti and Other Succulents

John Story admits he likes "to amaze and surprise and even shock people with unusual plants." He hit the jackpot with this one, a decidedly peculiar plant that many have described as "dead looking." Others who get past the plant's somber appearance want to know if the plant ever blooms, to which John is often able to reply, "Look closely." The tiny green flowers, correctly referred to as cyathia (shown in the detail at left), appear at the tips of the stems over much of the year. This odd-looking plant

is a relative of the flamboyant poinsettia, *Euphorbia pulcherrima*. Look into the center of a poinsettia, and you will see larger versions of the cyathia found at the tips of the unusual *E. platyclada*.

This plant was given six years of "easy" culture; that is, grown in a fast-draining potting mix, not overwatered, and kept in plenty of light but not strong sun. It is one of several similar specimens John has grown during his 30 years of fascination with cacti and succulents. As general manager for Meadowbrook Farm, he has propagated many pots of *Euphorbia platyclada* for sale from this plant, which he calls "Big Momma." To prevent scarring, John cuts a major branch at the base of the plant and takes small pieces from it to root.

"Big Momma" won a Philadelphia Cactus and Succulent Society rosette on the first judging day in 2003 and also won one in 2002.

Euphorbia platyclada
JOHN STORY

Stephen Maciejewski was reluctant to make his first entry in the Show in 1998. "I just couldn't imagine entering plants into competition at the prestigious Philadelphia Flower Show," he says. But it's not as if he came into gardening late in life; his father, a farmer from Poland, tended a vegetable and flower garden, and Stephen says he "just naturally followed in his footsteps." Like so many Philadelphia-area gardeners, young Stephen went along with his

parents to the Show. In the early 1980s, he started sharing a garden with a friend, Michael LoFurno, who was an exhibitor at the autumn Philadelphia Harvest Show. Stephen agreed to help with Michael's entries one year, but soon after, Stephen was hooked and started winning top prizes at the Harvest Show himself. Regular encouragement and advice from Walt Fisher (see page 86) about his entries, and training and grooming lessons from Nancy Volpe (see page 43) at orchid society meetings, finally convinced Stephen he was ready to enter the Show.

Stephen grows his potential Show entries in nearly every window of his home, and also maintains six carts of plants with grow lights. From winning a handful of ribbons in 1998 ("all but the coveted blue," he says) to placing fifth overall in the horticulture class sweepstakes in 2003, Stephen has come a long way in a few short years, but he feels there is more for him to achieve: "It's amazing that the Show has been going on for 175 years. When I think about all the work that has gone into this event, I feel a sense of responsibility to give back. It's now my turn to return the generosity and the enthusiasm and to help excite the next generation, so they too will fall in love with the green world and continue this marvelous tradition."

Many "succulentophiles"

are drawn to crested plants, which are propagated and grown to preserve their fanlike growth instead of their normal shoots. When Stephen Maciejewski read the description of this unusual red-leaved succulent in a catalog, he knew he had to have it, and when he saw it, it was love at first sight.

Although tolerant of dry conditions, this plant requires a surprising amount of water to give its best. But there is a delicate balance to observe to keep it Show-worthy. If underwatered, it quickly drops leaves, but, if watered daily to prevent leaf drop, it grows rapidly. Unfortunately, the new growth will be green, not its signature dark red. To complicate matters further, it needs strong light to produce and retain its dark leaves. Stephen grows it almost flush with fluorescent lights, so the new growth remains dark.

During Show week, in what (to a plant) is the dimly lit interior of the Pennsylvania Convention Center, new growth never has a chance to color up. The bright green stands out dramatically against the dark red, a contrast many judges find undesirable. In 2003 on the first day of judging (Saturday), Stephen's show-perfect *Aeonium* garnered a blue ribbon, but soon the green foliage began to appear. On the second day (Tuesday) it took a red, and on the third judging day (Friday), with those green centers glaring at the judges, it took only a yellow (third place) ribbon.

NEXT PAGE >>

Aeonium arboreum
 'Atropurpureum' crest
STEPHEN MACIEJEWSKI

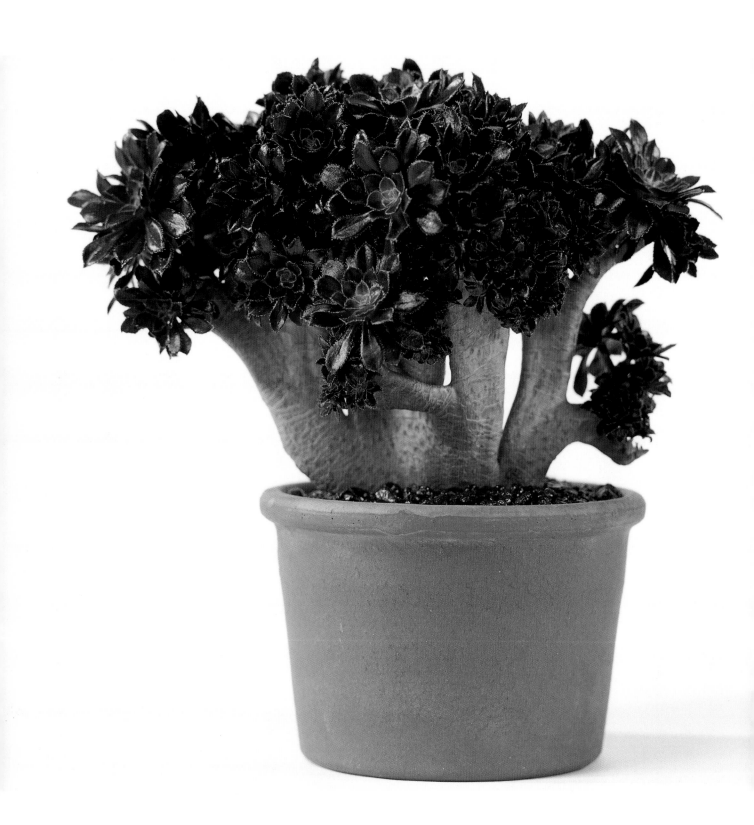

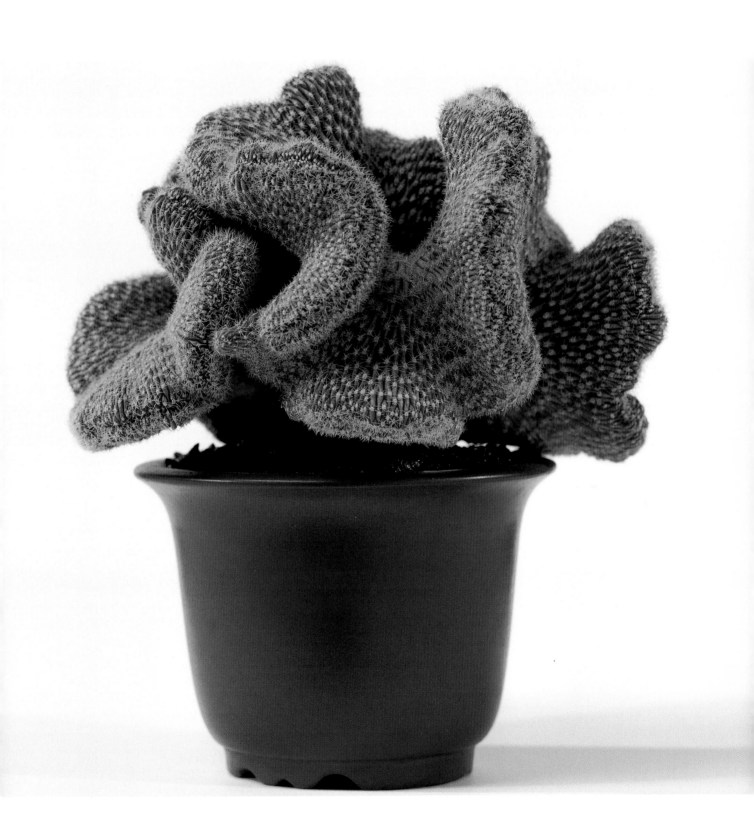

Rob Novelli first spotted his *Mammillaria elongata* 'Cristata' in 2002 while making one of his routine buying visits to Bob Mutschler's Nursery in Birdsboro, Pennsylvania. He admired the crested scion (the top part of the two-part grafted plant), but expressed to Bob that he felt the understock (the bottom part of the plant) was too long and detracted from the beauty of the wavy crest. Bob told him he would cut the understock and try to root it again.

When Rob visited again a few months later he saw that the understock had been cut down, but the new potting soil was very dry. Using a watering hose, he took the liberty of giving the plant a drink. A few weeks later, he returned and watered the plant again, deciding that if it looked good on his next visit he would purchase it and cultivate it as a potential Show plant. Finally, after periodically visiting and tending to the cactus for six months, Rob bought the plant.

He cleaned the crest, pruned the plant to remove unsightly growths, and experimented with how it would look in different pots. The plant was decidedly top-heavy, but putting it in a sizable pot detracted from its "Show quality." After repotting it again, he acquired a pot with the perfect fit. He used heavy black river stones to help the plant stay erect and then covered the stones with finer black topdressing.

In 2003 it won the blue ribbon in the class specifically for grafted cacti—the one-hundredth blue of Rob's competitive horticulture career.

<< PREVIOUS PAGE

Mammillaria elongata 'Cristata'
ROB NOVELLI

Sylvia R. Lin is a ten-time winner of the horti-cultural sweepstakes (for the most overall award points in the horticulture classes) and a runner-up 12 times. Her kitchen and dining-area walls are covered with framed certificates, ribbons, and rosettes, all a testimony to her consummate skills. Among the awards are three Edith Wilder Scott awards (for the outstanding blue ribbon winner of the week), eight Far Out cactus awards (for the best cactus or other succulent of the week), six best of day (one variety), and three Susie Walker awards (for the best begonia on a given judging day).

When asked why she exhibits year after year in the Show, Sylvia responds:

"I love it! The Show for me is like Christmas. They both come once a year and require months of preparation. In the weeks before both of them, I have the same intense feeling of anticipation. The last night of the Show is comparable to cleaning up after all of the gifts are opened: It's a bit of a letdown, but then I start thinking about next year."

Sylvia is a registered nurse as well as the mother of six children. Her plants are her children, too: "I love them, nurture them, and try to achieve the best possible results. Like with kids, you try for perfection, but..." She finds great satisfaction in cultivating a plant that makes it to the Show and wins a coveted blue ribbon. Like a proud parent she looks at it and thinks, "That's my baby!"

What does it take to win the blue ribbon in the class for any cactus in a pot 4 inches or under? You need to start with optimum conditions—exactly what Sylvia Lin provides in her southern-exposure beach house. Intense light all year round, plus night temperatures that drop to 58°F in winter, make an excellent start. Careful watering once a week or every other week (and even less in winter) completes the basic routine for this and many cacti and other succulents in Sylvia's collection. An occasional turning of the pot (to prevent lopsidedness) and periodic inspection for pests and diseases also insure prize-winning form and condition.

There's another factor to consider when choosing and growing plants for the Show, something that Jerry Barad (a veteran exhibitor) calls "sexiness." Any number of plants can be brought into nearly perfect condition for competition, but among those are the entries that immediately capture the judges' attention. The deciding factor might be bright, shiny leaves or voluptuous flowers or designer-colored fruit. In the case of many cacti and other succulents, it might be their bizarre or almost architectural form and rich coloration, often coupled with intricate patterns of spines or marks. No doubt the appeal of this *Uebelmannia*, plus its carefully chosen pot and flattering black topdressing, played a big part in its winning a blue ribbon.

Uebelmannia pectinifera
SYLVIA LIN

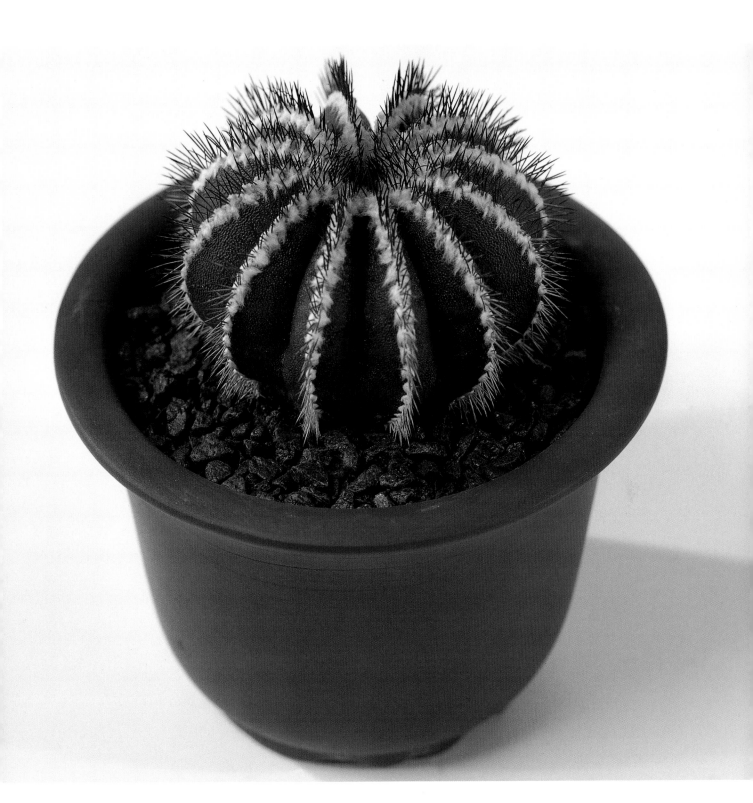

After winning the second rosette of his Show career in 2002 with a perfect *Astrophytum asterias* hybrid in bloom, Stephen Maciejewski was hoping for a repeat performance at the 2003 Show. He spent considerable time researching winter-blooming cacti, and then acquired six of them. Amazingly, every one developed at least one flower bud, and the *Astrophytum* from 2002 had a flower bud as well. Stephen was looking forward to choosing which plant would have the best flowers on any given judging day of the upcoming Show.

He was frustrated when some buds blasted (they dried up before blooming), some rotted off, and others just sat there unexpressed. However, just before the first judging day, his *Echinocereus* looked like it was ready to bloom. Stephen repotted it into a clay pot, determined how to present its best face for the judges, then optimistically brought it with his other entries to the Show. By then, Stephen was convinced the flower bud was going to burst open at any minute into a perfectly fresh, seductive bloom, and he imagined the judges awarding it a blue ribbon.

The judges came and the judges went. Stephen's *Echinocereus* was a little cactus with a big bud, and it failed to receive a ribbon. The next day, the flower opened in all its glory. The best-laid plans and expectations are not always met with a ribbon, but visitors to the Show were treated to this handsome cactus for a few glorious days.

Echinocereus reichenbachii
STEPHEN MACIEJEWSKI

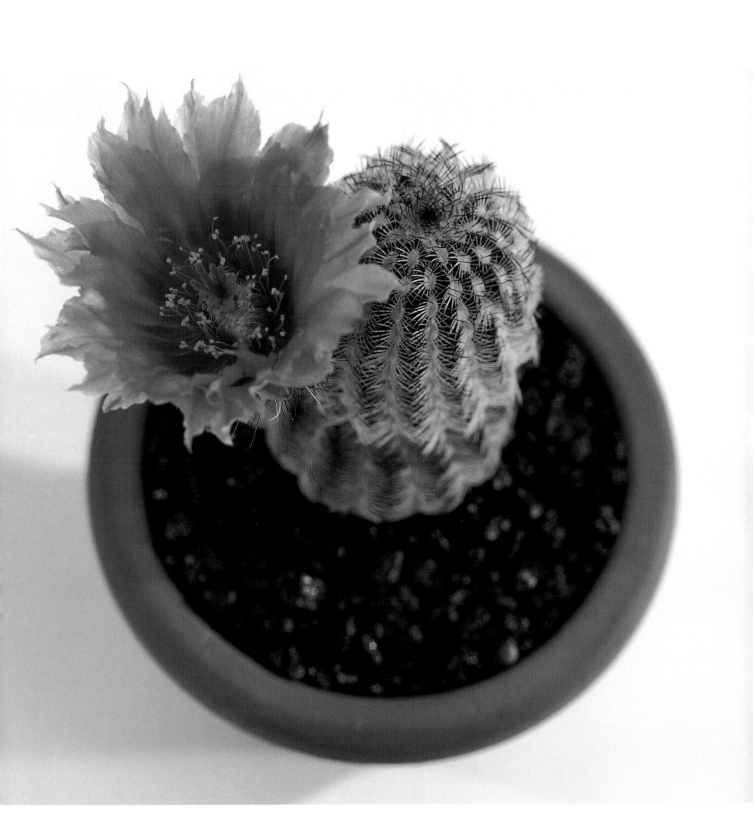

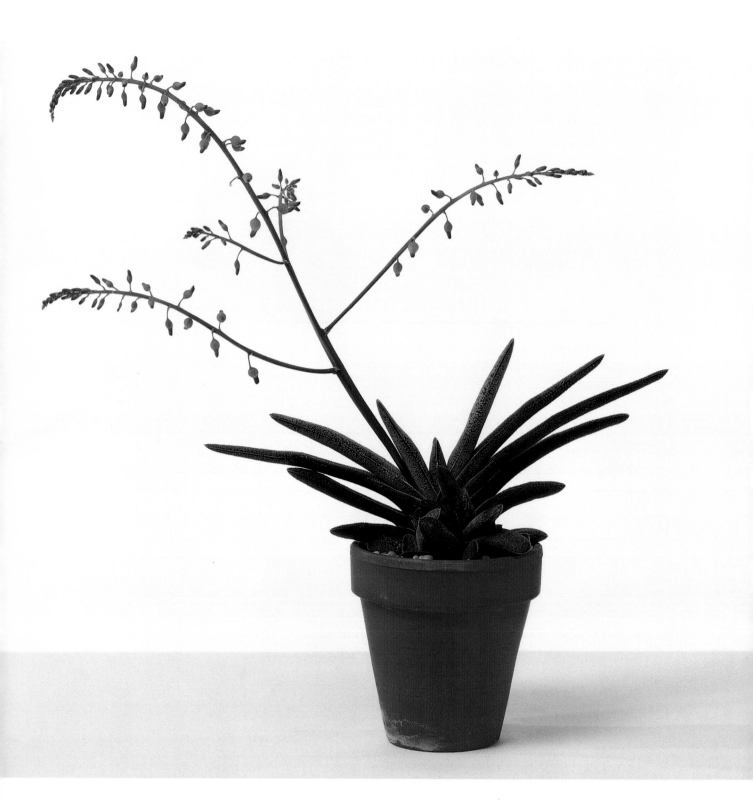

Sometimes a plant rises from humble beginnings to take its place as a ribbon-winning entry in the Show. At a Philadelphia Cactus and Succulent Society raffle in 2000, Marilyn Kenick held the next-to-last ticket to be called. She chose a little *Gasteria* that was planted in half of a styrofoam cup. In her words, "It didn't look like anything special." But as it grew, the leaves developed an appealing purple color and the plant began to flower prolifically. By the late winter of 2003 the humble little plant in the disposable cup had grown into a stunning specimen.

It's not surprising that Marilyn would take a small, unheralded plant under her wing and nurture it into a Show diva. As a child, she brought back so many animals to her house that her father decided to get her interested in plants to distract her from expanding the menagerie. His idea failed to dampen Marilyn's enthusiasm for animals, it only fanned the flames of a new interest. In time, Marilyn's plant collection grew so large that her father ended up adding a greenhouse onto their home. Marilyn now tends a large garden at her own house and still maintains several hundred cacti and other succulents in her parents' greenhouse. Many of those plants provide little offsets for the raffle table at Cactus Society meetings.

Gasteria baylissiana
MARILYN KENICK

The Challenge Classes

Every fall, three challenge plants are offered to exhibitors planning to enter the next year's Show. Chosen by a committee, more or less identical plants are made available to anyone wishing to take part in the challenge classes. The idea is simple: Grow the plant better than everyone else (in the opinion of the judges, of course). How to accomplish that, however, is different for every competitor.

When Sylvia Lin learned that *Echeveria* 'Topsy Turvy' was one of the three challenge plants for 2003, her first reaction was "Oh, no." She had failed "miserably" (in her opinion) with other echeveria, but Sylvia was determined to try again. Grown at her shore house, it thrived and won a blue ribbon on the first judging day of the Show.

2003 was Michael LoFurno's third year of competition at the Show. He grew his potential entry on a south-facing windowsill, turning it regularly to keep it symmetrical. To prepare it for the big day, he removed the faded lower leaves and repotted it in a deep rose pot. Second place went to Michael's entry.

Alice Bucher could well be called "Ms. Challenge Plant." Every year she acquires two specimens of each plant offered, usually growing one under lights and one on a windowsill, but this time all went under lights. They both responded by growing nicely and putting up a flower spike. The one Alice chose as the better of the two took third.

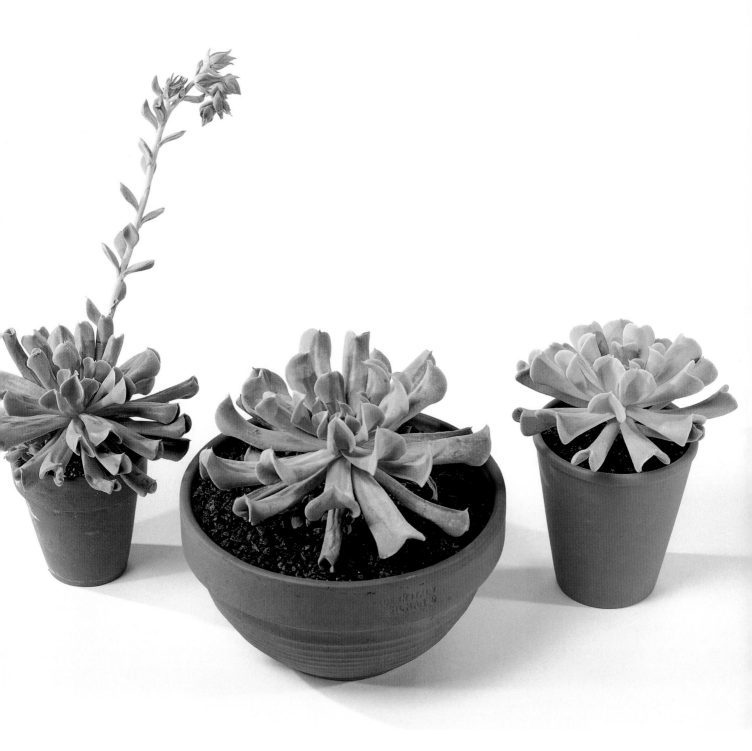

Echeveria 'Topsy Turvy' challenge

ALICE BUCHER SYLVIA LIN MICHAEL LOFURNO

Container Gardens

While admiring the high-quality container gardens entered in the Show, most visitors would never guess that many of them are made by teenagers. These young people even make their own containers by forming hypertufa (a mixture of cement, perlite, and peat moss) into the shape of their choice, keeping the Show specifications for container size in mind. Planting soon follows, and then the students tend their gardens until Show time, often caring for them throughout another year for entry in the next Show.

These talented exhibitors are the Shipley Sprouts, an extracurricular group of students attending the Shipley School in Bryn Mawr, Pennsylvania. They appear at the Show at entry time, their early-morning enthusiasm lightening up the often intense atmosphere. Formed in 1975 by Mary Allen and Leila Peck, then parents of middle-school children, today's Sprouts prepare their container gardens in a 12-by 28-foot greenhouse built on one side of the campus science building. From that greenhouse have sprung more than 700 ribbon-winning entries, including a particular one that made every adult in the Show take notice. In 1997, Katie Sachs, a ninth grader and first-time exhibitor, won a coveted best of day rosette for her miniature garden landscape, making her the youngest person ever to win that award at the Show.

All of their awards have been achieved without any special concessions extended to the students; their entries are anonymously judged along with all other entries in a given class.

Allison Gibbons says she participates in the Show "to be able to compete against great gardeners." Her entry took the blue ribbon in the class on the last judging day of the 2003 Show. Emily Chapin's reason for participating in the Show is echoed by many of

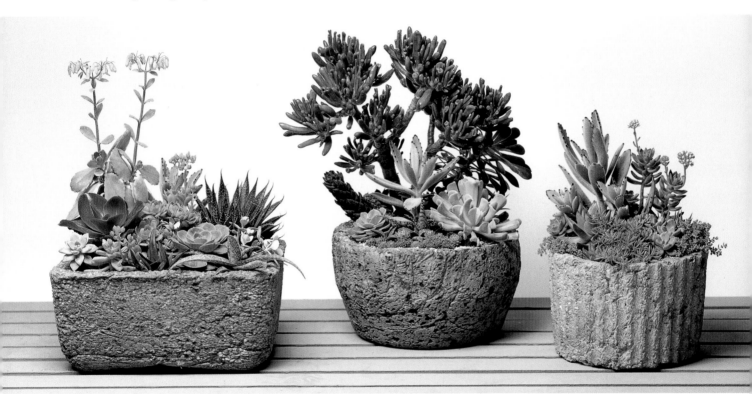

her fellow exhibitors, no matter what age: "It is always satisfying to work hard and then see other people enjoying what you did."

"I just love seeing the results of individuals planting tiny seeds and nurturing them until they bloom and thrive," says Gigi Combe. "The variety of plants and displays at the Show each year never ceases to mesmerize me."

Container Gardens
SHIPLEY SPROUTS

(LEFT TO RIGHT)
ALLISON GIBBONS,
EMILY CHAPIN,
GIGI COMBE

Bulbs

Sometimes you need to go against conventional gardening wisdom to produce something exceptional. Joe Paolino knows this from more than 20 years' experience overseeing thousands of plants at Dorrance Hamilton's estate in Wayne, Pennsylvania. In early May, even though the *Veltheimia* are still green and actively growing, Joe tips the pots on their sides and withholds water until August or September. He removes the long-dead leaves, cleans the bulbs, repots them in fresh potting mix and resumes watering.

Again going against common practice, Joe splits up any clump of bulbs that appears slightly crowded in the pot. Kept cool in fall and then at 55°F through winter in a sunny greenhouse, the *Veltheimia* come into spectacular bloom just in time for the Show. Careful and thorough cleaning of the big leaves adds the finishing touch.

In 2003, this plant won the PHS ribbon for the outstanding blue ribbon winner in the bulb section (other than narcissus) on Saturday.

Veltheimia bracteata
MRS. SAMUEL M. V. HAMILTON

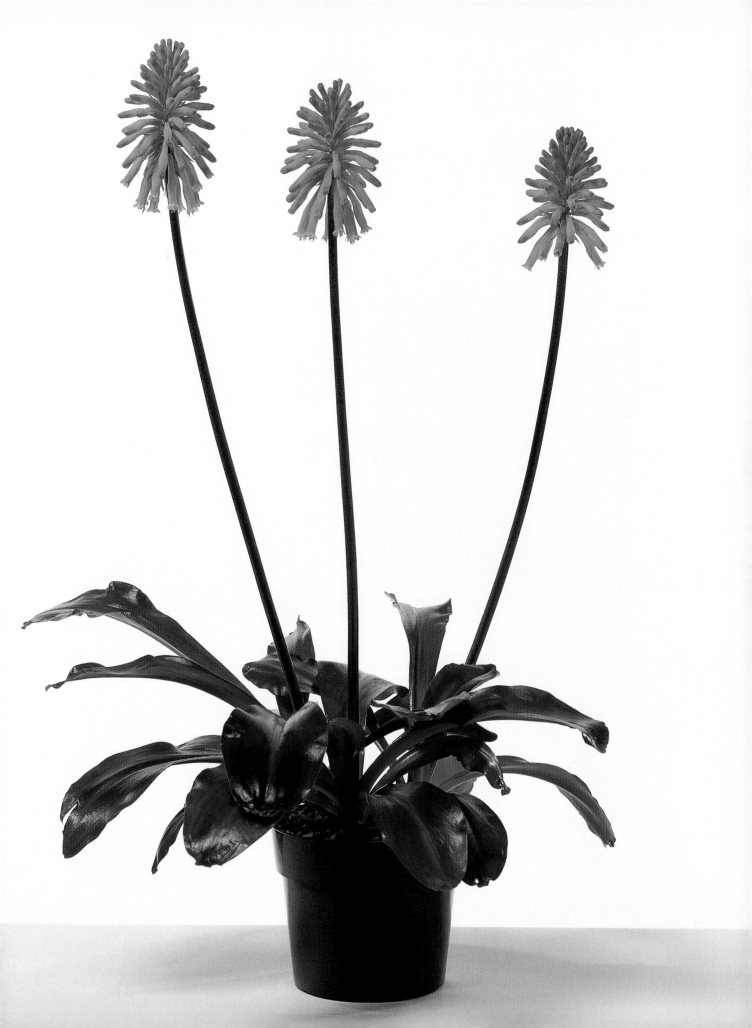

In November of 2002, John Story surprised me with a gift of not one but three pots of *Lachenalia*, a bulb native to South Africa. Already in growth, I asked John how to hold them back so they would be in bloom for the Show in March. He said they'd be fine if I kept them in a cold greenhouse

(no more than 45°F) until just before the Show. "They need just a little heat before the Show to bring them into bloom just like that," he replied, snapping his fingers for emphasis.

I kept the pots in a cold greenhouse, and as John predicted, they remained in good condition through January and didn't look like they were going to bloom prematurely. At the beginning of February, flower buds started to appear, but remembering John's finger-snapping admonition about heating them up, I kept them cold, thinking the bloomstalks would elongate anyway. They didn't, and so by mid-February I was concerned that the *Lachenalia* would be in bloom after the Show if I didn't get them moving along. I put them in two different warm greenhouses and in three different light conditions to maximize my chances of having at least one pot in bloom for the last entry day. By moving my pots around the warm greenhouses and giving them copious amounts of water, I was able to bring all three pots into bloom in time for the Show, and over the course of the week they won seven ribbons.

Lachenalia bulbifera
RAY ROGERS

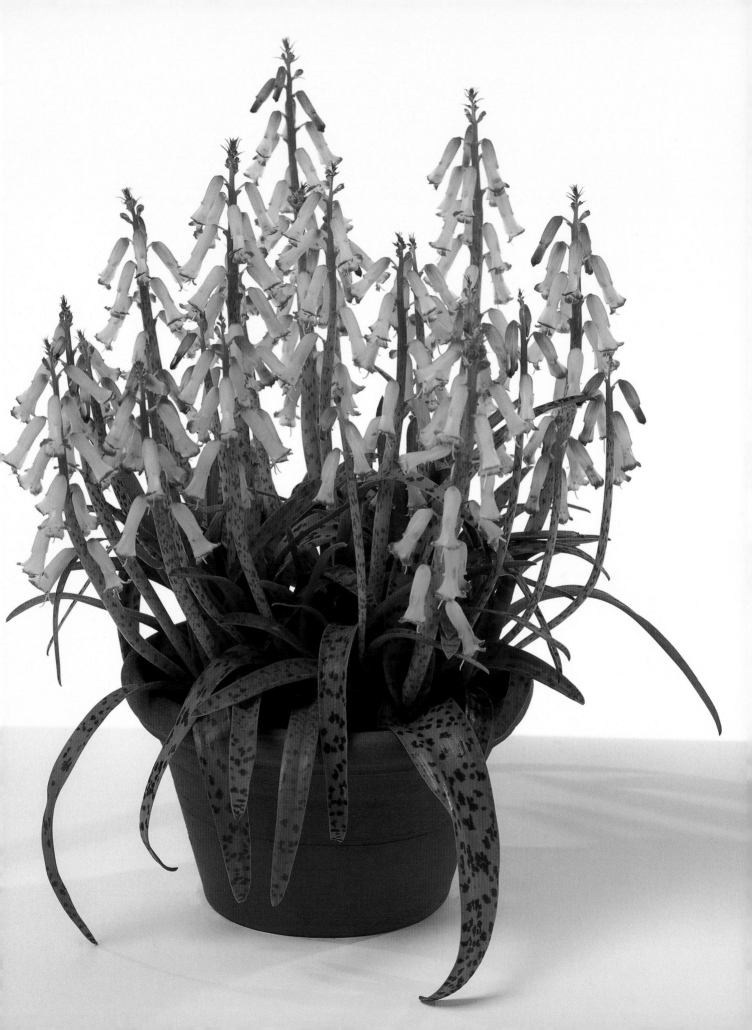

Lee Morris Raden is a pillar of the Pennsylvania Horticultural Society and the Philadelphia Flower Show. A three-time member of the PHS Council, he won the Distinguished Achievement Medal from PHS in 1998. He marked his 37th year as an exhibitor in the Show in 2003, and served as a passer (one of the quality-control inspectors of Horticourt entries) from 1969 to 1993, and as Horticulture Chair from 1998 to 2003.

Referring to his extensive collection of major Show awards as "mountainous" would make Lee smile, because he'd get the pun: He helped found the Delaware Valley Chapter of the North American Rock Garden Society in 1965 and served as its president from 1986 to 1990. Now retired from his career as a sales manager, Lee tends his garden, named Alpineflora, full time. Featuring a large rock garden and a special climate-controlled alpine house, it is a horticultural destination for invited visitors from around the world.

Most of Lee's Show entries are drawn from the world's choicest alpine species, many of which are challenging to grow either in the ground or in pots. Like many exhibitors, he happily spends a great deal of time and effort choosing, growing, and preparing his plants for the Show, and there have been many long nights endured before an entry day. In an interview in the early 1990s, Lee reflected on all of his horticultural endeavors and admitted, "I guess I'm just a plant masochist." What brings him back to the Show year after year? Lee says without hesitation, "It's the best horticulture in North America."

Narcissus bulbocodium 'Atlas Gold'
LEE MORRIS RADEN

It's safe to say that most of the pots of bulbs entered at the Show are forced. To professional horticulturists and hobbyists this means that plants are grown under carefully manipulated conditions to bring them into bloom earlier than they would outdoors. Bulbs are usually purchased the previous fall and kept in a cold frame, refrigerator, or similar cool spot for many weeks.

However, some entries are grown from seed, like Lee Raden's breathtaking *Narcissus bulbocodium* (page 77). Grown in a 6-inch pot it contains nearly 200 bulbs that were cultivated from seed collected in the Atlas Mountains in northwestern Africa in 1989.

Lee first admired entries of *Narcissus bulbocodium* at England's Royal Horticultural Society's Early Spring Show in 1970. That year he began growing various species in the genus *Narcissus* and since then he has grown and exhibited many plants from seed.

Their origin from seed isn't the only aspect that sets Lee's little daffodils apart from the rest of the forced bulbs. Unlike the vast majority of forced hardy bulbs that are aroused from their winter's sleep a few weeks before they bloom, the *bulbocodium* begin to emerge from their dry summer dormancy as early as October, and not always the same time every year. When they do start to grow, Lee begins to water them freely, simulating the conditions of the snow-melt areas where they grow in the wild. Like many of Lee's plants, the *bulbocodium* live in his alpine house, a specialized greenhouse that recreates alpine conditions in southeastern Pennsylvania. Shade cloth helps

reduce the air temperature by blocking the strong rays of the sun from early spring to fall, and two fans (one on the ceiling and an oscillating fan at the level of the plants on the benches) keep the air moving all day, every day of the year. In winter, a minimal heating regime keeps the nighttime temperatures from dropping below 34°F, and daytime temperatures are kept at 45–50°F.

Under these conditions, the *bulbocodium* thrive. Lee watches for flower buds to appear at soil level, which normally indicates the plants will bloom in two to three weeks. If a pot of bulbs seems to be coming on too slowly for a specific Show judging date, Lee resorts to a method used by many Show exhibitors: He places the pot immediately below a bank of fluorescent lights in his basement, which is kept at temperatures of 55–65°F.

This entry won the Delaware Valley Daffodil Society rosette for best narcissus on the first judging day of the 2003 Show.

It takes a great deal of space to force more than 200 pots of hardy bulbs for the Show. In Dorrance Hamilton's case, it takes a cold frame about 40 feet long. Sturdy covers, thick sheets of pink housing insulation along the sides, and cozy placement between two large greenhouses provide protection against fluctuating temperatures. During the winter of 2002–2003, heavy snowfall acted as a natural blanket, preventing a deep freeze.

To ensure there would be an entry of 'Jetfire' for all three judging days, the Hamilton garden crew potted approximately 20 good-sized bulbs of 'Jetfire' into each of several pots in early October 2002. The pots spent the winter in the cold frame and were then removed in early to mid-February. After a few days in a colder greenhouse, the pots were transferred into warmer houses to stimulate active growth. Mindful of the need to have entries for all three days, the crew kept some of the pots in the colder greenhouse longer than others. As the Show drew closer, the pots showing the most growth were selected for possible entry on the first day of the Show, and the slowpokes were singled out for the last day (Friday). Those in between were prepared for the middle entry day (Tuesday). Speeding some pots up in a warm greenhouse and slowing down others in a cold house resulted in excellent entries for all three days, including this 'Jetfire', which won the blue ribbon on Saturday.

Narcissus 'Jetfire'
MRS. SAMUEL M. V. HAMILTON

Growing a blooming amaryllis from seed takes only a few years, but achieving particular qualities can take much longer. In 1994 I pollinated a few flowers on a miniature, dark-leaved amaryllis labeled "× Scarlet Baby" with pollen from a unique *Hippeastrum striatum* var. *fulgidum*. What set this particular plant apart was its ruffled petal edges, a rare and lovely trait. About a month later, I was able to plant several dozen papery seeds from a few seed pods. Over the next two years I tended the growing seedlings, eagerly awaiting the appearance of their first flowers.

The first seedling to bloom produced flowers in an attractive color midway between its parents with a little bit of ruffling inherited from *fulgidum*. Then in 1996 I received some pollen from 'Amigo,' an amaryllis with reddish pink blossoms exhibited by my friend Sherry Santifer. I applied the 'Amigo' pollen to my first seedling that had blossomed, hoping to achieve an interesting combination of features in the offspring.

Two years later, in 1998, the seedling that I dubbed "Ruffles" bloomed for the first time. Happily, it brought everything I wanted together in one package: It was close to the lush color of its 'Amigo' parent, and inherited the miniature flower size plus a hint of the dark foliage of its "× Scarlet Baby" grandparent, and, best of all, it featured the distinctive ruffling of its other grandparent, the unique *fulgidum*. "Ruffles" grew into a good-size clump of bulbs, and in 2003, it was awarded the PHS rosette for best bulb other than narcissus on the last judging day of the 2003 Show.

Hippeastrum seedling "Ruffles"
RAY ROGERS

When I was a youngster, living with my family in Pittsburgh, Pennsylvania, I was fascinated with growing the common jack-in-the-pulpit *(Arisaema triphyllum)*. But it wasn't until the early 1990s that I began to cultivate more exotic species. My first acquisition was a Japanese species *(Arisaema sikokianum)* purchased from Ken Selody, owner of Atlock Farm, who had grown this variety from seed. It took a few years before I had a good *sikokianum* in bloom to enter for the Show. Its beautiful leaf coloration and distinctive "pulpit" were worth the effort. I won my first rosette at the Show with the beautiful Japanese relative of America's jack-in-the-pulpit.

Over the years I've avidly collected other *Arisaema* species: *taiwanense*, with its seductively fringed umbrella-like leaf; *intermedium*, a black-and-white flowered plant that can stretch to 3 feet tall; and even the common *triphyllum*, the species I grew as a child.

But the best of the group is the cumbersomely named *Arisaema angustatum* var. *peninsulae* 'Variegatum'. By 2003, all of my other *Arisaemas* had either died out or were being resurrected from tiny offset tubers. This exceptional plant survived years of its kin coming and going. In 2003 it stayed the course for the entire week of the Show, with the judges awarding it a blue ribbon on all three entry days.

Arisaema angustatum var. *peninsulae* 'Variegatum'
RAY ROGERS

Walt Fisher knows

exactly how to coax a pot of irises into bloom in time for the Show. In order to win a blue ribbon, irises must be at the peak of perfection, which spans a nerve-wrackingly narrow window of time.

Walt begins the process in the fall, when he "puts down" many kinds of bulbs, often preparing 150 pots by mid-November. The potted bulbs then go into a special cooler he constructed to accomodate his potential entries.

At a precise number of days before the judging day at the Show, Walt removes the pots from the cooler and brings them into an area set up specifically for forcing, a ping-pong table under a bank of fluorescent lights. He tries to keep the temperature at a minumum of 65°F and never higher than 70°F. Some bulbs, such as tulips, can require three weeks or more to force, but *Iris* 'George' is a sprinter: under these conditions, it reaches peak bloom in just four days. Using this formula, Walt has won the blue ribbon in the iris class with 'George' almost every time he has entered it over the course of five years.

Like so many Show exhibitors, Walt is generous with his horticultural advice, which is always accompanied by his signature smile. He's also generous with his entries, usually giving away most of them after they've had their run at the Show. When asked what inspires him to keep growing 'George', he says, "The year I first grew 'George', I offered a pot to one of the class chairs. She told me that George was the name of her recently deceased husband. Every year since then I have given her a pot."

Iris 'George'
WALT FISHER

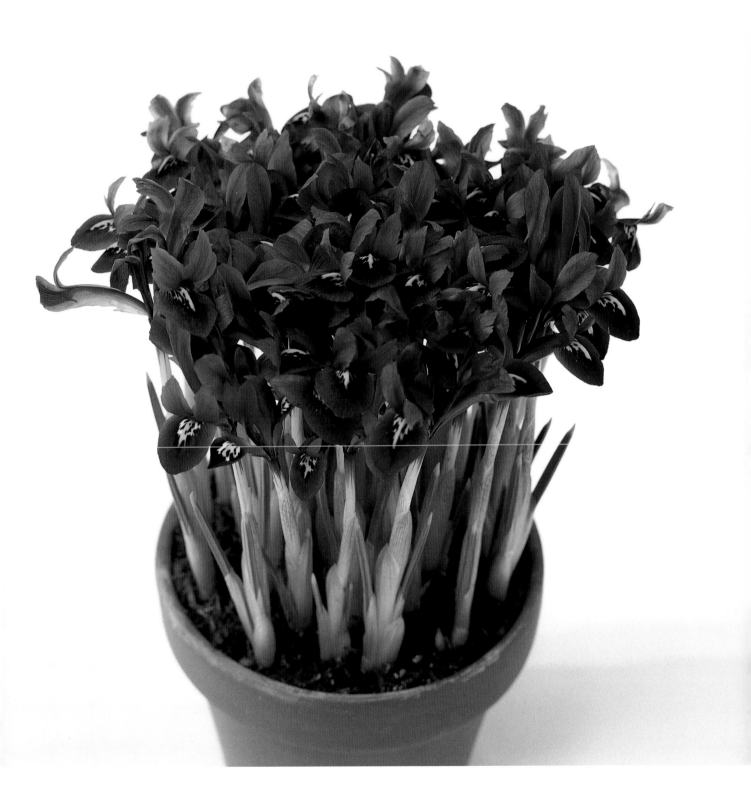

Rock Garden Plants

Although some potential

Show entries spend nearly all of their lives in one location (such as in a greenhouse, on a light stand, or on a windowsill), many others need to experience more varied conditions to thrive and excel at the Show. In an attempt to simulate the natural growing conditions—in the mountains of Afghanistan and northern Pakistan—of the parent species that produced 'Johanna' *(Primula clarkei* and *Primula warschenewskiana)*, Lee Morris Raden rotates this and similar primroses through several locations during the year. They spend late March to mid-June outdoors under shadecloth, then from mid-June to the end of September they spend time under a bank of fluorescent lights in Lee's air-conditioned basement. From the end of September until mid-February 'Johanna' remains in Lee's cool alpine house (see page 78) until it's time to return to a heated basement for a few weeks of active pre-Show growth. If the flowers seem to be coming on too quickly to peak during the Show, Lee returns the plant to the cooler alpine house for a few days to slow down the pace.

Lee's growing regimen for primroses has garnered him many rosettes and other high awards at the Show. In 2003, 'Johanna' won the American Primrose Society award, Doretta Klaber Chapter ribbon on the first judging day, and the North American Rock Garden Society Delaware Valley Chapter Doretta Klaber award for the outstanding rock garden plant of the week. Divided into three separate plants after the Show, 'Johanna' may well add more awards to Lee's collection.

Primula clarkei × *P. warschenewskiana* 'Johanna'
LEE MORRIS RADEN

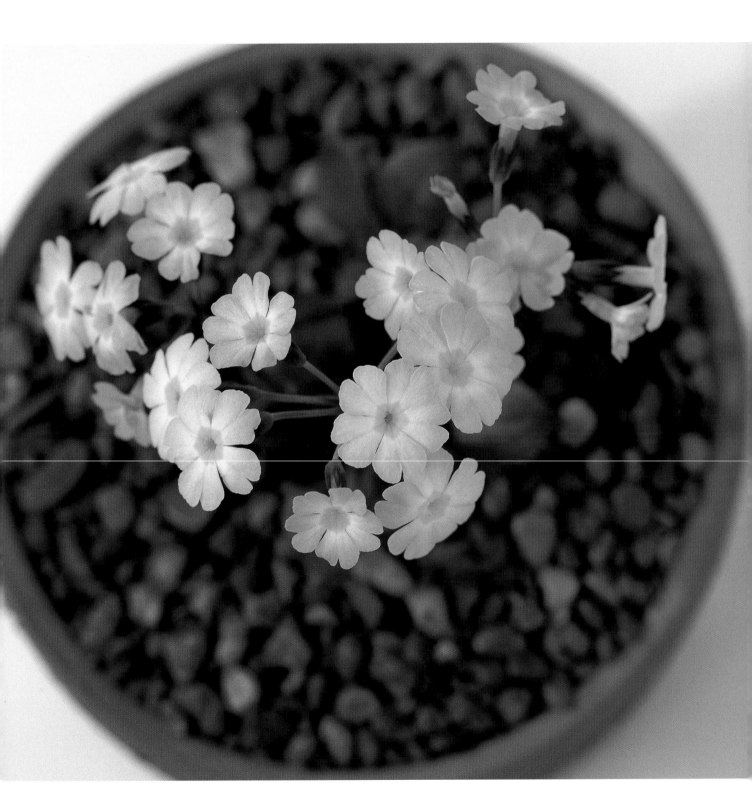

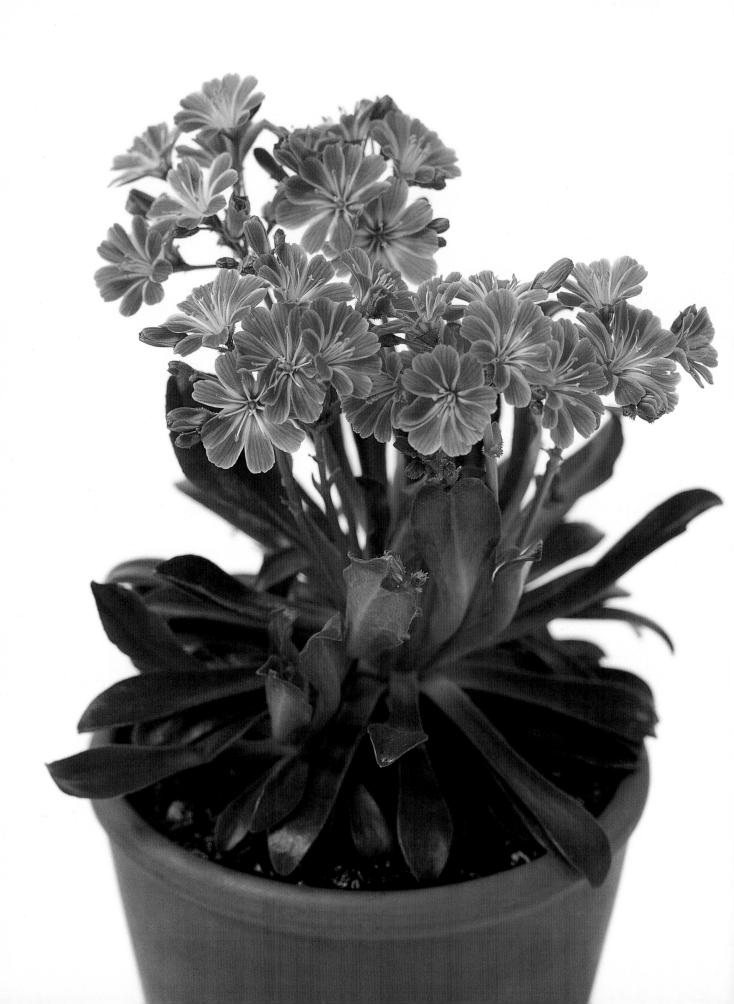

While admiring a showstopper such as this, you might well wonder how the exhibitor managed to get it to bloom just in time for the Show.

Stephen Maciejewski gave his *Lewisia* optimum growing conditions until the end of summer. In the fall he put it and other potential entries in pots outdoors and packed stones around them to provide insulation from temperature extremes.

Six weeks before the Show, Stephen went out to retrieve the plants and to his dismay, they were all frozen together into a mini monolith of ice and stones. Armed with a hammer, he freed them and positioned the pots on fluorescent-light carts. Much to Stephen's initial pleasure, all appeared to be going very well with his *Lewisia*. Too well, it turned out: The *Lewisia* was poised to flower two weeks before the Show. He had to slow it down, or it would be well past its prime before the Show opened. Stephen resourcefully put it on hold by placing it in his kitchen refrigerator for two weeks. He had to remove apples (they produce a gas, which ruins flower buds) and much of his food, since he chose to make room for ten plants. For almost two weeks he kept checking the plants and kept his fingers crossed.

A few days before the first judging day, Stephen removed the *Lewisia* from the refrigerator and put it back under the lights. Only two leaves had turned yellow, and the buds began to open. By Saturday morning, there was a crown of perfect flowers gracing the plant, and by week's end, five more ribbons and rosettes were in Stephen's collection.

Lewisia cotyledon var. *heckneri*
STEPHEN MACIEJEWSKI

Best of Day

'Joe' has a dazzling Show record: In 2002 it won a blue ribbon on all three entry days, plus several rosettes and an award for the outstanding entry of the week in the rock garden classes. In 2003, 'Joe' won two more blue ribbons and best of day (one variety) on both days it was entered.

Here is perhaps one of the most well-traveled entries in the Show. Its owner, Peggy Bowditch, grows a connoisseur's selection of plants, and when she travels to her summer home in Maine each year, her plants, including her *Clematis* 'Joe', come along for the ride.

Traveling for a few days with Show plants in a car takes a resourceful gardener. One October, on her return drive home to Pennsylvania, Peggy stopped for the night at a motel with her husband, Nat. The overnight weather forecast called for near-freezing temperatures, so Peggy was concerned about her plants surviving the night. Around 10:00 P.M., she turned the engine on and set the heater to High. When she'd warmed up the car, she turned the engine off and got out, quickly shutting the door to keep the heat in. Upon her return to the room, Nat reminded Peggy that a running car engine might produce harmful gases. She pondered what she would do in a few hours to warm the plants up again without running the engine. Awaking at around 2:00 A.M., Peggy filled a large motel ice bucket with very hot water and carried it to the car. She put it in with the plants, shut the door quickly, and went confidently back to bed.

At daybreak, as Nat was getting the car ready for the rest of the trip, he was puzzled by the thick frost that had formed on the *inside* of the windows. Scraping the windows, he complained to Peggy, but she didn't confess. Frost had formed, but her precious cargo had survived the night without harm.

Clematis × cartmanii 'Joe'
PEGGY BOWDITCH

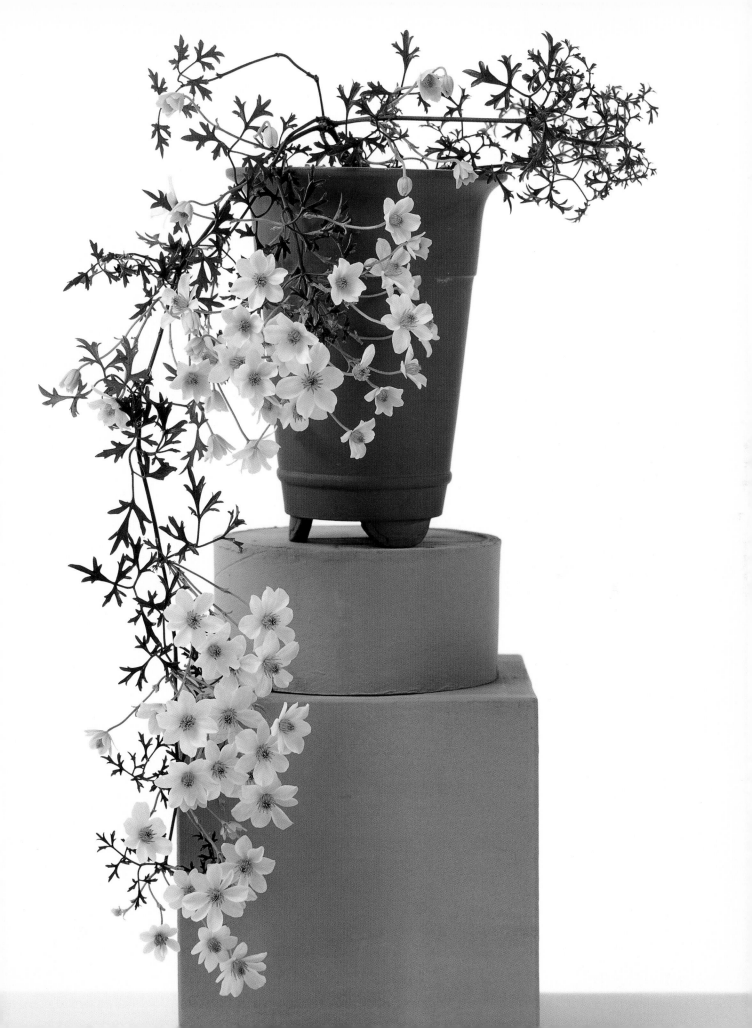

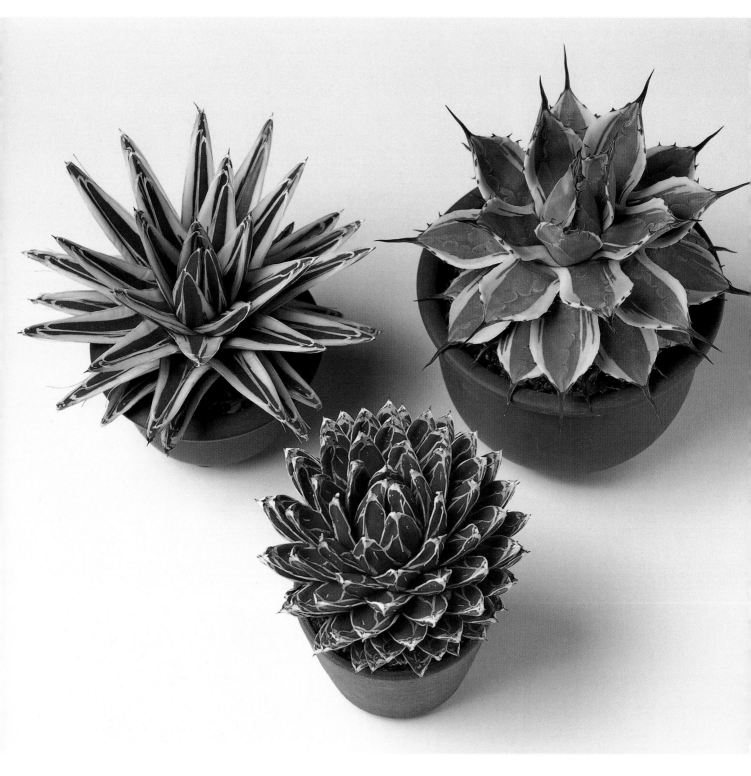

Agave victoriae-reginae variegated *Agave potatorum* variegated

Agave victoriae-reginae dwarf

DR. GERALD BARAD

Dr. Gerald Barad, an avid plant

collector, globe-trotter, and peerless grower, has shown plants for more than 50 years. On a trip to Thailand in 2002, he brought along some "pups" (small plants separated from the mother plant) of the uncommon variegated *Agave victoriae-reginae*. When a group of fellow enthusiasts discovered he had the pups, Jerry says he tried "to hold back the hounds" but eventually gave them all away. He later realized he had no pups left for a Thai nurseryman who had specifically requested one and with apologies, Jerry promised to send one upon his return home. He sent the promised plant back to Thailand, and within a few days of receiving it, the nurseryman told Jerry his customers had already spotted his brand-new agave and were begging him for a plant.

Halfway around the world from Thailand, England is home to equally avid collectors. At a plant auction in London, Jerry was engaged in spirited bidding for a choice specimen of variegated *Agave potatorum*. When the bid reached a lofty £450, Jerry's wife Bea elbowed him and said, "Let him have it!" Jerry relented. After the auction, another bidder went up to Jerry and said he had a pup to give him. Under Jerry's expert care in his greenhouse, that pup thrived and in turn produced other pups, one of which matured into this flawless plant entered in 2003. Entered together, this group won best of day (two or more varieties).

T H E A R T I S T I C

AND DESIGN CLASSES

The competitive artistic and design classes cover a wide range of expression, from miniature arrangements no more than 5 inches high to 500-square-foot garden rooms that incorporate full-size trees. In between these extremes are the familiar flower arrangements, displayed on tables, in rooms, in defined and open spaces, and in large, medium, small, and miniature niches. Other classes feature arrangements of live plants in a variety of settings, including balconies, urns, window boxes, and entryways. In the so-called "miniature settings," live plants are used as part of the decorations for elaborate scale models. The Show also includes pressed plant pictures, and a class in which elaborate jewelry is crafted out of dried plant material.

The 2003 Show included 322 entries in the artistic and design classes. Since many are team efforts, the entries represent more than 500 individual participants.

Entrants with larger displays, such as gardens and entryways, begin setting up early in the week, and by the Friday before the Show opens, most artistic competitors are in a frenzy of activity. The urn and balcony competitors can be seen toting guns—glue guns, that is, to attach dangling Spanish moss that hides the ugly underpinnings of their displays. Like giant Gullivers playing in the land of the Lilliputs, makers of the miniature settings tinker with their little worlds. The pressed plant pictures, some of which have arrived by mail from competitors around the world, are hung on a drab gray wall that emphasizes their vibrant colors. Jewelry pieces that seem to be dripping with precious metals and gems

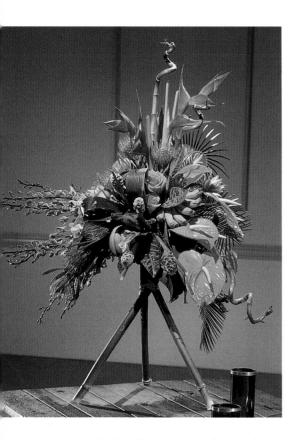

A detail of the arrangement done for the 2003 table class entry by the Huntingdon Valley Garden Club. The tripod of bamboo plays off the exhibitor's theme, A Photographic Safari to South America.

(but are actually made of beans, bananas, apples, and other plant materials) are staged in their lighted display cases. Room and table class entrants are busy arranging their background sets and props, with most of them putting off work on the flower arrangements until the last minute on Saturday morning.

By 6:30 A.M. on Saturday, with the judging to begin at 9:30 A.M., and the Show scheduled to open at noon, a cyclone of activity has touched down in the arrangement classes. The aisles are crowded with folding tables overflowing with buckets of cut flowers, baskets of fruit, tools of the trade such as pruners, scissors, florist foam, wire, tape—and the fuel of choice in the Show's early-morning hours, doughnuts, bagels, and coffee. All the practice arrangements of previous months are moot as crunch time begins. Depending on the class, the competitors have from 75 minutes to two hours to bring their ideas to life.

By 8:30 A.M. on Saturday the arrangers have made their final adjustments, and the entries are screened by volunteer passers who check for elements such as endangered plant species or taxidermy, both forbidden in the Show rules. The folding tables are put in storage, barricades are put in place in front of the displays, and then the judging teams sweep through, bestowing their honors. By the time the Show opens, the fog of frenzied anxiety that filled these aisles a few hours earlier has lifted, and all the public sees are the beautiful results.

In the niche, open, and defined space classes, this process is repeated three more times, on Monday,

Wednesday, and Friday mornings, as previous entries are removed and new entries, in new classes, replace them. Miniature arrangements and window box classes are replaced once, and others remain for the entire nine-day run of the Show. All exhibits of fresh flowers or live plants must be maintained daily, and some of the long-term exhibits are renewed on Wednesday morning, after which they are rejudged by a different panel.

The activities at the Pennsylvania Convention Center in March are the culmination of a long process of planning by both exhibitors and other volunteers working behind the scenes. Within a month after one Show ends, committees and PHS staff meet to decide on class titles for the following year. By late spring the schedule of competitive classes is finalized. Some of the classes for larger exhibits, which require long lead times for both design and gathering of accessories and plants—such as gardens, entryways, rooms, tables, balconies, urns, and window boxes—are filled on a first-come, first-served basis before the guide is published, usually by the many garden clubs in Philadelphia and its suburbs. For the rest of the classes, the guide goes public in September, after which there is a rush of entry forms as competitors try to reserve a slot in the classes of their choice.

Once entries are confirmed, detailed rules and information specific to each class are sent out to exhibitors. Class chairs and advisors, whose phone numbers are published in the guide, are available for consultation. In the fall and winter, workshops and meetings are held for various classes, the most

elaborate being those for the flower arrangers. In addition to an October symposium, the arrangement chairs run a series of weekly sessions in January and February, in which entrants can run their ideas by some of the most experienced exhibitors in the Show.

Whether they win a blue ribbon or not, the excitement of playing even a small part in the creation of one of the biggest and best flower shows in the world seems addicting to many competitors. "During the Show I'm always asking myself, 'Why am I doing this?'" said Hope Fox Coates, who has been exhibiting at Philadelphia for more than 40 years. "But then, when it's over, I can't wait to do it again." "It just gets in your blood," explains Ardyth Sobyak, a member of the Wayne Woods Garden Club.

Exhibitors range from teenagers, encouraged to enter by parents or teachers, to seniors, who have been participating for most of their lives. Though one long-time female competitor referred to the Show as akin to a "sorority reunion," the classes include many newcomers and a number of male entrants, among them members of the Men's Garden Club of Philadelphia. First-timers are encouraged and even doted on, and while the standards are high and the competition can be intense, the atmosphere is friendly and helpful.

Dottie Sheffield, a competitor since age 17, uses a sports analogy to explain her love affair with the Show. "Some people play golf for 60 years," she says. "My hobby is flowers, and it's no different from any sport, from tennis or golf. If you like the game, you like the game."

Melinda Moritz, as a young girl in the late 1950s, remembers that she and her grandmother had an annual "big day out"—a visit to the Philadelphia Flower Show. As a young adult she joined the Greene Countrie Garden Club and began volunteering in the Show's membership booth, and soon after that she entered a niche arrangement, partnering with a more experienced exhibitor, Diane Hanson. "Entering the Show is very intimidating to a lot of people," she says, "so for the first time it's nice to have someone with you who's done it before."

Since that first time, Melinda has entered many arrangements and won many ribbons and awards. She has also played an increasingly important role in the Show organization, culminating with her present position as chair of all the competitive classes. As with all the organizers of the competitive classes, one of her goals is to make them accessible for first-timers. Symposiums and workshops are scheduled in the months before the Show to demistify the entry process and provide helpful advice, and committee chairs and advisors are on call to answer questions. At the Show, extra matboards, light bulbs, gadgets, and tools, as well as free advice and helping hands, are always available for those in need. "We try to make it as friendly as we can," Melinda says, "because, in the end, it's supposed to be fun."

Like so many of the more than 3,500 volunteers who make the Show possible, she loves being a part of this annual extravaganza. "When the doors first open on Saturday, I enjoy watching the first visitors come in, seeing the smiles on their faces." As much as she has given to the Show over the years, Melinda says that such moments are how she gets it back.

Flower Arrangements

The niche, open space, and defined space arrangement classes change four times during the Show, with entry days on Saturday, Monday, Wednesday, and Friday. The volunteer committees who run these classes often try to tie them in to concurrent local artistic events. In 2003 the Philadelphia Museum of Art exhibition "Degas and the Dance," highlighting the work of French impressionist Edgar Degas, inspired all the class titles for Monday entrants.

Anne Coste chose a pink theme for her ballet-inspired exhibit, and spent hours at her local frame shop trying to select the appropriate color for the background mat. The semi-circular background was chosen for its gracefulness, she says, adding that installing the curved mat was much easier than trying to cut it to fit three sides of the niche.

The mat color dictated the flowers, and she chose white *Alstroemeria* with a blush pink center, which reminded her of the scalloped shape of a ballerina's tutu. After an hour in the florist's cooler, she found pieces of fantail willow with just the right curves. Though she only used a handful of flowers, she bought many more than she needed, as arrangers always do for competitive exhibits. "You have to hold each flower up to the light," she says. "If they're too translucent, they're on their way out."

The arrangement is built around a ballerina, which Anne received from the late Sarah Groome, who for years held flower arranging workshops in her house and was a mentor and friend to Anne and many others.

This exhibit won a blue ribbon and best of week award in the medium niche class, but such awards are simply "icing on the cake," she says. "If you like what you did, and it went in well, that's all you can hope for."

Medium Niche Class
Degas Day: The Ballet Class
ANNE COSTE

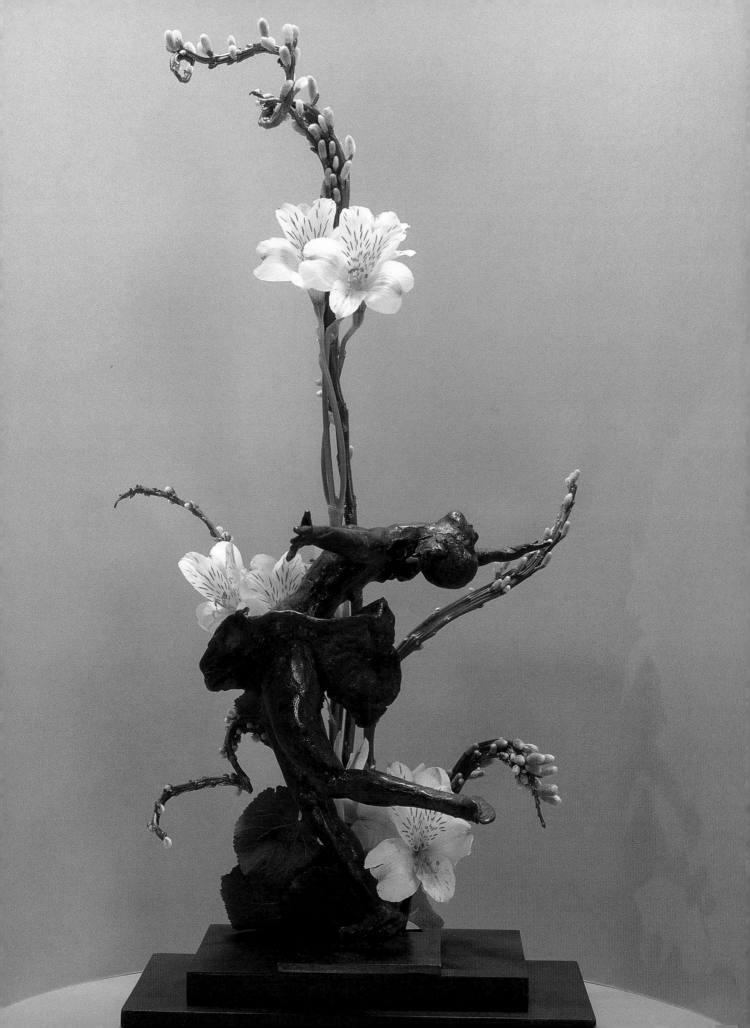

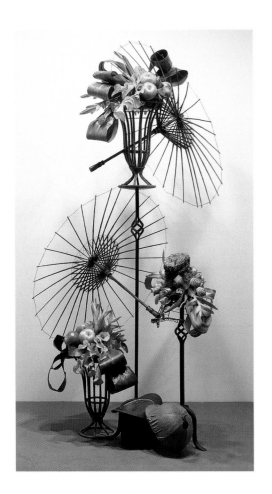

Defined Space Class
Degas Day: A Day at the Races
JULIE LAPHAM AND
ANNE ELWELL

When an exhibitor drops out of an artistic class late in the game, the class chairs get on the phone in a frantic search for someone to fill the space. Massachusetts flower arrangers Julie Lapham and Anne Elwell were two such replacements, called in three weeks before the Show to fill a space in this class inspired by Degas. Both had judged at Philadelphia before, but neither had ever exhibited, mainly because of the logistical problems of transporting materials and fresh flowers from such a long distance.

The paper-covered parasols in this exhibit were stripped to their wooden ribs and spray-painted brown to match the rust color of the metal candlestands that hold the flowers. The lady's hat on the middle stand is an upside-down wire basket, filled with moss and foam and covered with roses. The large bows are made of *Phormium* and *Cordyline* leaves, and the jockey cap and top hat are actually ornamental bird houses borrowed from a friend.

Anne and Julie, who have both exhibited for many years at other shows in the Boston area, found the frenzied excitement of the setup period in Philadelphia very familiar. "You have to be there way too early in the morning, it's cold, and you're working under not enough light," Anne says. "You feel like you never have enough time to do what you have to do." For their last-minute and long-distance effort, the two women won several awards, including a trophy for the Show's most outstanding exhibit in the defined and open space classes.

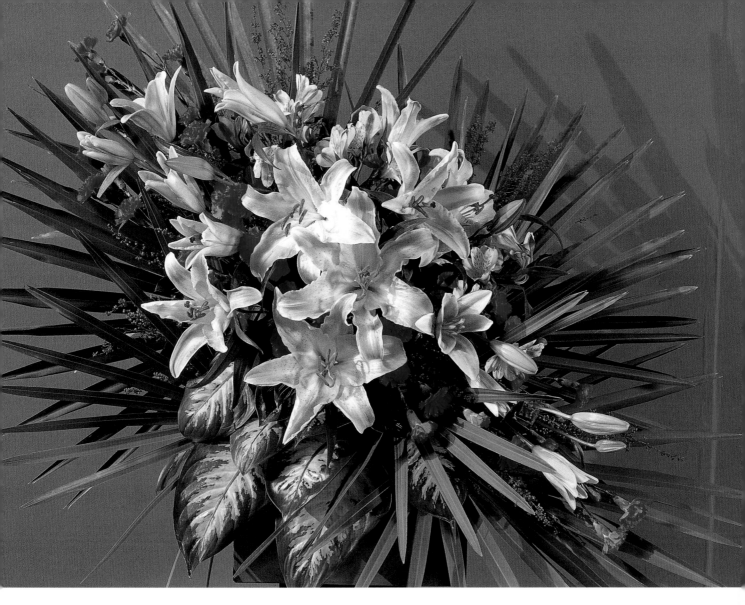

In contrast to the commonly held vision of ballerinas as tippy-toed waifs, Elizabeth Walker's arrangement reflects the solidity and sturdiness she saw in the dancers portrayed by Degas. The tutu-like fans of palmetto leaves and their shadows in the background evoke that moment in choreography when all the ballerinas float together center stage.

Open Space Class
Degas Day: Inspired by Degas
ELIZABETH WALKER

Miniature
Arrangements

Miniature arrangements cannot exceed 5 inches in any dimension. Unlike other arrangements, where fresh flowers are required, in the miniatures, only dried plant material can be used, either in its natural state or painted. These tiny jewel-like creations are displayed in small boxes similar to those used for the other niche arrangements.

A woman dancing the tango gave Joly Stewart the inspiration for this colorful arrangement. Dried globe amaranth flowers, painted red, and the black-painted *Leucothoe* and protea leaves are arranged on a twisted piece of black aluminum that reminded Joly of a tango step. "The black, red, and yellow seemed like Latin colors to me," she says. "Instead of being soft and lovely, I thought it should be zingy."

A Show competitor since 1968, Joly in previous years might have been disappointed with this arrangement's third place award in previous years. "We used to take it very seriously," she recalls. "We'd always think blue! We'd get those yellows and think it wasn't enough, but now I think it's fun just to make the effort."

Miniature Arrangement Class
Latin Rhythm: A Design
JOLY STEWART

The title of this class made some exhibitors think of a bullfight, but to Estelle Sherman the word brought to mind fireworks. The spirals bursting out of the arrangement are twisted pieces of wire, painted either aqua or pink, and the tiny balls are the painted heads of corsage pins. Red strawflowers and painted cotoneaster leaves fill out the rest of this arrangement. All the pieces are stuck into a piece of styrofoam, and tiny allium florets are glued onto this base to hide it. The whole arrangement hangs on a piece of nearly invisible fishing line. "You start thinking about the design as soon as you're accepted into the class," Sherman says. "Sometimes in the middle of the night I would lie awake wondering, would *this* work, would *that* work?"

Miniature Arrangement Class
Ole!: A Suspended Design
ESTELLE SHERMAN

Laura Philip has been attending the Show since almost before she can remember. Her mother, Ginnie Tietjens, is a veteran of the arrangement classes, and her father, Kenneth, has made occasional entries as well. At age 14, Laura got in on this family act, entering a medium niche class with her mother, and the next year she set out on her own. Now 34, she has missed only one year since then, when her first son, Thomas, was born. "Now that I have two kids and I'm a stay-at-home mom, entering the Show is one creative thing I still do for *me*," she says.

Among the most gratifying of Laura's many awards has been the Sarah C.Z. Groome award, which she won in 2002 for accumulating the most points in the artistic classes. For many years, the late Groome held workshops in her home, and Laura is one of many flower arrangers who considered her an invaluable teacher and mentor. "She was very elderly at the time," Laura recalls, "but she was so sharp, and she had such an eye for design."

Like many Show competitors, Laura can describe most of her many entries over the past twenty years. While this is partly due to a good memory, it is also a reflection of the drawn-out creative process that etched each one indelibly in her mind. She begins thinking about her arrangements in October, once the Show office confirms her entries. In January she sets up practice spaces around the house, which allow her to live with the designs for a while, so she can determine if they need a little tweaking or a complete reworking. Taking photographs of these initial efforts, she says, sometimes makes it easier to pick out their flaws. As the Show draws near and her practice setups get close to what she wants, Laura has learned over the years to leave well enough alone and deal with any other changes at the Show itself. "You can sometimes overthink it," she says.

*Table Class: Buen Provecho
A Photographic Safari
to South America*
HUNTINGDON VALLEY
GARDEN CLUB

For the average Show visitor, the table class, in which flower arrangements are displayed on a table with settings and props along the lines of a chosen theme, may provide the most realistic examples of what they might do at home. In other classes, such as defined space and niches, the arrangements can be viewed only from the front, allowing for hidden mechanics and supports that could not be used in a table arrangement, which can be viewed from all sides.

First-time competitor Gretchen Graham and Jane Woll, a veteran of many Shows, served as co-chairs of this Huntingdon Valley Garden Club entry. They focused on the setting, while Ginnie Tietjens and several assistants worked on the arrangement. Gretchen used her own kitchen chairs and bought the table in a used furniture shop. Everything from the plates and glasses to the wine bucket and the wine bottles themselves were chosen for their neutral tones, so they would not compete with the centerpiece. Ginnie's floral arrangement features coral anthurium, a last-minute substitution when the orange flowers she had ordered failed to come through. As it turned out, the coral went perfectly with the color of the wall behind the table. The arrangement, as part of the photographic theme, is elevated on a tripod of bamboo, which she harvested from a neighbor's yard.

For Sally Humphreys, personal relationships developed over nearly 40 years of participating in the Show stand out far more clearly than the multitude of ribbons, rosettes, and trophies she has managed to win along the way. It all began in 1965, when she and Tina Colehower made their first entry in the table class. They had so much fun that both of them were hooked, and since then, Sally has never missed a Show, working tirelessly as both an exhibitor as well as a chair and advisor in different artistic classes.

While she has exhibited on her own many times, Sally has always prefered to work with a partner. For 20 years she exhibited with the late Carolyn Waite, and the pair also lectured together and authored a book on flower arranging. She and another partner, Elizabeth Webb, were three-time winners of the Margaret Biddle Bright award for the best large niche in the Show. She and Melinda Moritz have worked together on exhibits, workshops, and in running the Show's arrangement classes. In perhaps her most satisfying collaboration, Sally has also exhibited and lectured with her daughter, art historian Stacey Blankin.

"If you're working with someone else and you win, then you can go out to lunch and celebrate," she says. "And if you don't win, you still can go out to lunch." For Sally, it is the camaraderie developed during the crazy excitement of putting on a show that keeps her coming back year after year. "The combination of people and flowers at the Philadelphia Flower Show—it doesn't get any better," she says.

The co-chairs of the Garden Club of Philadelphia's room class entry had worked together on Show exhibits before, and so they were familiar with the particular skills each brought to this project. As an artist who has done set and prop design for theatrical productions, Lawrie Harris is accustomed to working as the "handmaiden to the stars." In this case, the star would be Lani McCall's stunning flower arrangement.

Lani and Lawrie picked five other club members to help them, and the group first met in the summer of 2002, about seven months before the Show. "We always try to get younger members involved, so they can see how it works and get turned on," says Lani.

After coming up with the "Bedouin Wedding Night" theme, committee members researched the elements of the motif, and Lawrie made a tentative drawing to present to Show officials in the fall. Once approved, committee members started buying, building, or borrowing the necessary props, and in late fall, they began creating a full-size mock-up of the exhibit in Lawrie's studio. The exhibit was awarded a trophy for the best exhibit in the room class.

At the end of the Show, Lawrie says the tear-down of the exhibit happened very quickly. "The tent was held up by just three poles, and everything else was very light, and soon there was just a bare stage. We felt like nomads ourselves, packing up to move on."

ROOM AND TABLE CLASSES
In these classes, while all the elements must work together, the rules state that the arrangement must predominate. In both classes dried plant material may be used, and for the table settings, fruits or vegetables may be incorporated as well. In former years the Show organizers provided simple tables for the exhibits—two sawhorses and a piece of plywood. Today, each exhibitor must provide a table and a chandelier complementary to the scene.

Room and table displays stay up for the entire Show and, because of their size, installation can begin as early as two days before the Saturday judging. They are judged twice, on Saturday and again on Wednesday. Exhibitors are allowed to change their displays Wednesday morning if they desire, in an attempt to improve their standing in the second judging.

Room Class: Accent on Floriculture (A Celebration from a World Culture)
Bedouin Wedding Night
GARDEN CLUB OF PHILADELPHIA

Container Displays

Various design classes in the Show feature live plants in creative containers or settings. These include the balcony, window box and lamppost, and urn classes, collection classes displayed on glass shelves, container displays in small room settings, entryway gardens, and full-size outdoor garden spaces. Because of the expense of creating these exhibits, the Pennsylvania Horticultural Society offers monetary subsidies based on the size of the display, and modest maintenance awards in some classes.

The windowbox and the collection displays change mid-week, but the rest of these classes remain on display for the entire Show. As with the room and table classes, they are judged twice, on opening day and on Wednesday, and may be altered on Wednesday morning to try to improve their rank in the second judging.

During the months leading up to their first Show entry, Four Counties Garden Club members Susan Whiteley and Lucia Shen learned to appreciate the value of sphagnum moss. Working with a committee of more experienced advisors, they chose as their theme the Mexican national holiday *Cinco de Mayo*, with the goal of making their balcony resemble a fireworks display. By removing many specimens from their pots and placing the rootballs in plastic bags, they managed to fit more than two dozen plants into the narrow balcony. Plants at different heights were propped on chunks of foam and blocks of black painted wood—and when they ran out of them near the end of the setup, they threw mulch in a plastic bag to substitute. Some plants, such as the chartreuse fern at the bottom, went through the balcony sideways and had to be wired or duct-taped into place. When everything was in position, they used a glue gun to attach the sphagnum to hide any visible pots, and when they were finished, none of the underlying mechanics were apparent, only the colorful explosion of foliage and flowers.

Balcony Class: ¿Que Pasa?
Cinco de Mayo
FOUR COUNTIES GARDEN CLUB

When the balcony class debuted at the Show in 2001, the Planters, a suburban Philadelphia garden club, was among the initial entrants. "That year," says club member Sham Knight, "we chose to do it as a real balcony would look, and we ended up with a third prize." She learned afterward that instead of reality, the judges were looking for luxuriant balconies overstuffed with plants that would be impossible to maintain in real life.

Two years later overabundance is exactly what Sham and her co-chair M.L. Riley provided for the club's second balcony entry, titled *El Baile de las Flores* (The Dance of the Flowers). The balcony itself was lined with coir fiber (made from coconut by-products) and filled with styrofoam peanuts. The live plants were staged in that filling, their pots propped up and wedged between overturned pots, paint cans, and bricks. Not content to simply fill the base of the balcony with plants, they surrounded the exhibit's faux window with a foot-wide black-painted wooden arbor. From this superstructure they hung more than a dozen moss-lined baskets planted with begonias, ranunculus, and other colorful plants that punctuated the lush and twining foliage hiding most of this structure.

The committee worked for months on the project, and Sham estimates that the plants alone cost about $1,000. But all the time and money paid off when the Planters' over-planted balcony won a red ribbon on Saturday, a blue ribbon on Wednesday, and best of class for the week.

Balcony Class: ¿Que Pasa?
El Baile de las Flores
THE PLANTERS

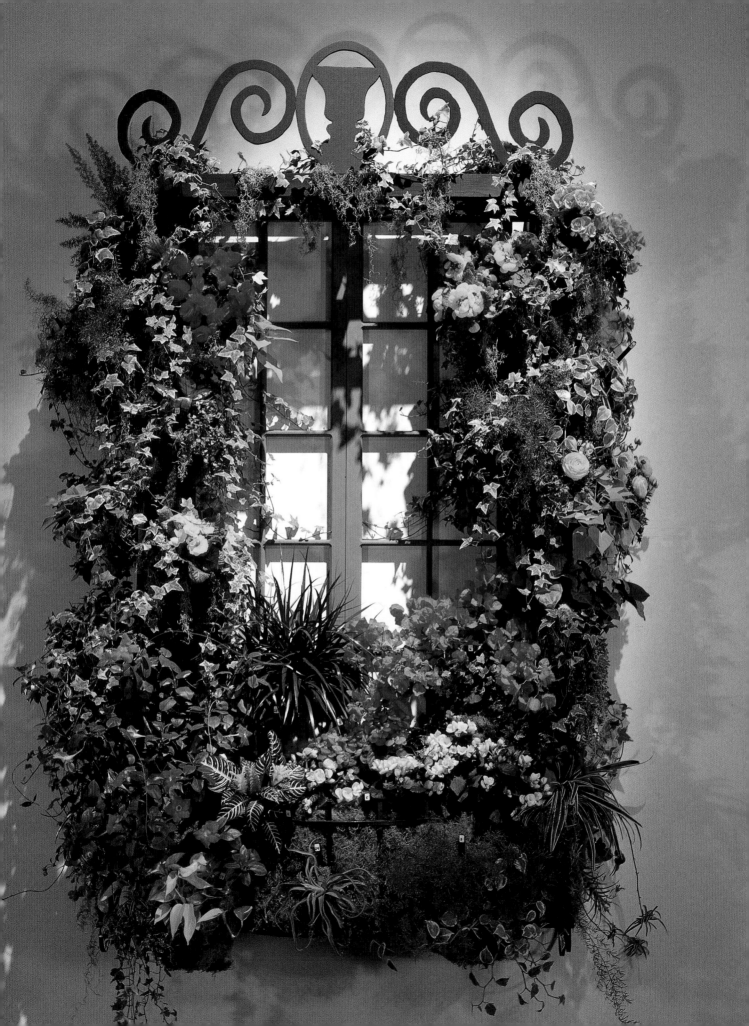

Dr. Wilfreta Baugh first exhibited at the Show almost three decades ago, in 1974, but she still remembers every detail of her debut arrangement. In the large niche class called "Luminous," she entered a minimalistic design using three different sizes of shiny copper tubing, one of which held two perfect stems of bird-of-paradise. The tubes were set on a thick piece of plexiglass that Wilfreta had asked a friend to cut in an irregular

shape. Her friend's idea of irregular was an outline of the United States, which caused Wilfreta a moment of panic and which she did her best to disguise by pointing Maine to the front of the niche and hiding Florida, Texas, and California in the rear. If the judges noticed this at all, it made no difference in the end. The arrangement won a blue ribbon and best in show. "With that," she says, "I was hooked!"

Dr. Baugh credits Bernice Makin for first praising her talent in arranging and then, through various workshops, teaching her the basics. A member of Our Garden Club of Philadelphia and Vicinity, she has exhibited every year since 1974, even during medical school and the hectic years of her residency. In recent years she has exhibited with her daughter, Gabrielle Smith, and her granddaughter, Valentina, has also begun to compete in smaller flower shows.

Wilfreta's style has remained the same through the years, spare and deceptively simple. She is one of a number of experienced arrangers at the Show that people look to for ideas, but has continued to learn from others as well. She is especially fascinated by other people's mechanics. "You can think of the best arrangement in the world," she says, "but if the mechanics aren't good, it can look awful."

Like all long-term exhibitors, Wilfreta has had her share of winners and her share of arrangements that were passed over or misunderstood. She says she simply tries to create designs that she can feel good about, regardless of what the judges decide. "I tell people who are just starting out, 'Don't look for the blue ribbon. Just do what makes you happy.'"

This window box for dappled shade, entered by the Norristown Garden Club, is only 30 inches long and 6 inches wide but includes 21 plants for a lush, overflowing look. The wire mesh dancing shoes hanging on the lower right are filled with reindeer moss and ornamented with star-shaped *Cryptanthus bromelioides* 'Tricolor'.

First-timer Bernadette Jackson chaired the club's five-member committee, with all the apprehensions attendant to her novice role. "I'd been going to the Philadelphia Flower Show for about 10 years," she says, "and I admired many of the exhibits, so it was rather intimidating to think of doing one myself."

Many of the artistic class entries are judged partly on how well the exhibitors fulfill their "intent," submitted before the Show. For this entry, called "Dance of the Shady Ladies," the intent read in part: "Like tango dancers, the plants sway and intertwine, some bold and vibrant, some coy and shy." Among the judges' comments on this blue ribbon winner: "The intent is completely revealed in the bold and vibrant use of plants."

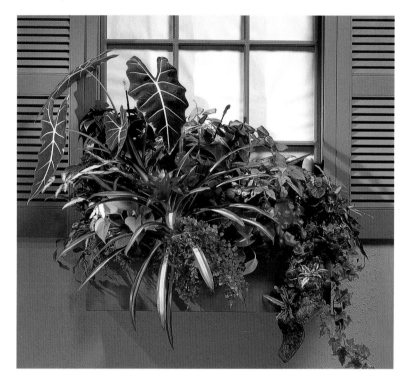

Window Box and Lamppost Class: Tango in the Shade Dance of the Shady Ladies
NORRISTOWN GARDEN CLUB

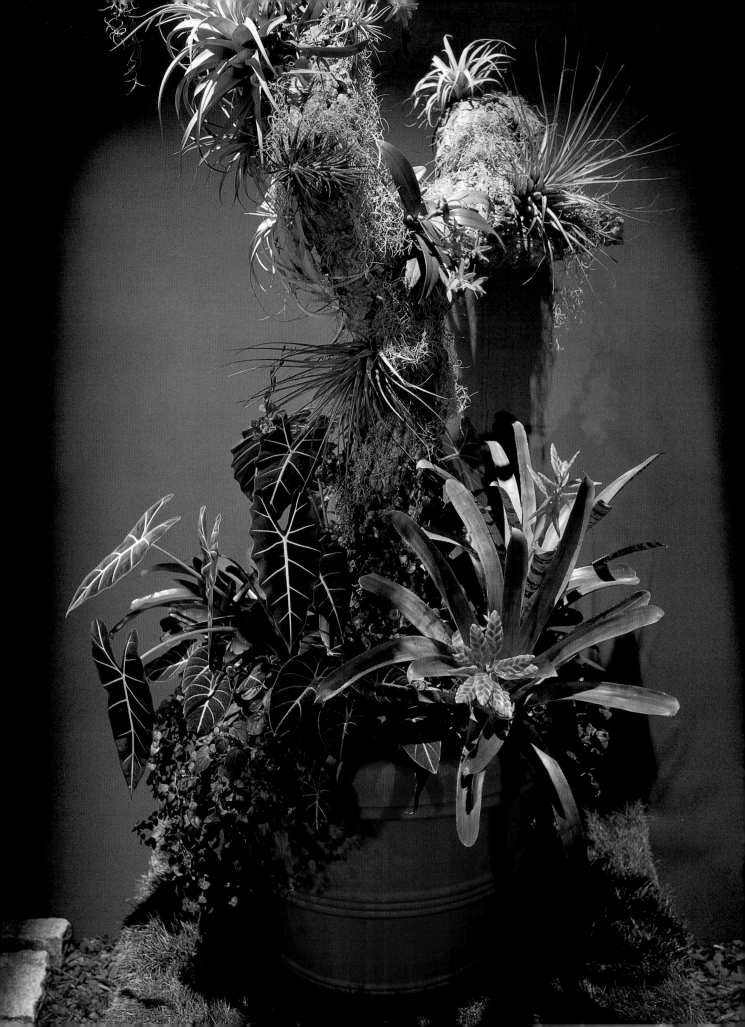

At the beach in the summer of 2002, Deborah Evans had no time for trashy novels. Instead she read books about the plants of Brazil, part of the research she and co-chair Kim Croney did for the Wissahickon Garden Club's urn exhibit, "Brazil Remembered." Their original idea was to support a collection of Brazilian rain forest plants on an upright piece of driftwood, but after seeing a cork "tree" at a nursery, they settled on this form of faux flora as a more authentic-looking solution. They commissioned a metal sculptor to weld an armature of steel reinforcement bar in the shape of a tree, and located a mail-order source for the cork bark and attached it to the frame.

The completed tree was "planted" by pinning plants of creeping fig *(Ficus pumila)* onto the cork, and giving them several months to grow and fill in. In early February the tillandsias were attached, using a special horticultural glue that doesn't damage plants. To attach orchids to the tree, they tucked the roots into the toes of cut panty hose and wrapped them with sphagnum moss. They then tied these bundled roots to the cork with fishing line. These and other visible mechanics were hidden behind a drapery of Spanish moss. Other plants were inserted into the soil at the tree's base, and the entire arrangement was "groomed" over the course of several days, to make sure it would be at its best for the judges.

Urn Class: South of the Border
Brazil Remembered
WISSAHICKON GARDEN CLUB

They find inspiration while working in the garden or walking in the woods. They find it in their kitchens, in minuscule mustard seeds and mushy banana peels. The competitors in the jewelry classes say that trying to create realistic-looking pieces out of dried plant material forces them to look at the world in a different way.

"A dried flower calyx can become a jewelry bezel," says Lisa Howe, the Show's jewelry chair. "A plant stem that dries hollow, if you carefully razor blade it into sections, can be painted and fashioned into tubular beads."

Jewelry is the Show's newest artistic class, added to the schedule in 1996. To encourage new entries, Show organizers provide a list of plant material that has worked in the past, but exhibitors do their own research into the historical or regional origins indicated by the class titles. Painting is allowed, and depending on the effect desired, a gold piece might be created with gold leaf, spray paint, or nail polish. While the judges do not remove the pieces from the case, they must appear to be wearable. "One judge is always a jeweler," says exhibitor Dottie Sheffield. "That person makes sure that the jewelry could be used, that the clasp could work, that the mounting is proper for the 'stone.'"

Dottie and other exhibitors could be considered alchemists of a sort, taking the proverbial hill of beans and, after much labor, endowing humble legumes with an appearance of pricelessness.

Jewelry

*Carnival Time: Pin fashioned
 after caretas*
EMILIE LAPHAM

Caretas *are masks traditionally worn in Puerto Rico during carnival time. For her colorful pin Emilie Lapham used a base of dried orange peel, which she found easy to sand and paint. The red freckles on the mask are mustard seeds, the teeth are rose thorns coated with white pearl nail polish, and the eyes are lined with balsam needles. The spiky projections at bottom are hardy orange thorns, and the two horns at top of the mask are from a Hawaiian palm. This inspired piece won best in show in the jewelry classes.*

Pre-Columbian Necklace
MARJORIE FAUST

Marjorie Faust considers herself a detail-oriented person, a good thing considering all the tiny bits that go into making a piece of jewelry for the Show. Like other jewelry exhibitors, she raids her spice cabinet and garden for materials. The medallion on this piece is her representation of a shaman, whose crown includes fennel and mustard seeds. While deadheading plants in her flower beds, she discovered that dried Siberian iris stems were hollow, and instead of relegating the debris to the compost pile she transformed them into beads. After making the necklace, Marjorie spray-painted it gold and then repainted the turquoise and carnelian elements.

Gaucho Belt Buckle
SUSAN O'REILLY

Trained as an arist, Susan O'Reilly lets the materials at hand dictate her design. The horse and gaucho, the medallions, and the eight flat loops are made of banana peel. An okra seed and cactus needles form the star. Sesame seeds edge the two medallions. Pieces of cat's claw pods, with their distinctive sharp hooks, form the large circle, and other materials finish out the details. The piece won a blue ribbon, which thrilled Susan's two young children. "As far as they were concerned," she says, "I'd won the whole Show."

Pre-Columbian Necklace
LAURA DAVIDSON

Laura Davidson, who travels from near Syracuse, New York, to enter the Show, used mainly dried apple slices for this blue ribbon—winning necklace. She fashioned the chain by using a hole punch to create quarter-inch apple slices, and a smaller punch to make holes in those. Each circle of apple was painted, cut and glued together to form the chain. She experimented with various materials and paints, but decided that the combination of apple and gold spray paint best mimicked the molten gold of Aztec jewelry.

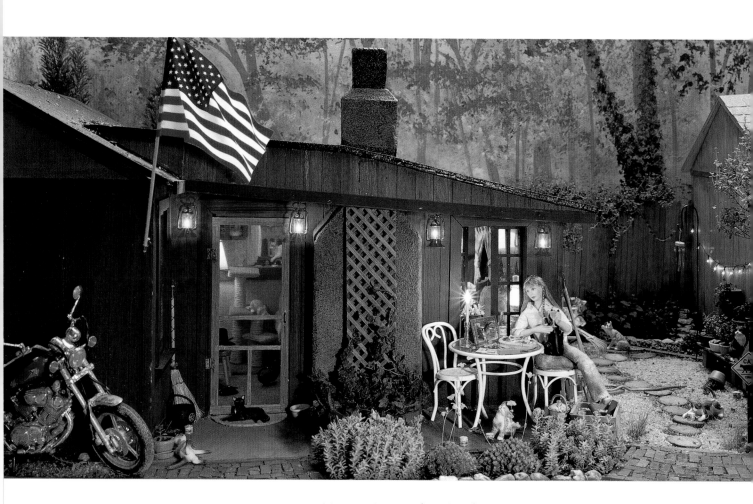

Miniature Setting: Chester's Wake

DEBORAH AND JAMES MACKIE

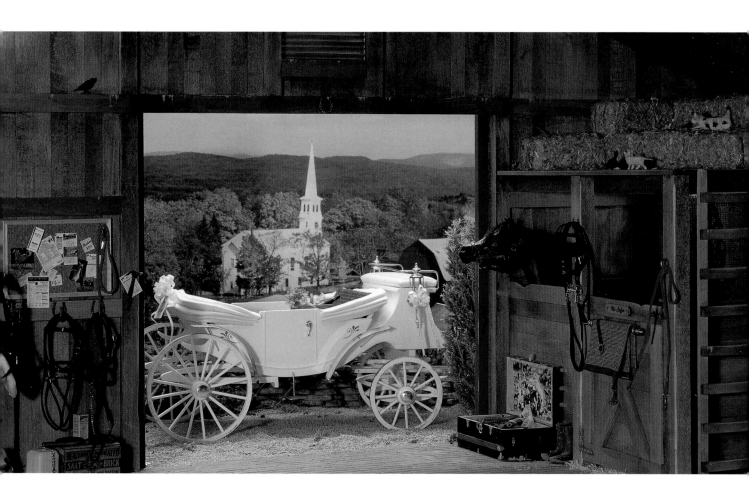

Miniature Setting: Samantha's Wedding

NANCY AND JOHN GRUBE

Art made from pressed plants can be intriguingly beautiful, but over time, if exposed to the light, the bright colors will fade to shades of brown and tan, the somber hues of all living things as they deteriorate to dust. Imagine if Van Gogh had painted his sunflowers in pigments that faded. Would it have stopped him? Undoubtedly not. As with many art forms, the painstaking process of creating pressed plant art rather than its everlasting appeal seems to be as much the point as the final result.

Besides two-dimensional works, the Show's pressed plant classes in recent years have included three-dimensional objects such as teapots, lampshades, mailboxes, *piñatas*, and masks. Entries submitted by mail from Japan, Taiwan, Australia, and Ukraine have enlivened the classes in recent years, according to Theresa Phillips. A long-time Show exhibitor, Theresa publishes a quarterly newsletter for pressed plant artists. In 2003 the painterly work of Liudmila Beletskaya, from Donetsk, Ukraine, won best of show in the pressed plant classes. Though trained as an artist, Liudmila worked for 20 years as a librarian, when she began pressing plants for herbarium specimens. She quickly saw the creative potential of this material, and experimented with different methods and techniques. Over time she began exhibiting and selling her pressed plant pictures, and then finally left the library to work full-time as an artist and teacher. She is among many artists (including Theresa Phillips and W. Eugene Burkhart Jr. whose work has won many awards at the

Pressed Plant Material

<< OPPOSITE PAGE

In the Courtyard: A courtyard garden scene with a fountain as a focal point
LIUDMILA BELETSKAYA

A variety of dried tree leaves are incorporated into this whimsical picture. The artist began creating pressed plant pictures in the 1980s, and now it is both her profession and passion. "I even see them in my dreams," she says.

Cinco De Mayo: Mass flower arrangement in earthenware pot or vase
LIUDMILA BELETSKAYA

*For this painterly picture Liudmila Beletskaya won a blue ribbon
and best in show. With no garden of her own, she collects plant
material in the forests, parks, and fields around her home in Donetsk,
one of the largest cities in Ukraine. With several other artists,
Liudmila runs a small school that teaches decorative floral arts,
including the art of pressed plants.*

El Sol: A mosaic sun design
W. EUGENE BURKHART JR.

W. Eugene Burkhart Jr. used pieces of primrose, rose, and pansy flowers, along with rose and poinsettia foliage, to create this mosaic. Like many award-winning exhibitors, Eugene is a proselytizer for his art, holding workshops and classes for people of all ages. In preparation for a series of workshops for the 525 students at the M.L. Lausch Elementary School in Reading, Pennsylvania (where he teaches), he pressed over 14,000 pieces of plant material.

Festival de las Flores:
 A design for a floral tapestry
CHUN-HUEI WU

The various materials used in this work by Chun-Huei Wu are reminiscent of the stained glass windows by Louis Comfort Tiffany. In fact, she got her inspiration for this blue ribbon–winning design from a honeymoon visit to a South American cathedral, where she stood transfixed by the sunlight streaming through the stained glass. A member of the Wonderful Oshibana Club in Taiwan, she is one of a number of international exhibitors who compete by mailing their work to the Show.

THE MAJOR

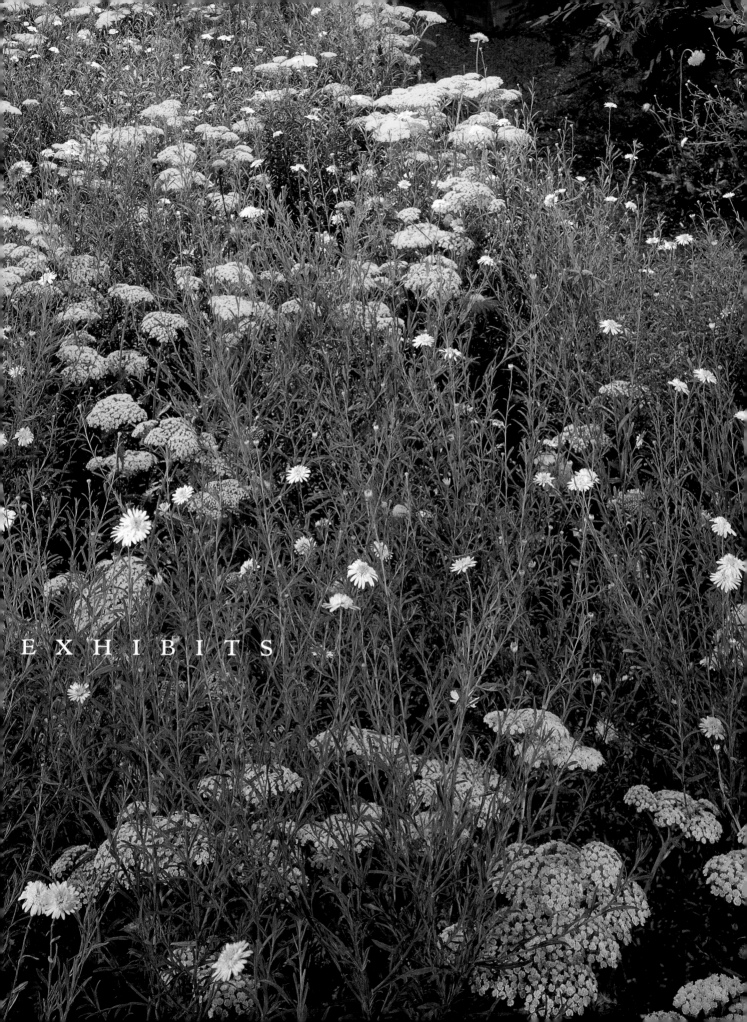

EXHIBITS

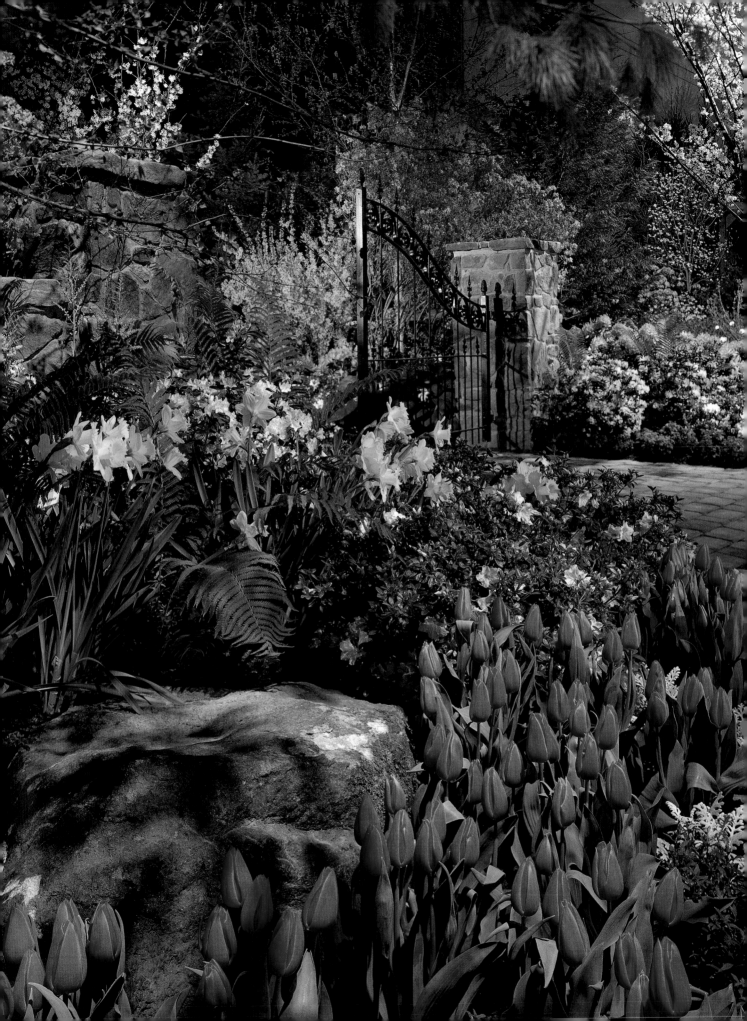

Starting with spaces ranging from several hundred to several thousand square feet, major exhibitors have less than 10 days—the hectic setup period—to execute plans that have been more than a year in the making. Outlined in chalk on the Pennsylvania Convention Center's bare concrete floor, 52 major exhibit spaces at the 2003 Show took up nearly 5 acres of display area.

The exhibits go up with all the swiftness and commotion of a military force establishing a base camp. Carpenters build gazebos and pergolas and entire small buildings, while craftsmen lay stone walls and patios that may incorporate ponds, waterfalls, fountains, or all three. Backhoes sculpt piles of composted sawdust that serve as the "soil" of many of these temporary gardens. Soon after, platoons of nursery workers bring in a fantastic array of plants, all forced out of dormancy into early leaf and bloom. Forklifts race across the floor, carrying pallets of stone or big burlapped trees in full flower. Heated tractor-trailers directly from Florida back up to the loading bays with thousands of dollars' worth of tropical plants, and pity the poor exhibitor (not to mention his shivering plants) whose tropical-themed exhibit might be adjacent to a wide-open 30-foot-high bay on a frigid late February day.

Teams of florists using tens of thousands of cut flowers construct colorful mosaics and towering arrangements dramatically lit in elaborate scenes, often accompanied by recorded music and other special theatrical effects. The end result of this frenzy

The Major Exhibits

<<OPPOSITE PAGE

Home Again: The Beginning
DANIEL G. KEPICH
& ASSOCIATES
1995

can be both realistic and surreal, a combination
of theater and horticulture that provides visitors
with a welcome blast of color and life that, for the
Philadelphia area, often marks the end of a long,
gray winter.

The largest major exhibit is the Central Feature,
which is the first thing visitors see after coming
through the main entrance. Based on the Show theme,
which changes every year, this important display
often includes a number of experienced nurseries and
florists, who are invited to work in collaboration with
the Show designer. Planning for a Central Feature
begins at least two and sometimes three years ahead,
and while it means extra work for an exhibitor, it is
considered an honor.

Other major exhibits are mounted by a variety
of entities—including plant societies, non-profit
institutions, for-profit companies, government
agencies, public utilities, and schools—but the
largest are those created by local florists and nurseries.
These competitiors vie for a wide range of trophies
and awards and accompanying cash prizes, which
supplement a Show subsidy based on the square
footage of their exhibit space. Many major exhibitors
consider the Show a part of their annual advertising
and promotion budget and say that it pays for itself in
terms of new business generated. Beyond that, in some
ways simply participating in the Show bestows an
unofficial "seal of approval" that gives these businesses
a level of credibility with potential clients that no
amount of advertising could provide.

<< PREVIOUS PAGE

Festival de las Flores
ROBERTSON'S
2003 CENTRAL FEATURE

*This re-creation of a street festival in Loiza,
Puerto Rico, was executed by Robertson's,
a floral design company, in conjunction with
the Show's designer, Ed Lindemann. Iris
Brown, a native of Loiza, was instrumental
in bringing the exhibit to life by connecting the
designers with the Puerto Rican communities
in Philadelphia's Norris Square neighborhood
and in her Caribbean home town.*

Knowing that the Show's proceeds help support the urban greening programs of the Pennyslvania Horticultural Society also motivates exhibitors, and a number of them end up playing major roles in the organization of both the Show and PHS. But it has to be more than just business or philanthropy that motivates them to take weeks or months out of their busy lives, year after year.

The thrill of creating something fresh and exciting out of nothing, quickly and with a definite deadline, is surely part of the attraction. Outside the Show, few if any of them have had the chance to have their work viewed by so many people in so short a time. Besides the boost this gives to any business, it also boosts the spirits of staff who have put so much overtime into the displays. No creative person—and all the major exhibitors are such people—can fail to get at least a little bit of a kick out of such concentrated attention.

After setup is done and the judging is over and the trophies and other awards are distributed, the main task is to maintain the exhibit—watering and replacing spent plants or flowers—so it looks good for the entire run of the Show. The Show flies by, with new exhibitors making new friends, and old-timers catching up with old friends, all of them becoming part of what one called "the Flower Show family."

For the nine-day run of the Show, the Convention Center is like Cinderella dressed up for the ball, but as soon as the Show closes on Sunday night, the fantasy is quickly stripped away. In less than three days—by a

4 P.M. Wednesday deadline—the so-called "tear-down" is complete, the cavernous hall emptied back down to the bare concrete floor, with hardly a single rose petal to serve as evidence that the Show ever happened at all. Like many a wondrous flower, the Show blooms only once a year.

Part science and part horticultural intuition, forcing plants into early bloom is what makes this late winter event a true flower show. Other features in the major exhibits can be cleverly faked or deceptively designed, but when it comes to the blossoming plants, nothing artificial is allowed. Forcing for the major exhibits is similar to the forcing done for entries in the horticulture classes. In both cases, the plants must be tricked into winter dormancy, roused out of sleep with warmth and light, and then either held back or hurried up to coax them to perfection on their day in front of the judging panels. The differences are partly those of scale. While a Horticourt exhibitor might mimic winter by popping a few pots of bulbs into a refrigerator or cold basement, the nurseries will stack hundreds or even thousands of pots into refrigerated trucks. The nursery displays can also include plants far larger than anything displayed in the Horticourt—including mature trees—forced by laying balled-and-burlapped specimens on their sides in heated greenhouses.

Aside from sheer numbers and size, the greenhouses of major exhibitors include sophisticated

A detail of J. Franklin Styer Nurseries' 1992 exhibit, "The Garden of the Ancient Walls", for which the nursery forced 300 rose bushes into early bloom.

systems beyond the means of all but the wealthiest or most determined horticulture competitors. To approximate a long spring day in the dead of winter, high-intensity lights are run for as long as 18 hours at a stretch. Studies have shown that carbon dioxide (CO_2) levels in the atmosphere increase during warm weather, so many growers also run CO_2 generators for several hours a day. Computerized watering and ventilation controls allow the soil to be kept constantly warm, by injecting it with warm water or using heating pads, while keeping the air temperature cool, which is ideal for growing stocky plants with flowers packed tightly on the stem.

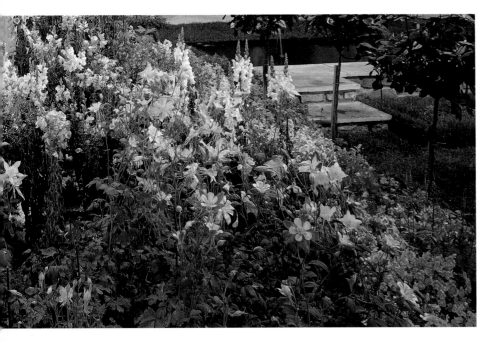

In the 1970s, the PHS executive director at the time, Ernesta Ballard, encouraged Charlie Gale, the late proprietor of Gale Nurseries, to force perennials for the Show. The profusion of flowers, shown above, is from the 1987 Gale exhibit.

The delphiniums, shown opposite, are from Gale's 1989 display. They required a year of pampering to bring them from seed into glorious bloom.

Many growers keep forcing log books which, over a period of years, can give a good indication of when to take certain steps with various plants. But even with historical knowledge and complex systems to control the greenhouse environment, one uncontrollable variable is the weather. The outdoor temperature and the amount of sunlight can dramatically speed up or slow down a plant's march toward bloom time. Most major exhibitors have several greenhouses that are kept

at different temperatures, so plants coming along too slowly can be hurried along in a warmer house, and those coming on too fast can be sent to a cooler house to chill out. Another variable is that plants sometimes fail to do what is expected of them. Growers might force as many as twice the number they need, since not all will bloom in time for the Show.

Most exhibitors are willing to share information with fellow competitors, but in the end, nothing counts like experience. Years ago nurseryman Robert Montgomery, eager to learn all the ins and outs of forcing, paid a visit to the operation of the late Charlie Gale, of Gale Nurseries. Charlie was one of the first Show exhibitors to perfect the art of forcing late-spring and summer-blooming perennials. He politely showed Rob around his operation, describing in detail all the equipment he would need. After the tour Rob said, "Great, Charlie, but how do you actually force?" Charlie smiled and said, "That's what I've spent the last 25 years learning, and that's what you've got to learn." Rob explains the moral to his story, "He was telling me that you can have all the right gadgets, but forcing is as much an art as it is a science."

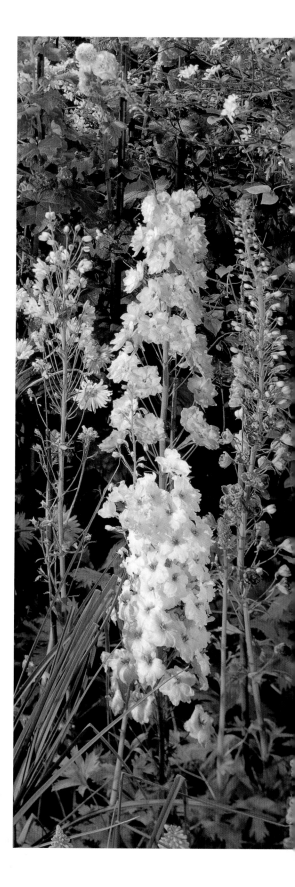

Workers of the Pine Barrens
JUDD'S HOLLYLAN NURSERIES
1986

New Jersey nurseryman William Judd
was one of a number of long-time
exhibitors who focused on naturalistic
scenes. This exhibit includes a beaver
pond surrounded by plant life
indigenous to the New Jersey Pine
Barrens, including ferns, birches, cedars
and several species of native orchids.

NEXT SPREAD >>

The Bartlett Tree
BARTLETT TREE EXPERTS
2003

A hollow trunk of an oversized tree, destroyed in a
forest fire, houses a walk-through exhibit about forest
regeneration. Designed and built for Bartlett Tree
Experts by Gale Nurseries in consultation with Kate
Bartlett, this 38-foot-diameter trunk reminded some
visitors of a volcano or a scene from J.R.R. Tolkien's
Lord of the Rings. The exhibit's 14 sections, created out

of polyurethane spray foam, were
pieced together during the Show
setup like a giant 3-D puzzle.

The plants are typical of the
palette that Gale Nurseries has
used in its exhibits over the years,
with the stately spires of delphinium
the highlight.

"You have mixed emotions at
the end of the Show," said Chuck
Gale, proprietor of Gale Nurseries.
"You're relieved, obviously, that it's
over. And it is sad, since you put a whole year into this
one week. But you're also reborn. You can begin a new
search, start thinking about what you want to do at
the Show next year."

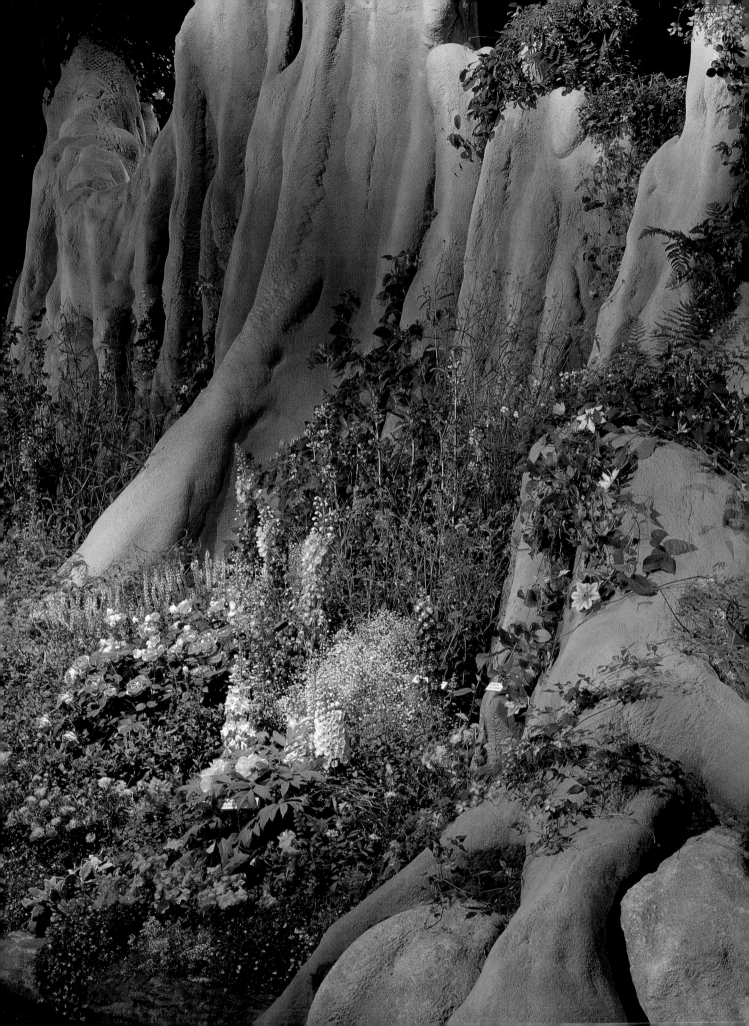

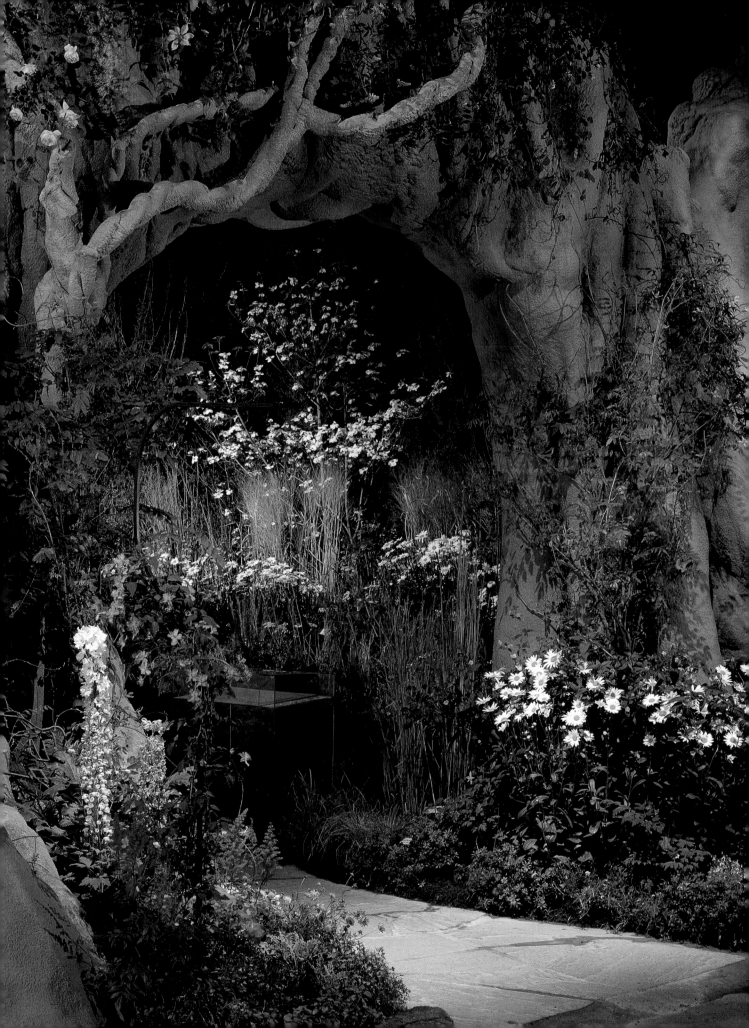

A Touch of America
VICK'S WILDGARDENS
1985

Albert F.W. Vick Jr.'s specialty for more than 60 years at the Show was creating naturalistic scenes using woodland plants. He remembers attending the Show as a boy in the 1920s, and he began helping his father install Show exhibits in 1930. After his father's untimely death, Al took over the business and exhibited at the Show for every year except one until 1993. Now age 87 and living in California, he still returns to the Show every year as a judge of the major exhibits.

A 1951 article in the *Philadelphia Evening Bulletin* expressed amazement that Vick's Wildgardens could install its display—which that year featured a pond, grist mill, and working water wheel—without using a plan.

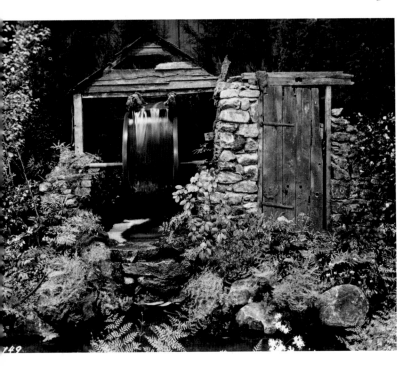

This woodland garden by Vick's was one of the most popular exhibits at the 1951 Show. They used a similar waterwheel in several other Show exhibits over the years.

"The plan was in our heads," says Al. "There's no way you can do a naturalistic garden and draw on a plan exactly where everything will go. We forced a bunch of plants, we brought them to the Show, and we arranged and designed it there. We knew what the big things were going to be, the background or the staging. That was done ahead of time. But the actual 'picture' was done right there."

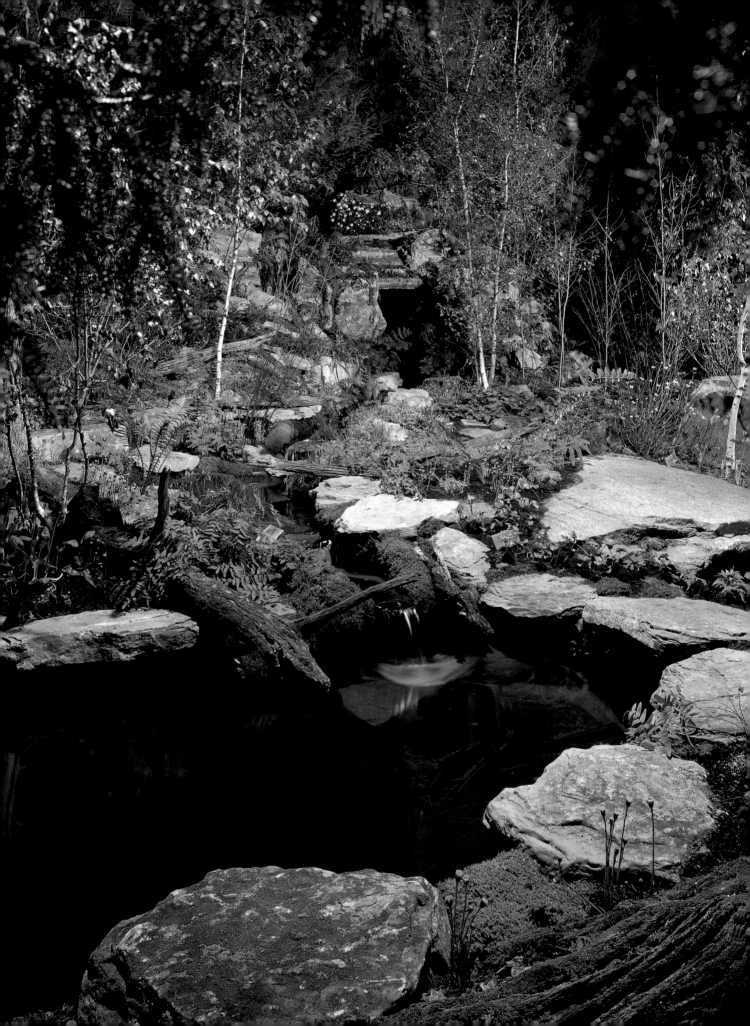

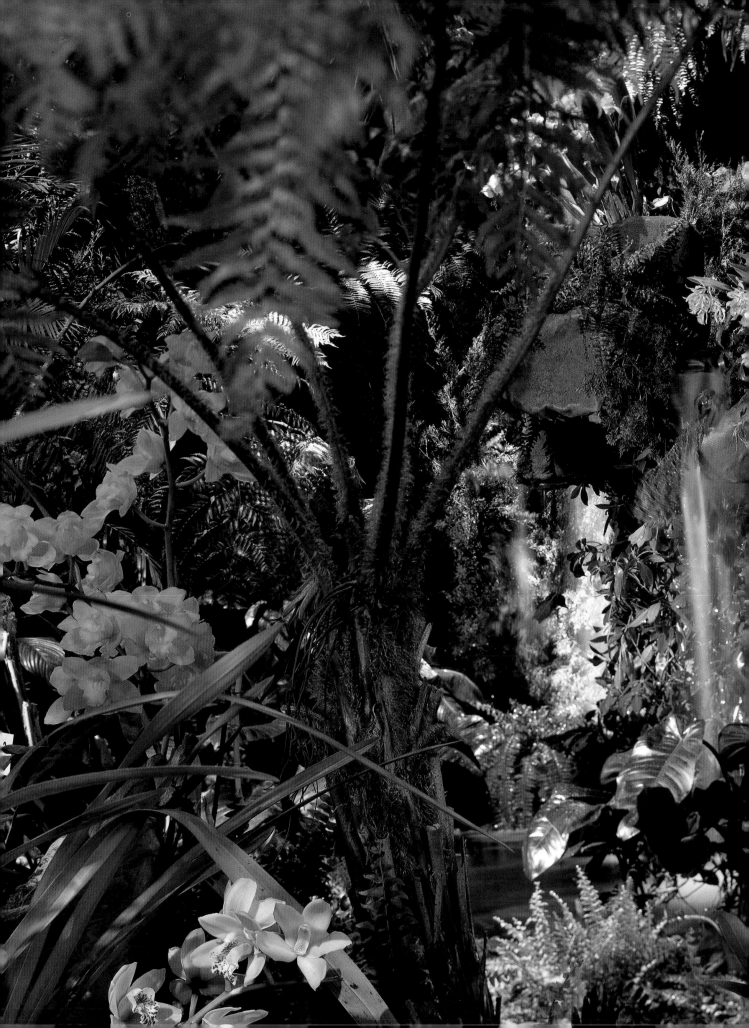

<< PREVIOUS SPREAD

On the Edge of Extinction
WALDOR ORCHIDS
1993

To create the backdrop for this double cascade, Waldor Orchids' proprietor Walter Off followed the method developed by his late father, George Off, who first exhibited orchids in the Show in the 1930s. Branches of yew and red cedar foliage, which have a mossy look, were woven through 4-inch square openings

in rusty wire panels. These panels were attached on top of scaffolding that had been draped with several layers of waterproof material, which caught any backsplashes from the cascade and channeled this water into the pool at the bottom. A general rule of thumb, which Walt learned through damp experience, is that the higher the waterfall, the bigger the pool needs to be to contain the splash.

The beautiful orchid-filled jungle scene was only half of this exhibit. In the display's dark side, out of this view, Walt created a rainforest "on the edge of extinction"—a slash-and-burn scenario that is far too common in various parts of the developing world. He parked a yellow front-end loader in the middle of a charred rainforest made by putting a torch to old logs and even to a few old, decrepit orchids. He scattered fireplace ash, collected from friends and neighbors, all over the forest floor. Not able to capture both halves of the scene in one shot, Show photographer Adam Laipson chose to accentuate the positive.

Metamorphosis: From Reality to Fantasy
ZOOLOGICAL SOCIETY OF
PHILADELPHIA
1989

The Philadelphia Zoo is one of a number of city non-profit organizations and governmental agencies that exhibit at the Show. The striped insect is a monarch caterpillar. This painted boardwalk winds a path through hundreds of forced perennials ending in a mirrored back drop to give the illusion of a long walk through a fantasy garden of butterflies.

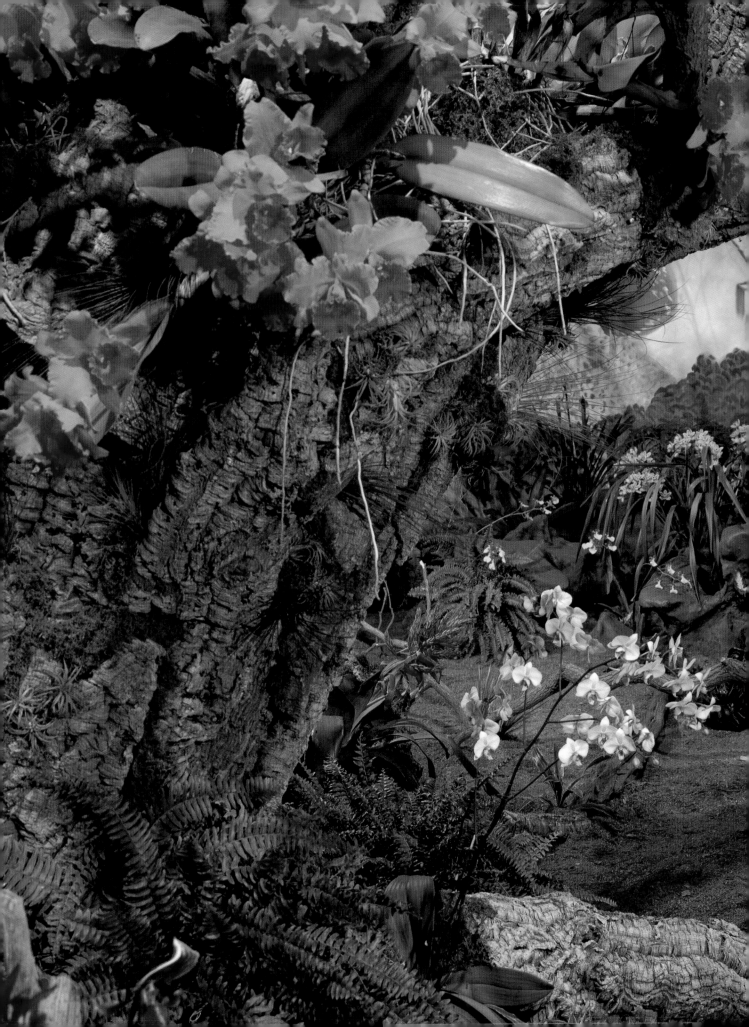

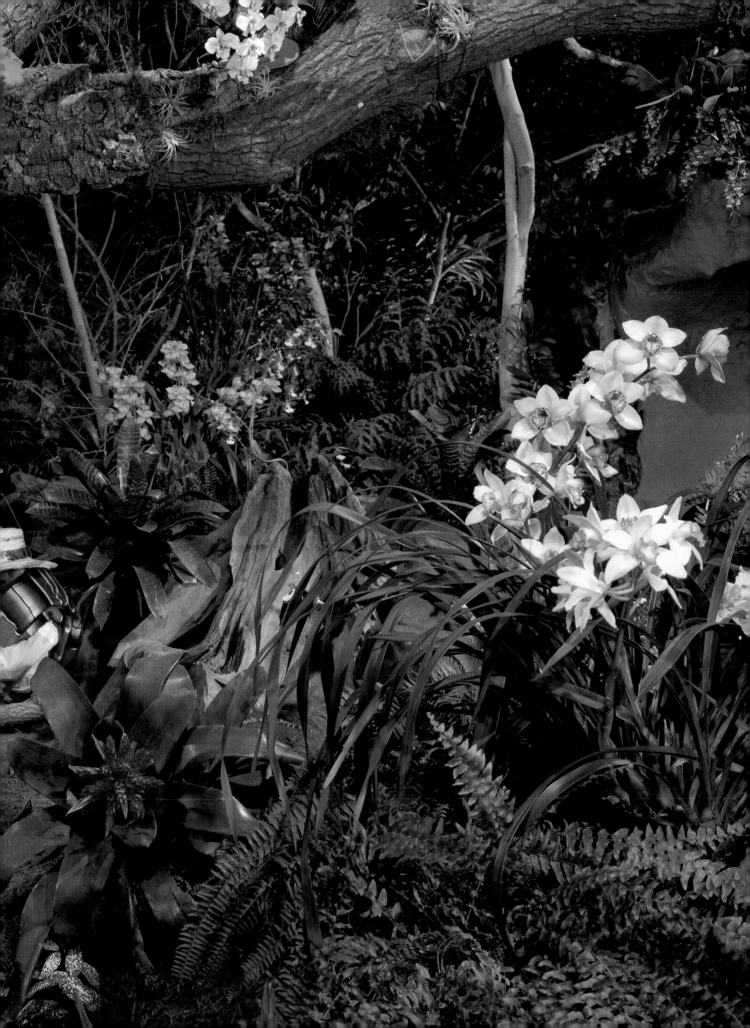

<< PREVIOUS SPREAD

Orchids Over Rio
WALDOR ORCHIDS
1987

The artificial tree in the front of this exhibit was made of cork wrapped around a circular wooden framework, with mosses used to cover the seams. Branches of more common trees and shrubs were attached to this cork trunk, orchid pots were hidden in the crotches of the branches or in pockets cut into the cork, and then the entire creation was dangled from the ceiling on a series of wires. One trick Waldor proprietor Walter Off learned from his father was to stage most of the orchids just above eye level, to keep visitors from looking up too high and seeing all the rigging that keeps this illusion from crashing to the floor.

The exhibit's backdrop mural creates another illusion, that of looking down a steep mountainside into the city of Rio de Janeiro, Brazil. The blue and tan in the background depicts the shoreline, and several buildings are also evident through the branches of the "tree."

Walk on Water
STONEY BANK NURSERIES
1996

The bridge for this exhibit is a classic example of false perspective. "Each board was cut wider to narrower so it would appear to be going to a vanishing point in the landscape," says Jack Blandy, president of Stoney Bank Nurseries and the exhibit's designer. He accentuated the apparent depth of the display by using coarser textures and large leaf sizes in the foreground, and finer textures farther back. Both of these techniques are useful for making small spaces appear larger, whether in a real garden or at the Show.

Water made up 60 percent of the exhibit, and Jack used a double liner to make sure it was completely leakproof. When doing a water feature at the Show, he makes sure that reflections from signs on the Convention Center walls are concealed from key viewpoints. "Otherwise," he says, "the tranquil waters might have a Convention Center exit sign glaring up at the observer."

On opening day that year, five women in high heels found the exhibit's bridge so convincing that they tried to walk across it. When the boards narrowed and they realized it was not meant to support traffic, they panicked and had to be talked down, back onto the solidity of the concrete Show floor. Breathless with the excitement of their near-disaster, they told Jack their motivation: "Your exhibit was titled 'Walk on Water,' and we've always wanted to know what that was like."

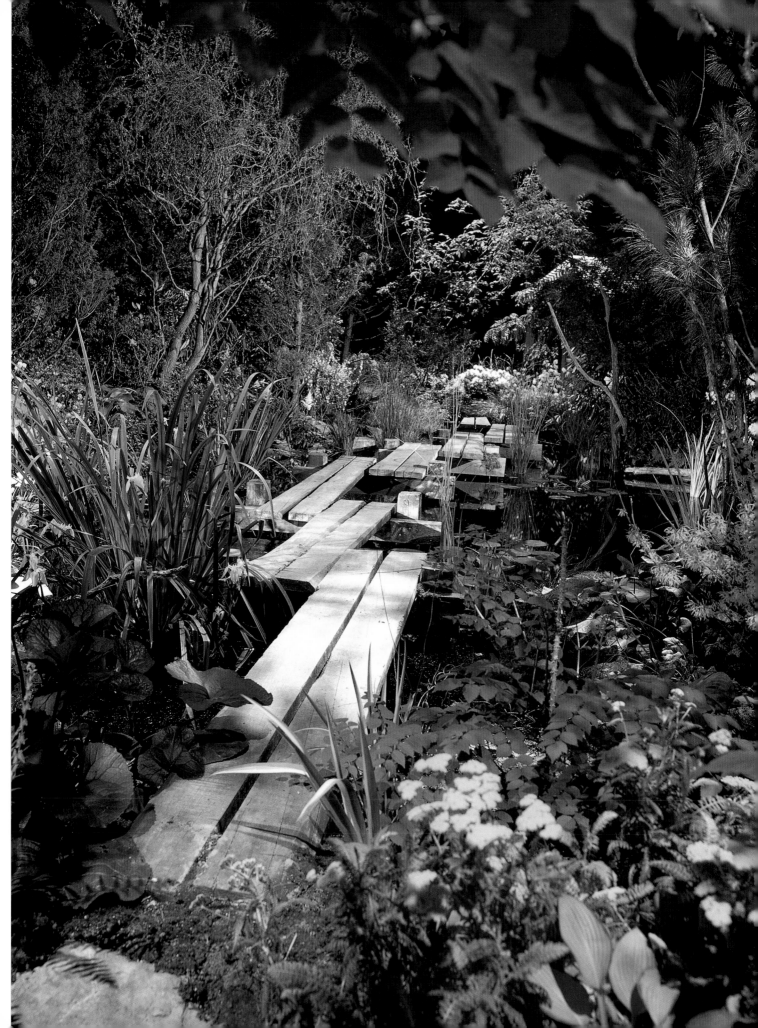

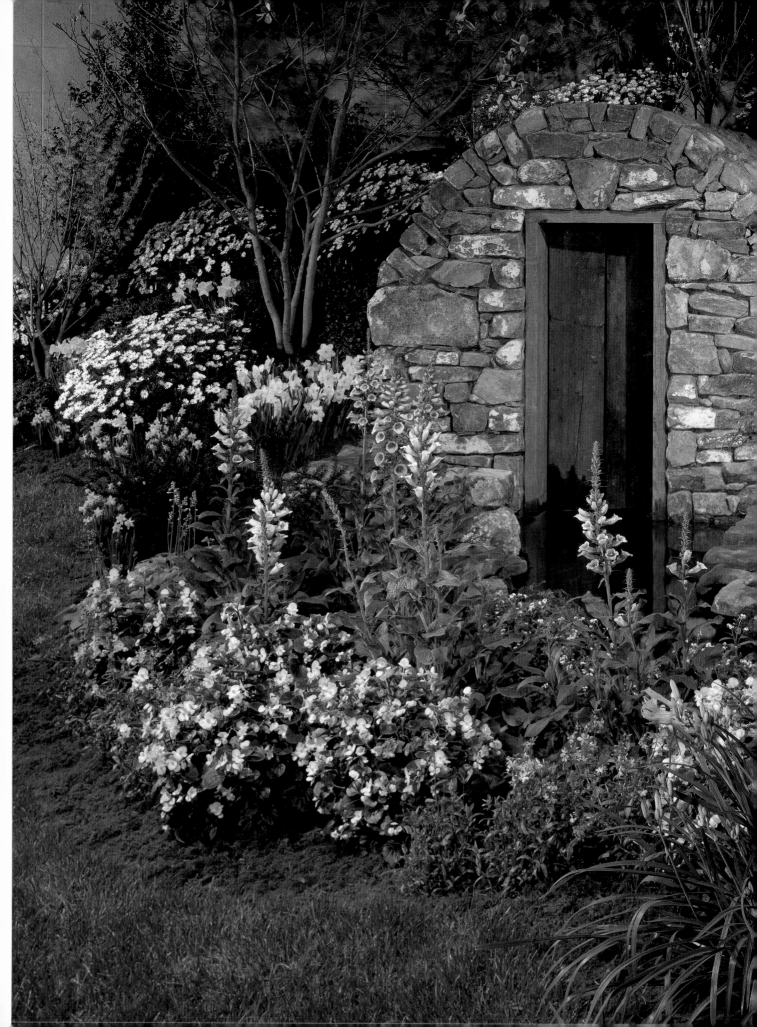

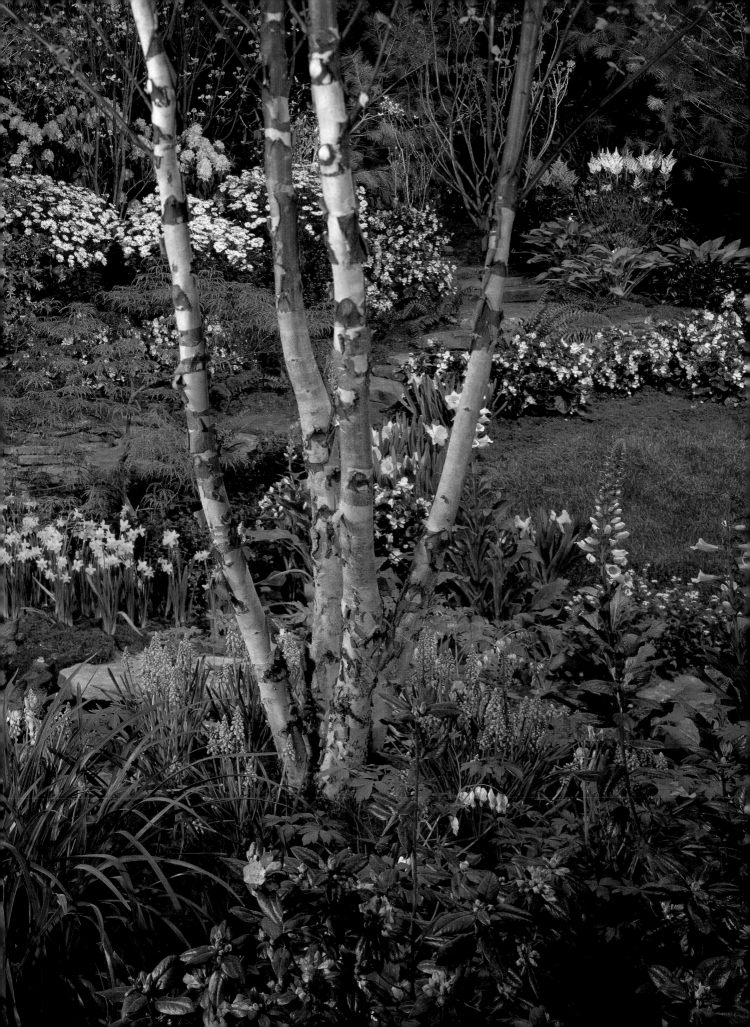

Over the River

1997

When it comes to exhibits at the Flower Show, the entire Lamsback family becomes involved in the frenzy. Bob and Karen run the floral decorating business, but their children, Brian and Christina, have grown up with the Show and now help with construction and maintenance, devise props, record background music, and even suggest ideas. One day in 1996, when Christina was 10 years old, she told her father, "You should do an exhibit called 'Over the River,' and you could make it a teddy bear's picnic."

A daughter's wish became the father's command, and while the three bears don't appear in this view, the river does, with a topiary rabbit crossing a flower-laden bridge and a deer waiting on the opposite side. The spray of yellow oncidium orchids in the distance is actually the top of a two-tiered umbrella of flowers that decorates one of the picnic tables.

For Bob Lamsback participating in the Show for the past 11 years has been a chance to create fantasy parties where the only client that counts is himself, or, in this case, his daughter.

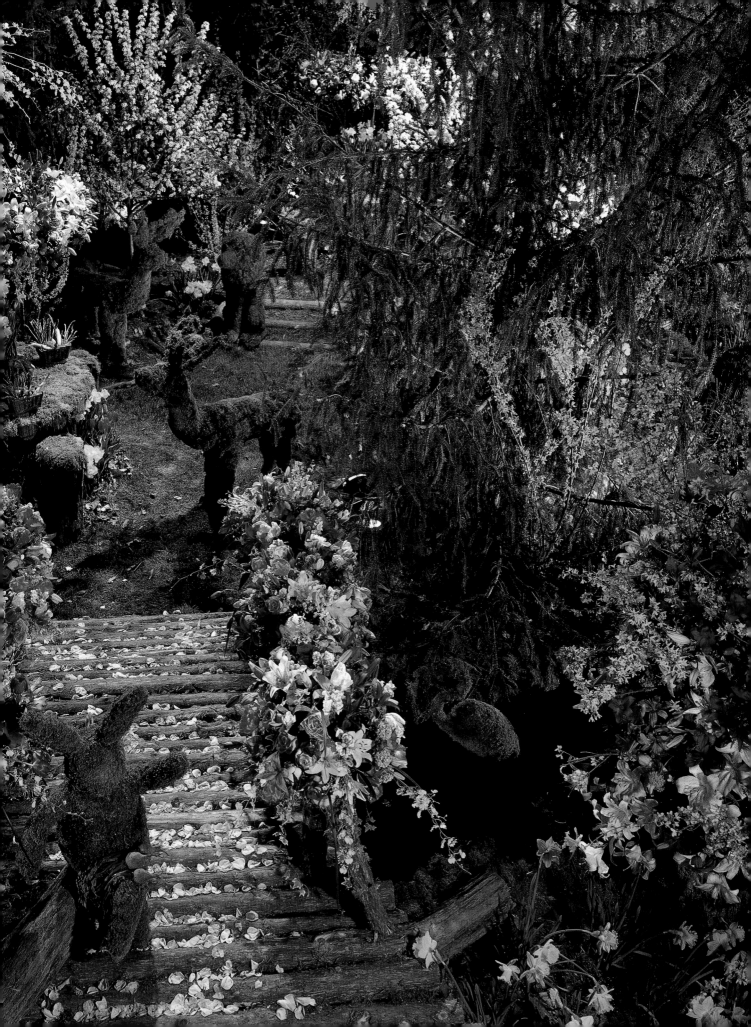

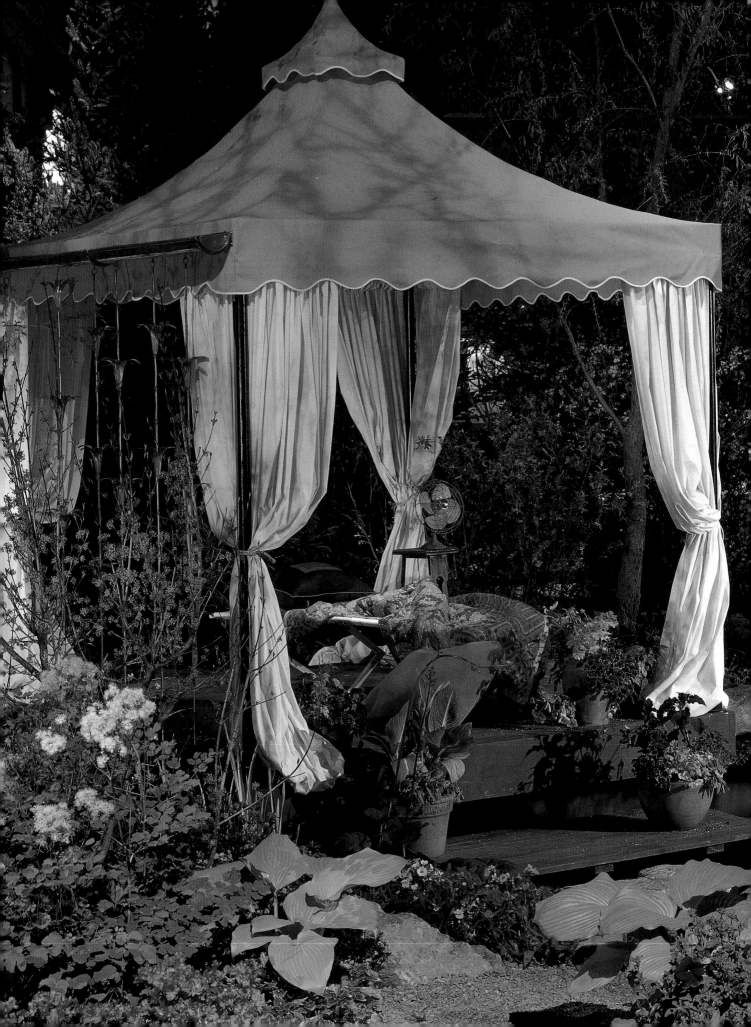

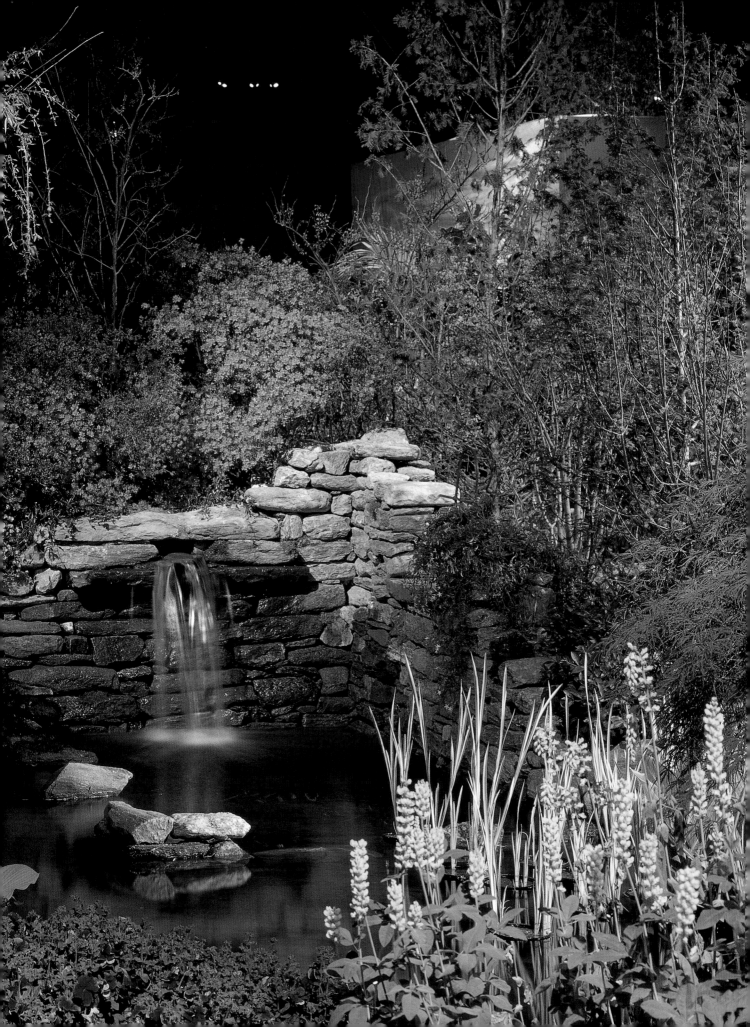

<< PREVIOUS SPREAD

The Journey Home
BURKE BROTHERS LANDSCAPE
CONTRACTORS
2003

Sometimes flower arrangers in the artistic classes of the Show order one color of flowers and get another, and depending on how late in the game it is, they sometimes just go with what they get. Something similar happened to Kevin and Sean Burke when the tent they ordered for this major exhibit came in a few shades too pink. With less than a week to go before opening day, they had to use it and managed to soften the color by bathing it in blue light. "We use lighting a lot at the Show, to try to achieve a certain mood," says Kevin. "It's not cheating—we're just trying to make the lighting of the Convention Center look real." They also projected branch-like shadows on the top of the tent to suggest overhanging trees.

The waterfall is made from Wissahickon schist, a local Pennsylvania stone, and the yellow flowers in the foreground are Carolina lupines. This attractive water feature was actually the first the Burkes attempted at the Show. The apparent change in depth toward the waterfall was made by leaving that spot in the dark and floodlighting the area closer to "shore." The pond liner is hidden under a layer of gravel, stones, and moss.

A Woodland Retreat
DANIEL G. KEPICH & ASSOCIATES
1994

Daniel G. Kepich first exhibited at the Show in 1986, when he created the display for the Pennsylvania Nurserymen's Association. The PNA is no longer part of the Show, but for years it served as a "feeder program," allowing new exhibitors to get a foot in the door and, if successful, to be invited back to do an exhibit on their own.

The large trees in this scene were actually cut specimens. To keep them upright, Dan and current exhibitors use what, in essence, are oversized Christmas tree stands. The trunk of the tree is inserted into a hollow pipe onto which long steel legs have been welded. The trunk is secured in the pipe with tightly wedged shims, and the whole stand is hidden under mulch. To provide added support for taller specimens, guy wires are often strung from the tree trunk to the ceiling. This works only with evergreen specimens which, like Christmas trees, will hold their needles for a time. For safety reasons, the cut trees must be treated with a fire-retardant spray before being put on display.

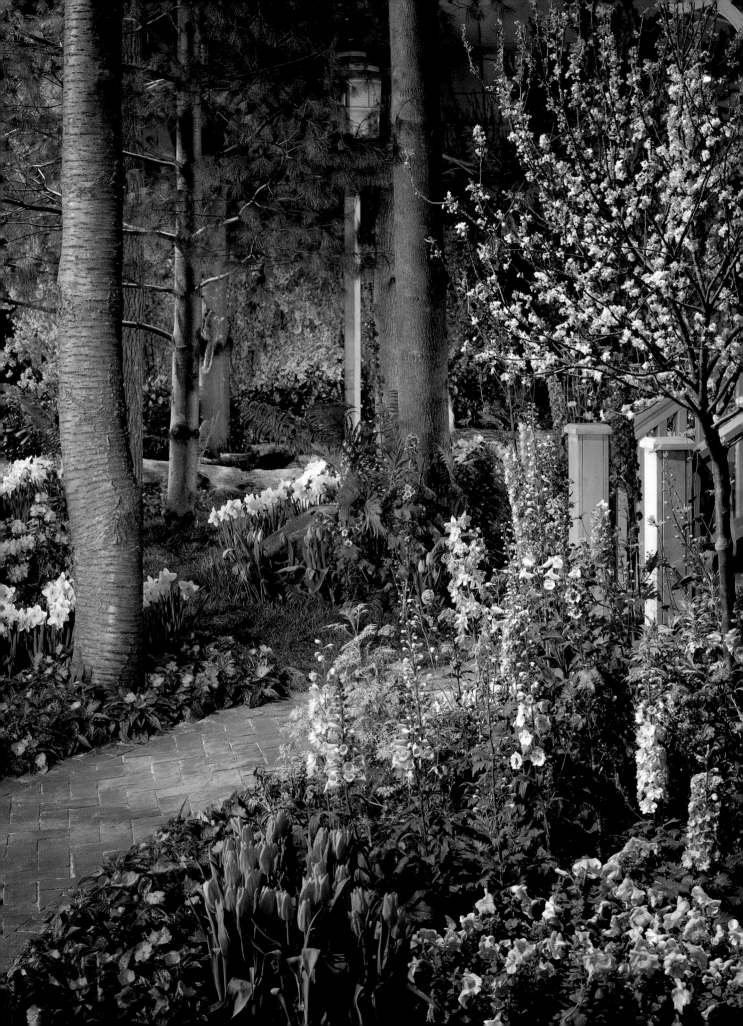

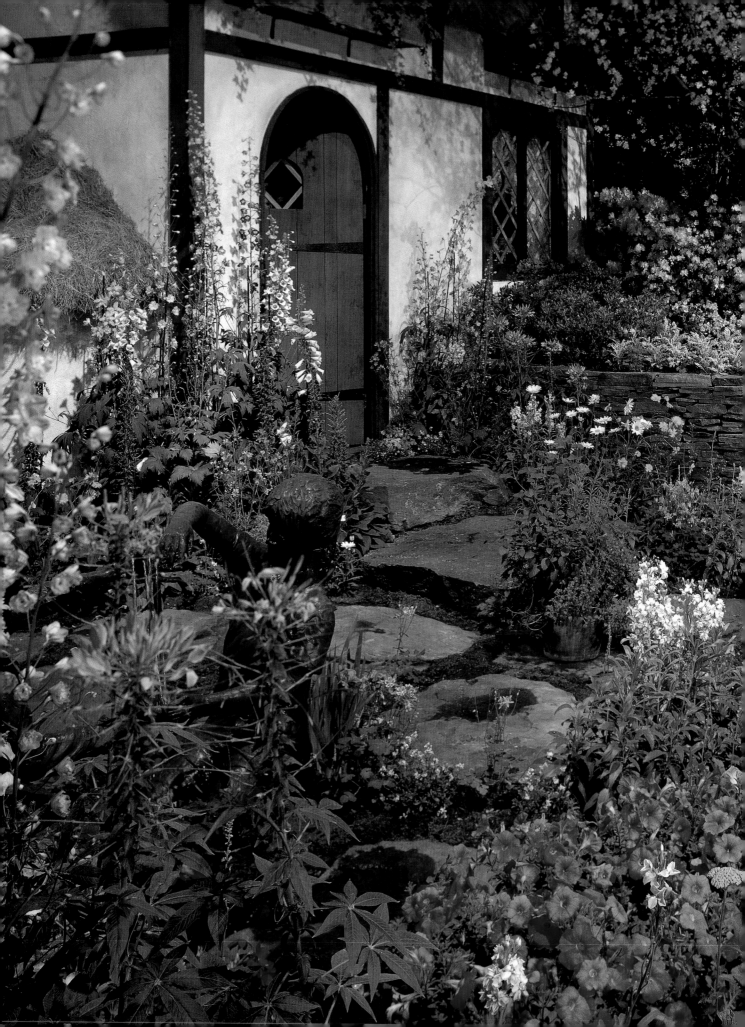

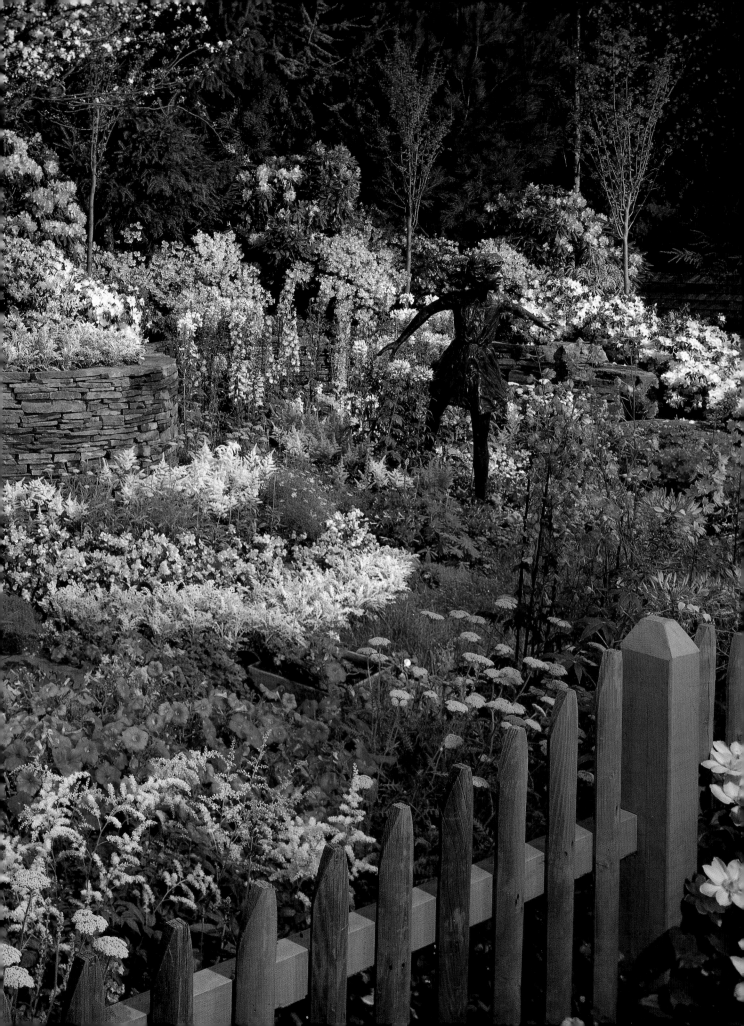

<< PREVIOUS SPREAD

Summers of Discovery
MCNAUGHTON'S NURSERIES
1992

As the exhibit designer for McNaughton's Nurseries in Cherry Hill, New Jersey, Harry Gamble always tried to come up with a story to wrap the garden around. The "discoveries" in this display are those

of a young woman who returns to her governess's country home where she spent many summers of her youth. There, she recalls the pleasant days frolicking in the garden, her memories represented by bronze sculptures created by Utah artist Dennis Smith.

The thatched roof cottage was built at the nursery and taken to the Show in two pieces. Harry supervised the forcing of all the plants, which he took as a point of pride and also one of control. "That way, it would be our success or our failure," he says.

One way Harry judged the success of his displays was to watch the crowds. If they slowed down or stopped, clogging traffic in the aisles at various viewpoints into the exhibit, he knew he had done his job well.

FOLLOWING SPREAD >>

Pickering Pond
MANSMANN/LISKEY LANDSCAPE CONTRACTORS
1994

Ian Mansmann and Ken Liskey, based in Chester Springs, Pennsylvania, modeled their romantic boathouse on Pickering Pond after a nearby property of the same name. The building protrudes over the water, which, as in many Show exhibits, is treated with black dye to make it more reflective and conceal the rubber liner at the bottom.

The two partners exhibited at the Show for 13 years, forcing all their plants in sometimes makeshift conditions, such as the time they coaxed a 15-foot rhododendron to bloom by placing it under a draping of plastic with a couple of space heaters. The Show, for them, was partly a family affair, with parents and siblings working alongside the company's full-time crew. "It would take two weeks to set it up and two whole days to tear it down," Ken Liskey recalls. "By that time, midway into March, as a landscape contractor you're supposed to be fresh as a daisy for the spring rush, and instead you're thinking, 'I need a vacation!'"

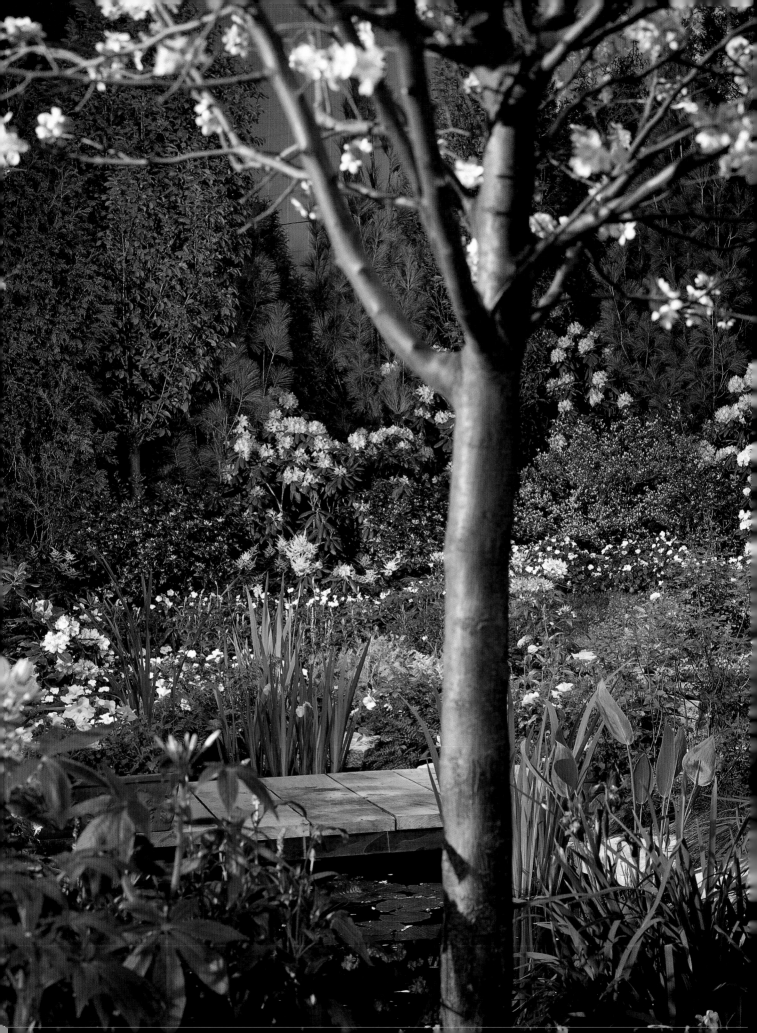

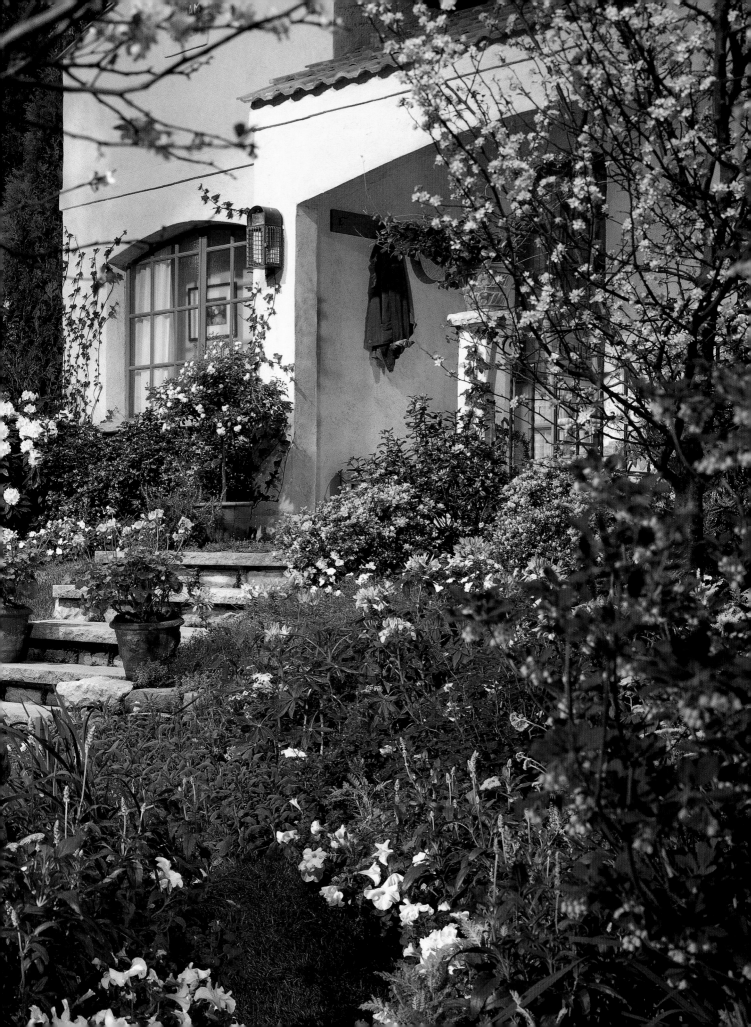

<< PREVIOUS SPREAD

Lá Malía—A Magical Memory
COLIBRARO LANDSCAPING & NURSERY
LAND DESIGN & CONSTRUCTION CO.
1995

For the three Colibraro brothers, creating this exhibit was a journey back to the place they were born—a farm their father called *Lá Malía*, in the Calabria region of Italy. The plantings are not indigenous to Italy, and they confess that the house is more Tuscan than Calabrian, but like many displays in the Show, it is more fantasy than reality.

The Colibraros forced all the plants used in this display, their first and only Show appearance, with expert guidance from Duane McCarthy of Land Design & Construction Co., a veteran exhibitor. They built the one-third of a house at the nursery, then dismantled and reassembled it at the Show, where the stucco was applied and roof tiles installed. After the Show the Colibraros salvaged pieces of the structure, with the idea of setting it up at the nursery. But they never did, because as an indoor display, it had not been built to withstand the outdoor elements. "Over time, it just went into the earth," says Michael Colibraro. "We gave it back to nature."

NEXT SPREAD >>

Simple Things
J. CUGLIOTTA LANDSCAPE/NURSERY
1996

Joe Cugliotta forces almost all of the plants for his Show exhibits, including the delphiniums here. He credits John Story of Meadowbrook Farm and Charlie Gale, the late proprietor of Gale Nurseries, with helping to teach him the art of forcing.

The structures in the background of this display were part of other exhibits, but they add to the small-town feeling of the scene, which was part of the theme of that year's Show, "This Land is Your Land."

Joe Cugliotta

When Joe Cugliotta bought a pickup truck and three lawnmowers shortly after graduating from La Salle University in 1972, he barely knew that such a thing as landscaping existed. But when customers began asking him to plant trees and flowers and do other tasks besides mow their lawns, he knew he had to somehow expand his knowledge into horticulture and design as well.

To that end he spent six years working for—and learning from—Tito Sasaki, a talented landscape architect. He then went back into business on his own, first doing "production landscaping" for builders of tract homes and finally, by 1982, focusing solely on residential work.

The year 1982 also marked the beginning of his involvement in the Philadelpha Flower Show, when he helped create the backdrop for a friend's floral display. When the friend dropped out of the Show after the following year, Joe jumped into the void. Show designer Ed Lindemann agreed to let him fill the space in 1984, and he has been part of the Show ever since.

Eager to continue learning even after 25 years in the field, Joe began taking courses at Longwood Gardens about five years ago, which he says have greatly expanded his plant palette and given him more confidence in his design choices.

"At first I did the Show mainly for business reasons," says Joe, whose company is based in Southampton, New Jersey. "But over the years, there's a camaraderie that I've developed with the other exhibitors. I've also developed a great relationship with the PHS people, and have a tremendous respect for the work they do through Philadelphia Green. While being in the Show has absolutely helped my business, at this point in my life I feel that it's a commitment, almost as if I'm part of a team."

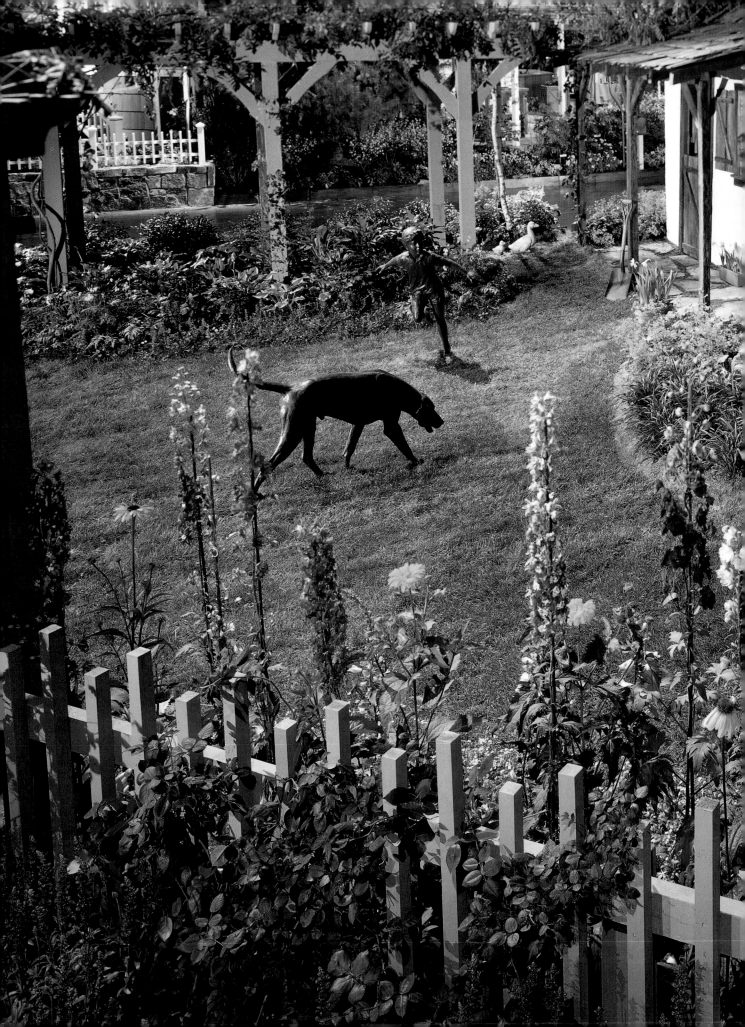

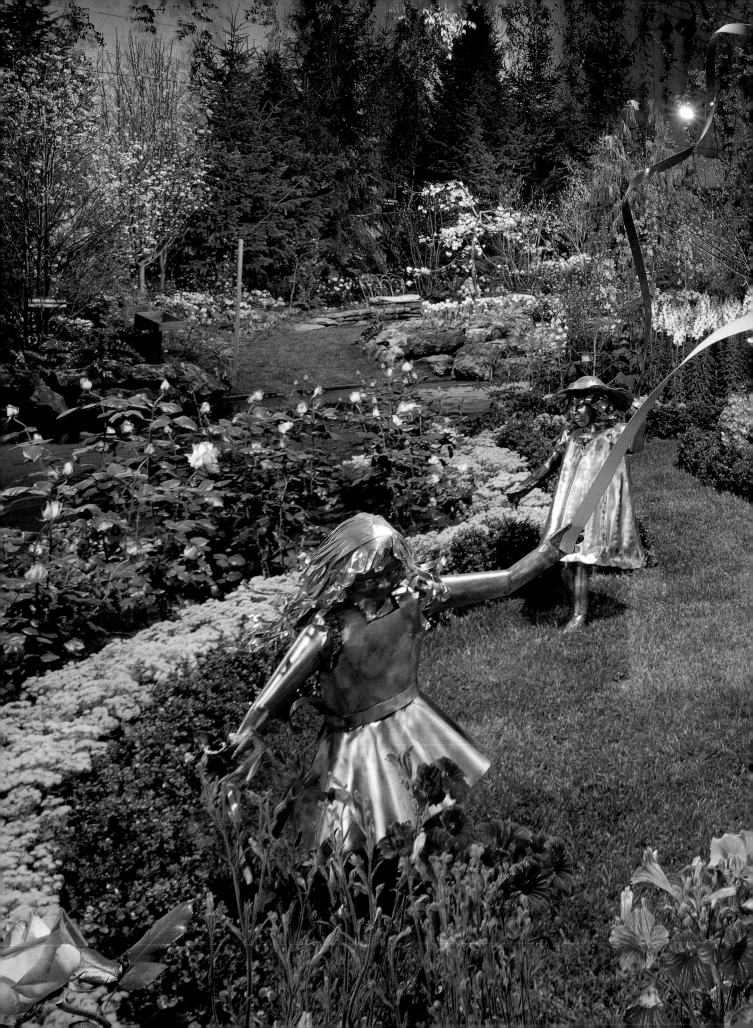

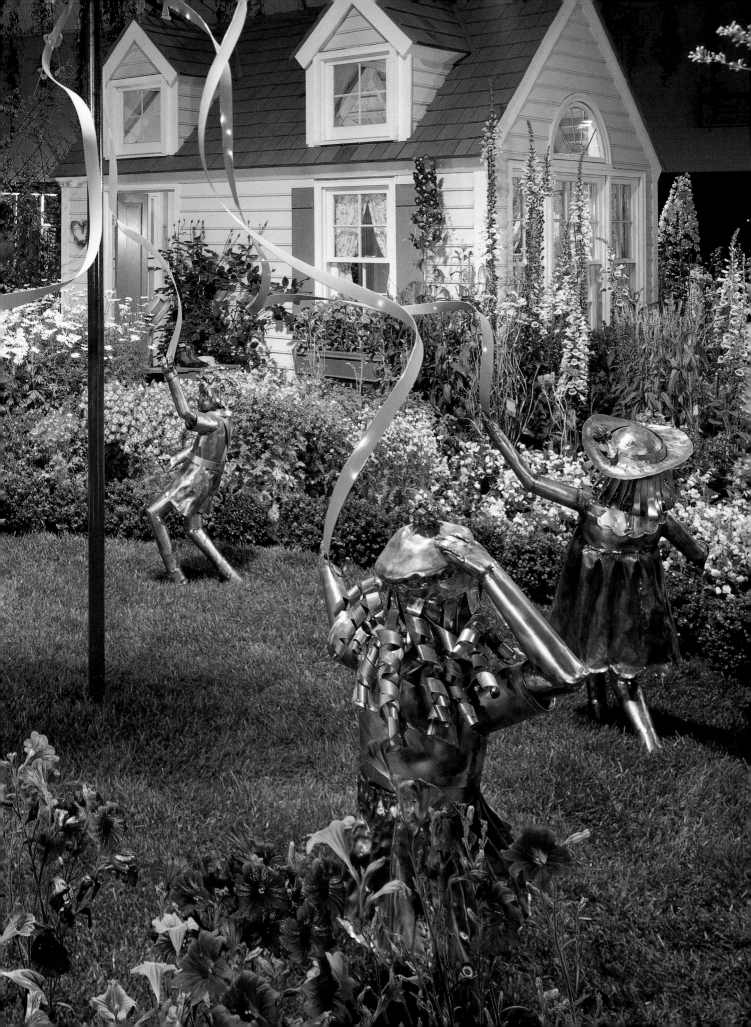

<< PREVIOUS SPREAD

Christine's Garden
GALE NURSERIES
1986

This exhibit's centerpiece was a playhouse that Chuck Gale designed for his daughter, Christine, then four years old. Chuck is the third in a line of Charles H. Gales to run the nursery, which his grandfather

started in the late 1920s. His late father, Charlie Gale III, was a fixture at the Show for many years, and one of the first exhibitors to force garden plants such as foxgloves and delphiniums. "My father didn't play golf and he didn't have a sailboat," Chuck recalls. "The Show was my father's hobby."

The sculptures of the children around the maypole are by artist Greg Leavitt, whose work has adorned many Show exhibits over the years. The playhouse still stands on Chuck's property, but Christine Gale doesn't play in it anymore. Now a college student, she is very interested in horticulture and plans to pursue a master's degree in landscape architecture and join the family business. Her father will be glad to have her. "She's very talented," he says.

NEXT SPREAD >>

Our Special Spring
EBERHARDT'S LANDSCAPE & DESIGN
AND ROMANO'S LANDSCAPING
1993

Mark Eberhardt worked on Flower Show exhibits for 12 years as
an employee, but in 1992 when he started his own business, Show
designer Ed Lindemann offered him his own exhibit. Mark was
hesitant at first. "I had the talent and the knowledge," he recalls,
"but I didn't have the means or the equipment." Not wanting to turn
down the opportunity for Show exposure, he assembled a team to
tackle the project. He enlisted his friend Ed Slevin to help with the
design and construction of the exhibit. Ed's employers, Mike and
Nick Romano of Romano's Landscaping in Berwyn, Pennsylvania,
provided a space to do the prefabrication work, the trucks needed to
tranport materials to and from the Show, and the extra labor needed
to pull it off. For the finishing touches, Elizabeth Schumacher of
Garden Accents loaned a number of sculptures and ornaments, as
she has done for many exhibitors over the years, in exchange for
credit in Mark's Show brochure.

For help with the most crucial part of the exhibit—the plants—
Mark turned to his mentor Herbert Bieberfeld, who gave him
use of a greenhouse for only the cost of the heat that winter. The
teacher also gave his eager student invaluable advice and assistance
throughout that fall and winter, and in subsequent years, Mark
went on to produce three other successful exhibits.

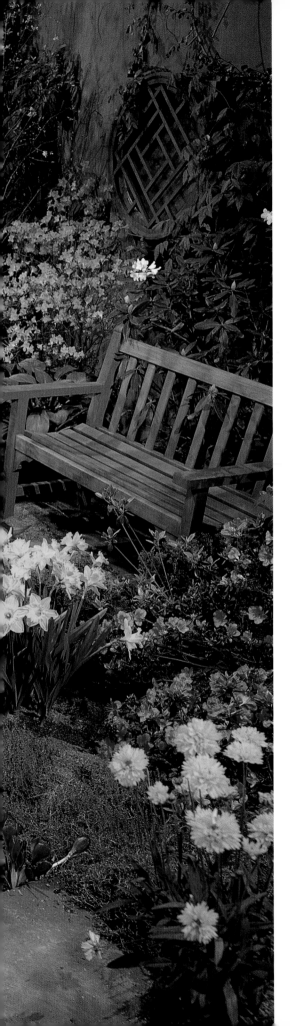

Nature's Retreat
STONEY BANK NURSERIES
1990

While Stoney Bank Nurseries has
done many large exhibits over the
years, including the Central Feature
in 1999, this was an example of how to
make effective use of a small space. The
designer, Jack Blandy, used flagstone
that was larger in the front than the
back; the teak bench in back is smaller
than the one on the side; and the white
flowers in the rear draw the eye into
the distance—tricks that make a small
space appear larger. Separating the old
flagstone with wide gaps filled with
moss also helped make this new garden
appear old and established.

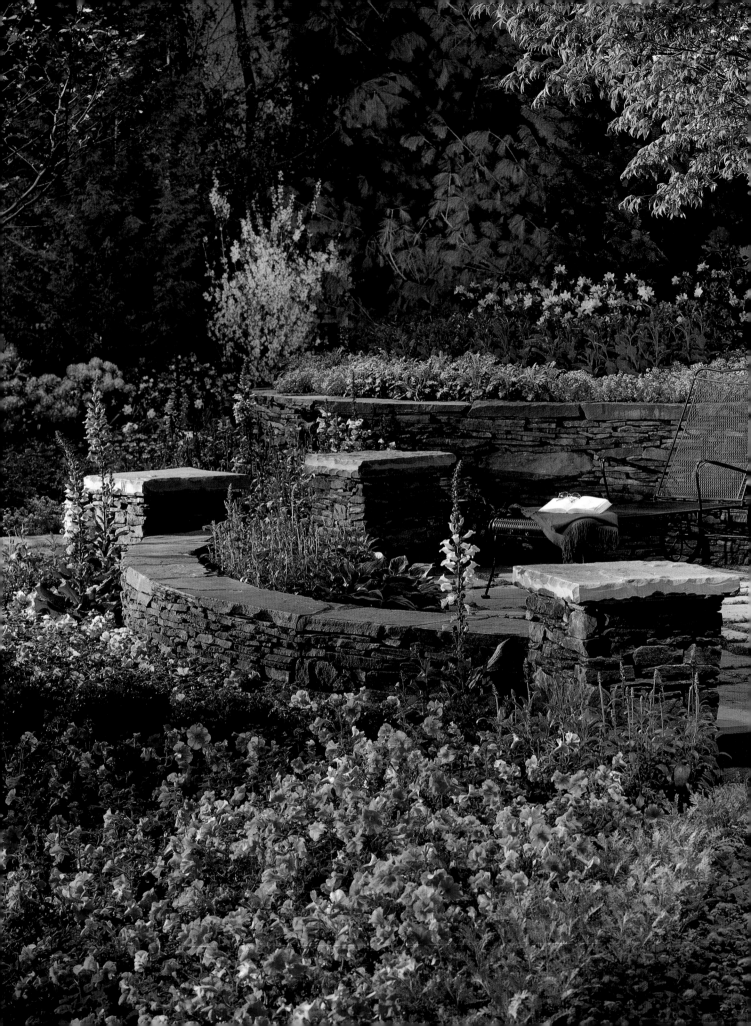

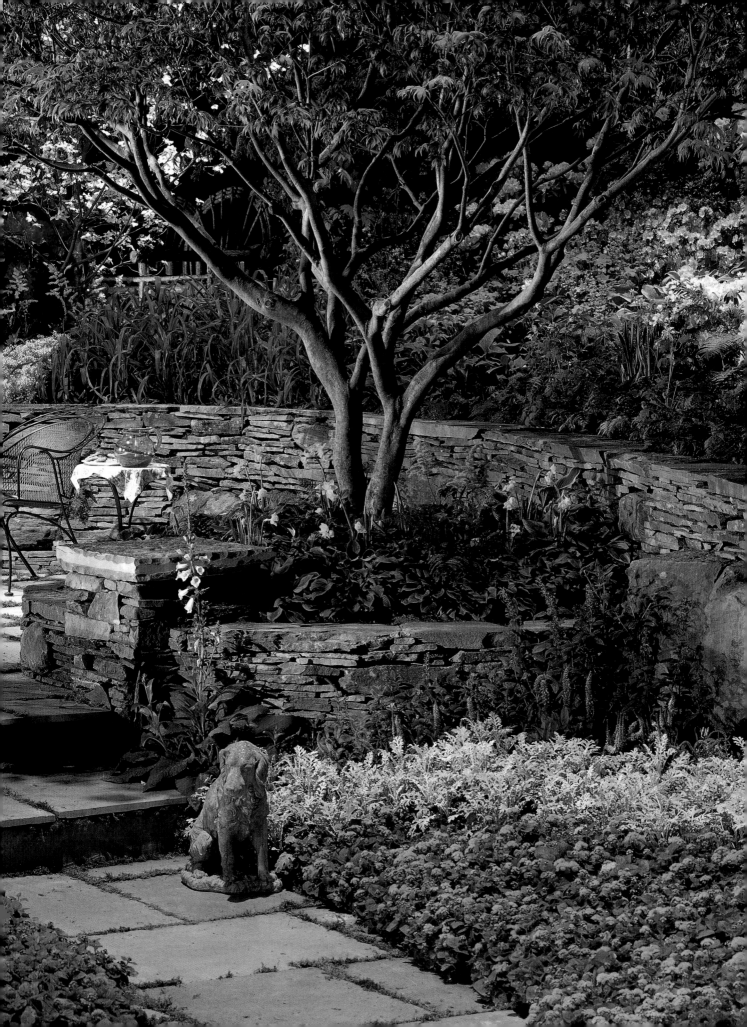

<< PREVIOUS SPREAD

Rustic Retreat

J. CUGLIOTTA LANDSCAPE/NURSERY

1995

The sloping hillside to the upper right in this exhibit was created out of hay bales and rounded off by a mulch of sawdust into which plants were inserted. The dry-laid wall is capped with bluestone, and

moss is used as chinking between the bluestone patio pavers. All of this stone was salvaged after the Show, even the mortared piers, which were constructed at the nursery before the Show and, afterward, installed in a customer's garden.

As in many exhibits, the flowers represent a couple of different seasons and would never bloom at the same time in the real world. "Sometimes people come up to me at the Show and say, 'I want a garden just like this,'" Joe says. "I tell them right off, 'This is not reality here, folks—this is for your enjoyment. You can have this, but you can't have it all at the same time.'"

Michael Petrie of J. Franklin Styer Nurseries knows how to play up the theatrical side of the Show. It wasn't always that way. As is evident from the photograph on pages 198–199, for many years Petrie and the Styer's staff produced Show displays that exemplified the real-world work done by the company.

The chance to break that mold came in 1994. When Show designer Ed Lindemann, was faced with an empty space on the floor after another exhibitor pulled out, Ed asked if Styer's could fill it. "We were already doing another exhibit for the 1995 Show," Michael recalls, "so this second one had to be simple." The solution was called "Potbound", in which two tractor-trailer loads of terra-cotta pots and a small hill of broken pot shards were stacked up and strewn about and hung from the ceiling in a wild garden scene.

The attention this exhibit got from both Showgoers and the media made Petrie realize that such crazy creations had at least as much promotional value for the nursery as anything real, and they were lots more fun to produce. Subsequent Styer's exhibits have included "Styer's Tyres" in 1997, which featured a tractor-trailer load of tires, the largest of which was 10 feet high; "Tooleries" in 1998, with its whirlwind of 500 long-handled tools painted in fluorescent colors; and most recently, "Squash Blocks" (2003), which used compressed bales of waste paper and aluminum cans, borrowed from a local recycling business, as sculptural elements in a lush garden setting.

Michael attended both the Philadelphia College of Art and Pennsylvania Academy of Fine Arts and after college he worked as a bar manager, an arborist, and finally got a job watering plants at Rose Valley Nursery in 1980. He was

immediately recruited to help with that nursery's Show exhibit, and in 1987 he joined the team at Styer's.

Coming up with wild ideas isn't a problem for Michael. "I have a million ideas," he says. "The hard part is figuring out how to create them in the real world. Can I pull it off?" For many visitors who attend the Show year after year, part of the excitement is coming upon the Styer's exhibit and seeing what outrageous idea Michael Petrie has managed to pull off this time.

Potbound
J. FRANKLIN STYER NURSERIES
1995

FOLLOWING SPREAD >>

Everyman's Garden
J. FRANKLIN STYER NURSERIES
1990

This exhibit is a classic example of what was done at the Show by J. Franklin Styer Nurseries before designer Michael Petrie was allowed to let his uncanny imagination go off into places where no exhibitor had gone before. It epitomizes what Michael calls "the patio age," when the ruling idea was, "We have to show people at the Show what we do."

That said, this is a beautiful example of a practical garden, with a bi-level patio and a water feature that runs from one level down to the other. While Michael has more lately become a fan of incorporating fake rocks and other faux features into his Show designs, real boulders were used in this exhibit. Very heavy and difficult to maneuver, they were, in his words, "real pains in the butt."

<< PREVIOUS SPREAD

Backyard Barbecue

J. CUGLIOTTA LANDSCAPE/NURSERY

1986

As inviting as this pool looks, divers beware: It is only a foot deep, a display model that Joe Cugliotta borrowed from an in-ground pool salesman. A

plywood platform, built to hug the pool's kidney-shaped contours, serves as the base for the mortared stones of the deck. The garage provides an added stroke of realism, but Joe can take no credit for this structure, as it belonged to the neighboring display of another nursery, Waterloo Gardens.

Whenever he designs a Show exhibit, Joe tries to figure out the perfect vantage point from which most visitors will see it. He then tries to create a frame for this "million-dollar" view, provided in this display by an unusual black pine. He first saw this tree several years before, growing in the shade of a roadside hedgerow and reaching sideways for the light. "I approached the owner and asked if I could have the tree," Joe remembers. "He looked at me and said, 'Can you mow that field?'" A deal was struck: The field was mowed, and the tree was removed and used in the Show. About 20 years old, with a 14-inch diameter trunk, it was hung from the ceiling on two sturdy wires.

NEXT SPREAD >>

Inside Out
HIGHMEADOW GARDENS
1989

Designed by Tom Borkowski, this exhibit blurred the lines between indoors and outdoors. "It was a study in color and space as much as a garden," says Tom, now owner of his own design-build company, Spruce Hill Design. "I didn't want to make it too literal, because it's

a show, and if you start getting too real it can get to be kitsch."

The still water was as reflective as a mirror, and the placement of the wicker furniture maximized that effect. The pillar that appeared to be floating on the water had no bottom support, and was simply hung from the beam above. The flowers in the lower right were the biennial larkspur, seedlings of which Tom dug from a friend's community garden in November and forced with the rest of the plants. Behind the floating post was one of several regal geraniums in the display. These plants failed to sell as Mother's Day gifts the previous year and languished in one of the nursery's greenhouses until they were rediscovered and revived for the Show.

Wayne Norton, then-owner of Highmeadow, consulted on the design and helped supervise the installation. Now an instructor in horticulture at the Williamson Free School of Mechanical Trades in Media, Pennsylvania, he also designs the school's annual Show exhibit.

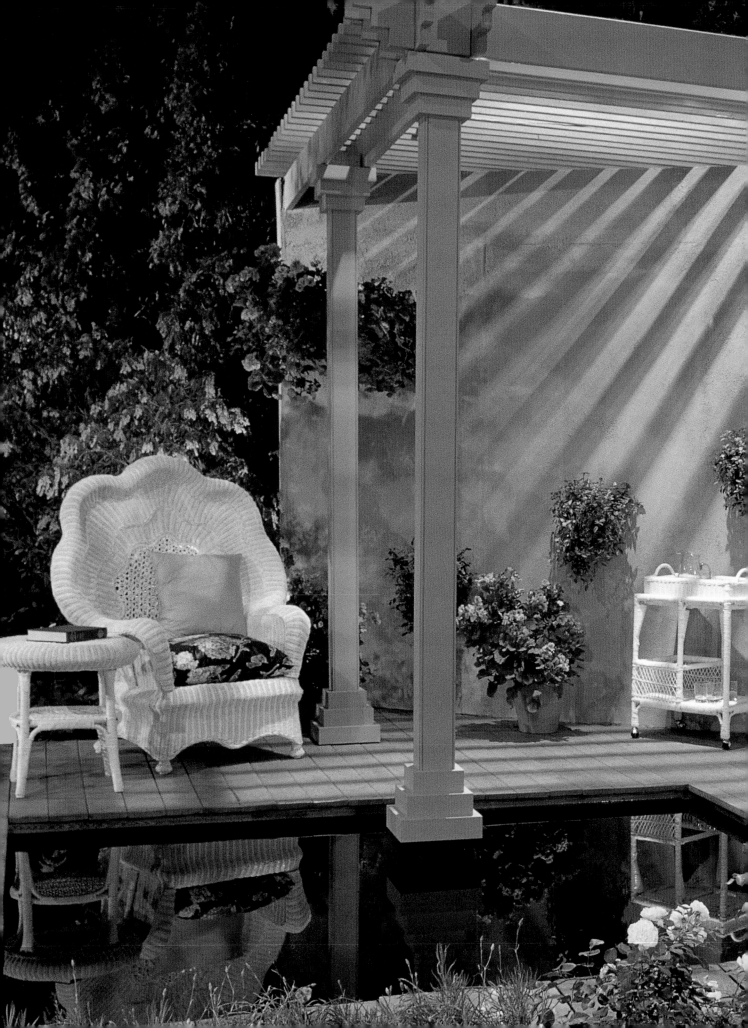

Jamaican Tranquility
ROBERTSON'S
1994

The house in this lush tropical setting
is modeled after a similar building the
Robertson family of florists once owned
in Jamaica. The fish-motif gingerbread
was carved by members of the company's
staff. The table, set for dinner, was one
of several set out in front of the house.
Like many of the major exhibitors,
Robertson's uses the Show as a major
vehicle for advertising. "We always try
to do some kind of garden party, so we
can showcase our flower arrangements,"
says Bruce Robertson Jr.

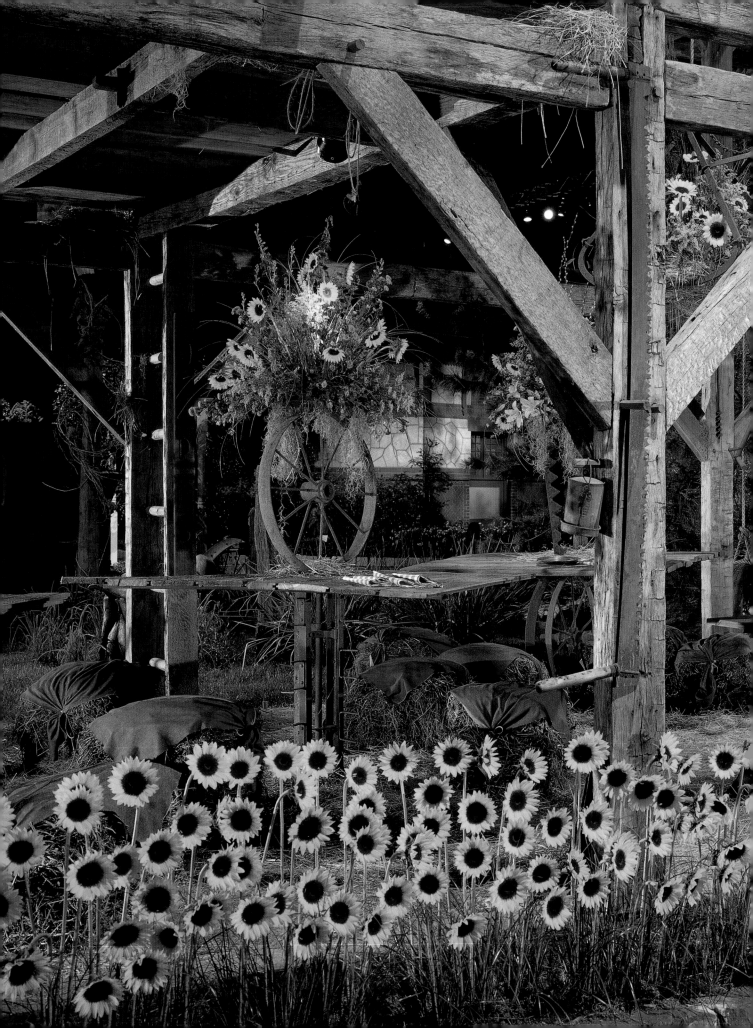

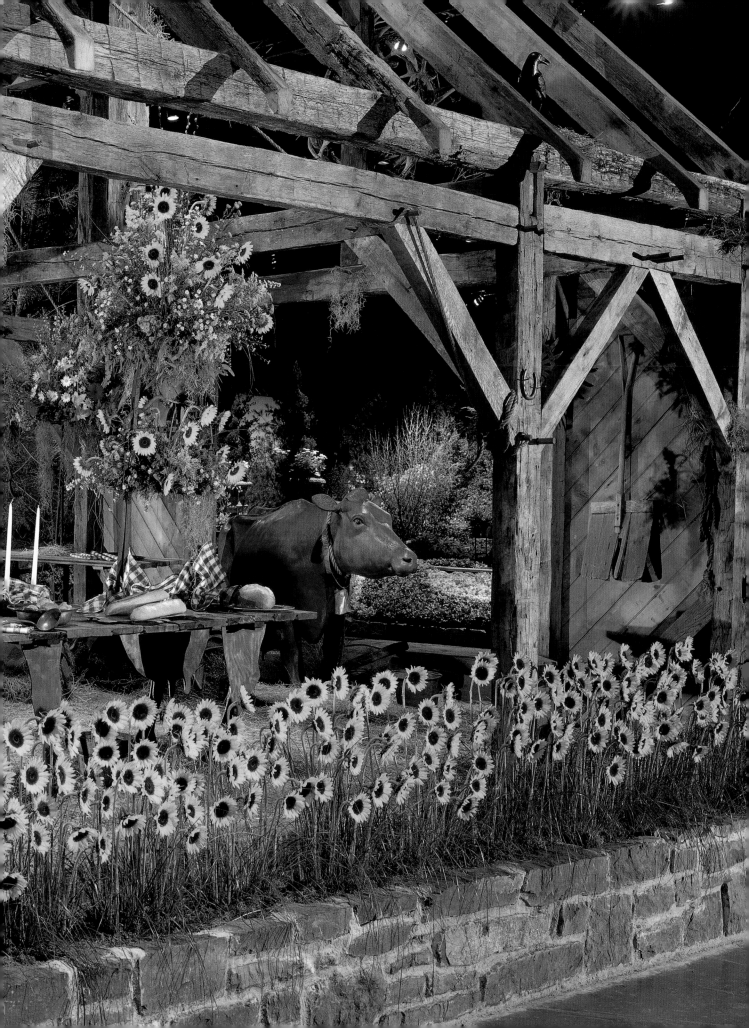

<< PREVIOUS SPREAD

Ei Ei O
ROBERTSON'S
1996

This farm scene by Robertson's was staged under the pegged frame of an authentic Lancaster County, Pennsylvania, barn, raised at the Show by a team of 10 Amish carpenters. Many visitors were surprised to learn that the sunflowers were not live plants, but cut stems stuck in water-retentive floral foam. "All our exhibits are filled with little details, so even if you walk around it five times you'll see something different each time," says Bruce Robertson Jr., part of the fourth generation of the family to run the business. Denim-covered hay bales provide seating at rustic tables. The life-size cow was among a barnyard of farm animals by Delaware sculptor Andre Harvey.

The wrought-iron table bases (one in the shape of a cow, complete with udders), as well as several of the stands for the arrangements, were forged by Bruce Robertson Sr., an accomplished amateur blacksmith as well as a retired florist.

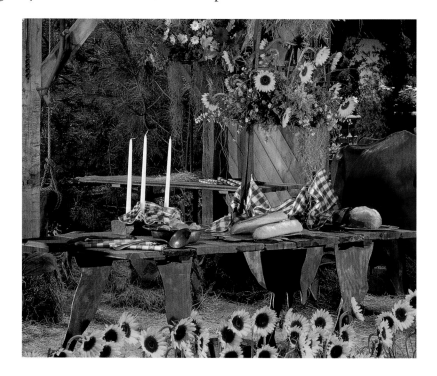

NEXT SPREAD >>

Garden with Pool
ROBERT W. MONTGOMERY LANDSCAPE NURSERY
1987

This intimate poolside scene, one of the smallest of Rob
Montgomery's 13 Flower Show exhibits between 1983 and 1996,
was also one of his favorites. Everything in it is real—from the
poolhouse to the wall (made of cinderblock with stone facing) to

the 25-foot swimming pool and the working spa behind it. After
the Show the poolhouse was recycled into the nursery's information
center, and the arbor was sold, but the rest was costly to remove.
"This exhibit taught us that we had to learn faux if we wanted to
make the exhibit bigger," Rob says. "Faux is quicker, faster, lighter,
and cheaper."

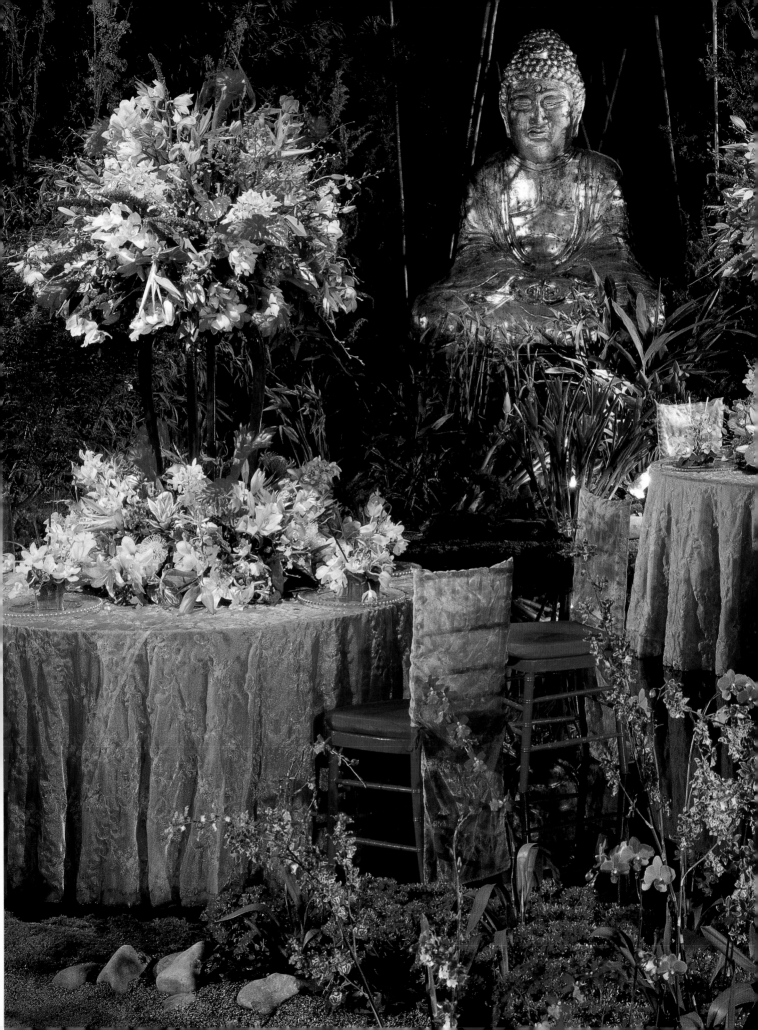

The Pennsylvania Bonsai Society

is one of a number of local and national plant societies that produce educational exhibits for the Show. Each year, the trees are displayed in a darkened room, with each specimen spotlighted in its own niche and framed by a circular "moon gate," allowing it to be viewed without distraction.

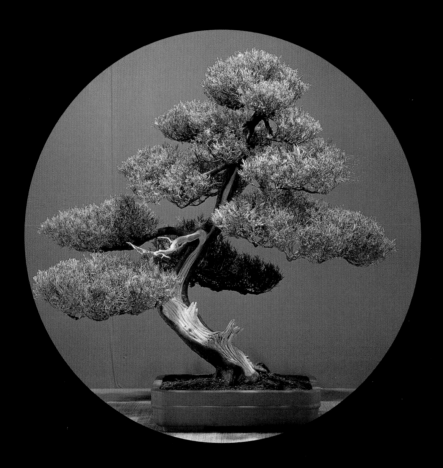

Blue Hetz Juniper (Juniperus chinensis
 'Hetzii Glauca')
PENNSYLVANIA BONSAI SOCIETY
AGE: 30 YEARS; TRAINING: 20 YEARS
ARTIST: ROGER LEHMAN
2003

Dwarf Hinoki Cypress
 (Chamaecyparis obtusa 'Nana')
PENNSYLVANIA BONSAI SOCIETY
AGE: 25 YEARS; TRAINING: 15 YEARS
ARTIST: JIM RILEY
2003

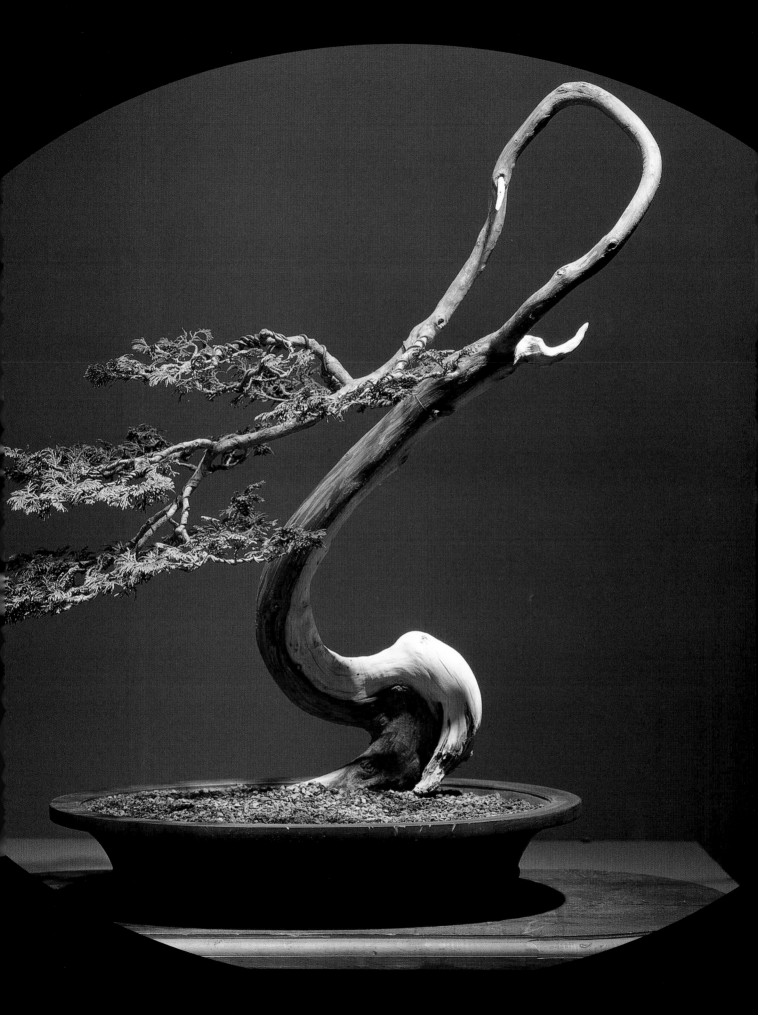

Flowers for the Seasons
JAMIE ROTHSTEIN
1989

This arrrangement for summer was one of four oversized arrangements created by Jamie Rothstein, a Philadelphia florist, for her first major exhibit at the Show. She has been a part of every

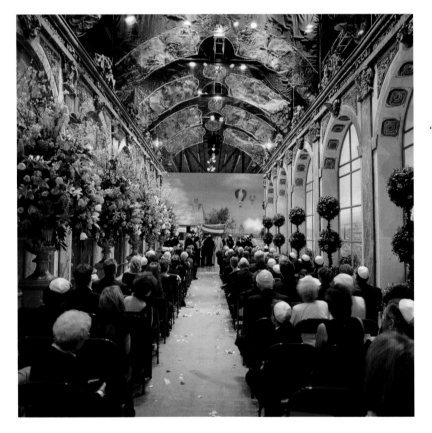

Show since, and her more recent displays have become fantastically elaborate, incorporating tens of thousands of cut flowers into both formal and whimsical scenes. "The Show is my vehicle for expressing myself," she says, "and doing something I don't normally do in my business."

At a Philadelphia Flower Show in the 1920s, Charles Baxter, a local florist, exhibited wedding flowers by staging an actual ceremony, complete with bride and groom and all attendants. When the ceremony began, everyone in the hall surged toward the display, creating a dangerous crowd-control situation. No other weddings were ever attempted during the Show's open hours. However, in 1998, Jamie Rothstein and Bill "Buzzy" Rosenberg, who has worked on Show public relations, were married one night after the Show was closed to the public. The ceremony took place in front of 300 guests in Jamie's Show exhibit, a recreation of the Hall of Mirrors at Versailles. The next year, on her way to the Show setup, Jamie went into labor and soon after gave birth to her first child, Joy.

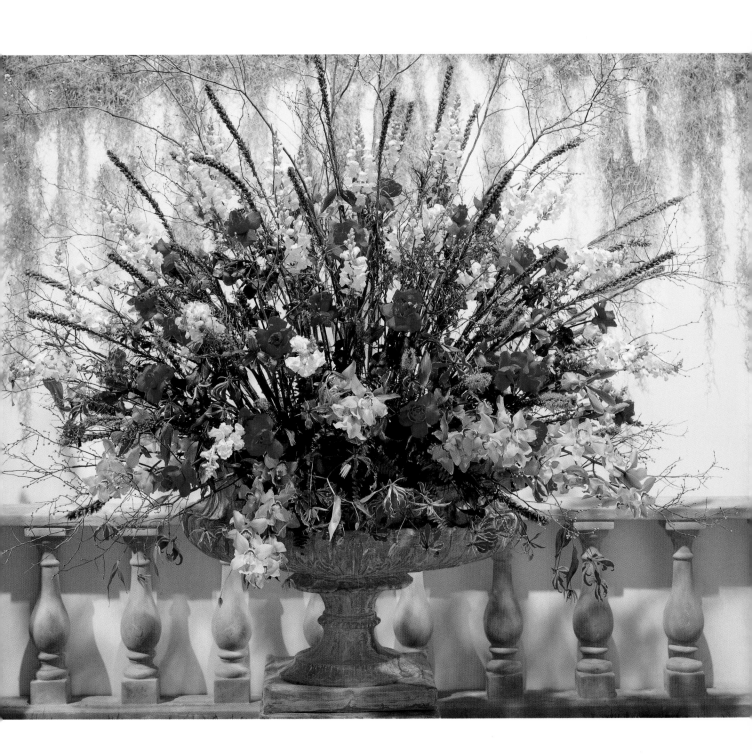

Garden Colonnade
MCNAUGHTON'S NURSERIES
1997

The wisteria on this colonnade is only partly what it seems to be. The large trunks are actually dead vines with their butt ends stuck in the mulch at the base of the columns. The horizontal beams atop the columns appear solid, but are actually U-shaped troughs made of planks. Many separate wisteria plants, placed in strategic points along the troughs and tucked around the bases of the columns, give the appearance of a living vine.

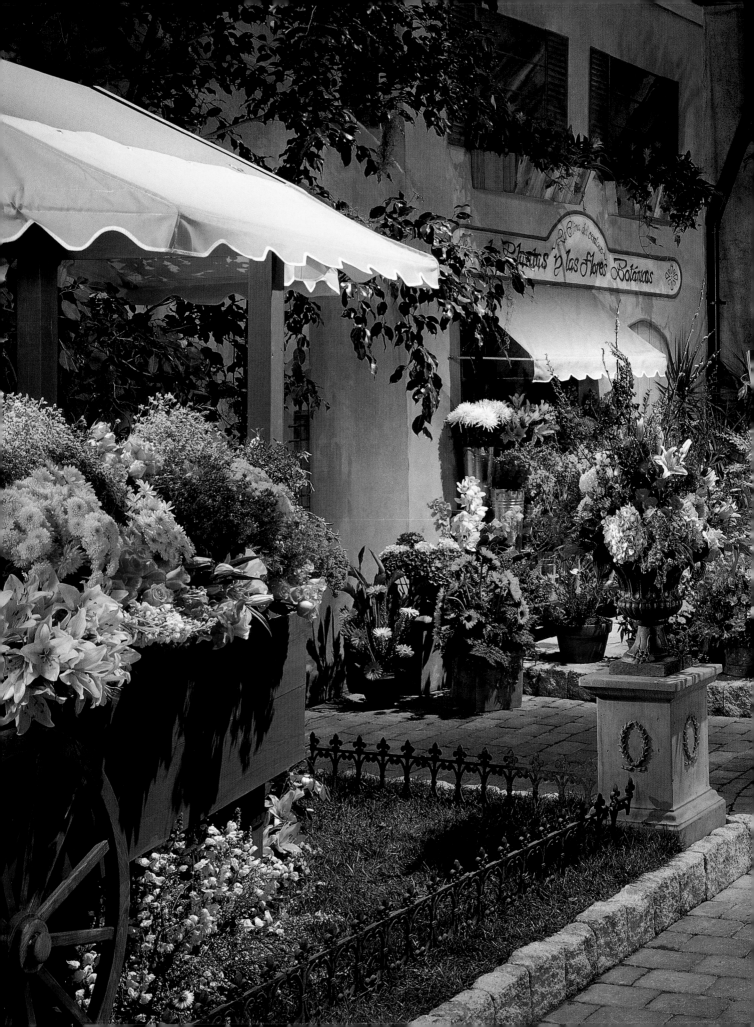

Old Tijuana Cantina
SAMIA ROSE TOPIARY
2003 CENTRAL FEATURE

The figures shown here—musicians in a *mariachi* band, and "Francesca," the *señorita* descending the staircase—were among nine figures created for this exhibit by topiary impresario Pat Hammer. Show designer Ed Lindemann had met Pat years ago, when she worked for Longwood Gardens outside Philadelphia. In

1992 Pat, author of *The New Topiary*, moved to California to start her own business, but she and Ed kept in touch. After visiting her greenhouses and seeing slides of her more recent work, he invited Pat to be a part of the 2003 Central Feature, which had a Latin theme, *Festival de las Flores*.

The graceful frames for the figures, created by artist Jeff Brees, were packed tightly with moss, into which various types of English ivy were planted. For Francesca's pile of Dolly Partonesque hair, an ivy named 'Fluffy Ruffles' was the aptly named choice. Her blouse was made of 'Midas Touch', and her dress from 'Ingot', with a splash of purple ageratum. The highest figure in the exhibit, Francesca stood closest to the spotlights. This may have been befitting of her star status, but the heat from the lights began to wilt her hair. "I was afraid it would completely go down and I'd have to give her a new hairdo in the middle of the Show," Pat said, "but somehow it held up all right." The faces on the figures were made in clay by Debbie Schaefer from plaster life masks taken from several of the designer's friends.

The topiaries were planted and grown to perfection in Pat's Encinitas, California greenhouses, and they made the four-day journey to and from the Show by truck. Later in 2003, Francesca and crew—joined by some newly made topiary horses and burros—went on display at the San Diego Wild Animal Park.

Acknowledgments

We extend our heartfelt thanks to the many people
that assisted us in the writing and research for
this book. The following staff members at the
Pennsylvania Horticultural Society were particularly
helpful with our questions and concerns: Elsa Efran,
Ed Lindemann, Rosemary McGeary, Jane Pepper,
Pete Prown, and Lisa Stephano. Also special thanks
go to Jane Alling, Janet Evans, and Josepha Miller
at the PHS McLean Library for providing access
to historical information and images and generous
photocopying privileges.

Many thanks are due to George Scott at
Chanticleer Press for his editing skill, endless tact and
humor, and belief in the book, all of which combined
to make the project as pleasurable as any bookmaking
adventure can be. Thanks to designer and typographer
Charles Nix, whose vision assured that the book was
beautiful as well as informative, and to Adam Laipson,
for his extraordinary and inspirational photographs.

Margaret T. Bennett, president of the Four
Counties Garden Club provided useful information
on the Edith Wilder Scott award. Thanks to Joyce
Moulis, member of the Orchid Society of Greater
Kansas, for permitting use of the President Harry
Truman story about Cattleya Bess Truman 'Spring
Fling.' Joe Paolino, estate manager at Mrs. Samuel
M. V. Hamilton's Pennsylvania home provided
information on plant entries and Alison Osborne
arranged for a visit to the estate. For background on
forcing plants for the major exhibits, we are grateful
for extended conversations with Chuck Gale, Jack

CHANTICLEER PRESS, INC.

Paul Steiner
Founding Publisher

Andrew Stewart
Publisher

Staff for this book:

George Scott
Editor-in-Chief

Alicia Mills
Associate Publisher

Flynne Wiley
Assistant Editor

Arthur Riscen
Production Associate

Michelle Bredeson, Annemarie McNamara
Contributing Editors

Katherine Thomason
Color Correction

Sui Ping Cheung
Office Manager

Kindly address all editorial inquiries to:

Chanticleer Press, Inc.
665 Broadway, Suite 1001
New York, NY 10012

or via e-mail to:

flowershow@chanticleer.net

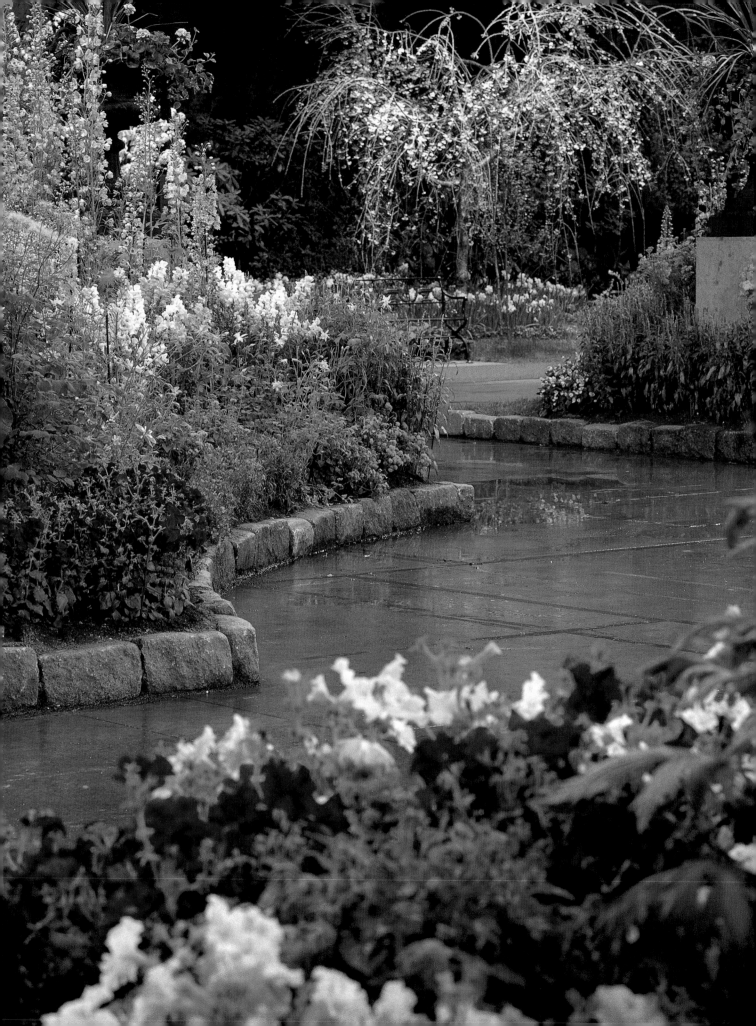

Index

COLOPHON

The text of this book is set in 12/18 point *Abrams Venetian* designed by George Abrams.

The heads are set in *Monotype Grotesque* from the Monotype Corporation.

All files for production were prepared in Adobe InDesign 2.0 on Macintosh computers.

Color separations were prepared by Bright Arts, Hong Kong.

It was printed and bound in Singapore by Imago, Inc.

The stock is 150 gsm Biberist Demi Matt Art Paper.

It was designed by Charles Nix.